In the Blink of an Ear

TOWARD A NON-COCHLEAR SONIC ART

by
Seth Kim-Cohen

continuum

NEW YORK • LONDON

2009

The Continuum International Publishing Group Inc
80 Maiden Lane, New York, NY 10038

The Continuum International Publishing Group Ltd
The Tower Building, 11 York Road, London SE1 7NX

www.continuumbooks.com

Library of Congress Cataloging-in-Publication Data

A catalog record for this book is available from the Library of Congress.

Printed in the United States of America

9780826429704 (hardcover)
9780826429711 (paperback)

Contents

Those unmindful when they hear,
for all they make of their intelligence,
may be regarded as the walking dead.

—Heraclitus (ca. 500 BCE)

Preface

In the Blink of an Ear is not a survey. Nor is it, properly speaking, a history of the sonic arts. Its primary concerns are not chronology, comprehensiveness, or the connecting of the dots. Those in search of such efforts can turn to any of a number of exceptional recent publications. Alan Licht's *Sound Art: Beyond Music, Between Categories* (Rizzoli, 2007) is a thorough and beautifully appointed compendium of works straddling the boundary between music and the gallery arts. It is, to date, the most exhaustive effort to survey the field of sound art. Christoph Cox and Daniel Warner's *Audio Culture: Readings in Modern Music* (Continuum, 2004) is by far the most thoughtfully assembled collection of writings about vanguard sound and music. In the worn-out copy on my desk, well over half its pages are marked by sticky notes. Douglas Kahn's *Noise, Water, Meat: A History of Sound in the Arts* (MIT, 1999) is a deeply informed, idiosyncratic, and at times visionary account of the incursions of the aural into the visual- and literary arts from the turn of the twentieth century through the 1960s. Brandon LaBelle's *Background Noise: Perspectives on Sound Art* (Continuum, 2006) draws unsuspected parallels among disparate instances of theory and practice in the sonic and gallery arts since the middle of the twentieth century. And Branden Joseph's *Beyond the Dream Syndicate: Tony Conrad and the Arts after Cage* (Zone Books, 2008) is that rarest of scholarly enterprises: a project both startlingly innovative and painstakingly detailed. I am indebted to each of these works and would be genuinely flattered to share shelf space with any of them.

Since this book asserts the intertextual nature of any text, I am obliged (in both the senses of *appreciative* and *beholden*) to

acknowledge my debt to those who have coaxed, cajoled, cooperated, collaborated, and comforted this book into being. The original impulse arose while I was teaching in the history of art department at Yale University in 2007 and 2008. My heartfelt thanks to David Joselit, Department Chair, and Sandy Isenstadt, Director of Undergraduate Studies, for their openness, warmth, and willingness to accept the bundle left on their doorstep.

As anyone who has done it will tell you, the activity of teaching puts you in more intimate contact with what you do not know than what you do know. My students delicately alerted me to the former while enthusiastically confirming the value of the latter.

Brian Kane of the music department at Yale is a fabulously smart cookie with a finely calibrated skew on his discipline. His insights and recommendations whether on the topic of music, phenomenology, deconstruction, or the best twenty-four-hour donut shop in New York, have been much valued.

Any evidence in these pages of intellectual invention is, in actuality, evidence of Steve Connor's influence. The London Consortium, of which he is the academic director, and of which I am a graduate, is cast in his image. The pioneering course of Steve's thinking seems constitutionally incapable of traveling the blazed trail, and yet it has laid the groundwork for many of us who follow in his footsteps.

Christoph Cox is, in my opinion, our most penetrating thinker of the sonic arts. Through his various writings and, even more profoundly, in personal conversation, Christoph has challenged me to pursue ideas further and to root out elusive implications. Whatever this book is, it would be diminished were it not for his example.

David Barker's enthusiasm for this project was a heartening buoy when the waters roiled. David has been a complete pleasure to work with, as has everyone else at Continuum.

With the exception of the putting-pen-to-paper part (I'm speaking metaphorically, of course), this book took form and flight in conversations with my friend and colleague Seth Brodsky, of the music

department at Yale. In saying so, it is not my intention to off-load any enmity this project might generate—that heat is entirely mine to warm by—but the spirit of this book is as much Brodsky's as it is mine. If a propitious return should accrue, a sizable share will be held in escrow in his name (specifically his surname, so as to avoid the confusion wrought by the nominal tastes of our equally unusual Jewish mothers). Brodsky's intellect is a torrent. To be caught in its enthusiastic spate is to surf the Kantian sublime, the whelming joy of encounter. I have caught that wave and am more ardent for it, probably even a little bit smarter.

I am grateful to Jarrod Fowler and Marina Rosenfeld, who were both extremely generous with their time and insights.

My family has battened down the hatches in more storms than any of us care to remember. To Matthew, Robin, Talia, Jack, and William, to Rebecca, Marc, Addy, Charlotte, and Annika, and to Arthur, I offer not just thanks, but love.

Despite the old saw, we are all prone to judge a book by its cover. In this case, I would encourage potential critics not to resist such urges, to go right ahead and form their opinions based exclusively on Rebecca's impeccable jacket design. I only wish I could have written something *ugualmente senza macchia*.

Many years ago, in a piece of collegiate writing, I thanked my mother, calling her "an ideal reader." Now that my conception of reading has expanded to encompass every variety of experience, that epithet is all the more fitting. I repeat it here, in its expansive sense.

This book, and everything before and after it, is dedicated to Jules.

INTRODUCTION

AT, OUT, ABOUT

"Excuse me, do you say in English, 'I look *at* the window,' or do you say in English, 'I look *out* the window'?" In Jim Jarmusch's film *Down By Law*, the Italian drifter, Bob (played by Roberto Benigni), draws a window on the wall of his windowless jail cell. Bob, who speaks little English, asks his cellmate, Jack (played, incidentally, by the musician John Lurie), which preposition to use when speaking of his window. Jack replies, "In this case, Bob, I'm afraid you've got to say, 'I look *at* the window.'"

One would be hard-pressed to find a better dramatization of the critical conflict of art history in the 1960s. On the one hand, the question asked by Bob poses the essential Greenbergian problem. It was the illusion of looking *out* the window—when looking, in fact, at a painting—to which Clement Greenberg, the preeminent postwar art critic, so vehemently objected. Instead, he suggested, we should be looking *at* the window. But there is another way to parse this problem. The post-Greenbergian art of the sixties—Minimalism, Conceptualism, performance, and so on—might accept that the illusion of the window on the jail cell wall is a problem, but its solution is entirely different from Greenberg's. Rather than retreating into the sanctity of the window's depictive flatness, sixties art ignores the prepositional problem of looking *at* or *out* the window and focuses instead on what a window *is*, the light it permits, its conduction of inside to outside and vice versa. It was Michael Fried, Greenberg's disciple, who in 1967 would so accurately diagnose Minimalism as a case of what he called "literalism": an encounter not with the window-as-illusion but with the window-as-window, with all that a literal window implies and allows.

Not surprisingly, if we peek around the figurative corner, into the adjacent cell, we find that artists working with sound have been

xv

grappling with similar issues. In 1948, the same year as Willem de Kooning's first solo show—a watershed for Greenbergian abstraction—Pierre Schaeffer, an engineer at the Office de Radiodiffusion Télévision Française in Paris, invented the techniques that would come to be known as musique concrète. By manipulating, first, phonograph records, and, later, by cutting and splicing magnetic audio tape, Schaeffer isolated what he referred to as the *objet sonore*, the sonic object. He suggests that we should listen "acousmatically," without regard to the source of the sound. The experience of listening to recorded sound, removed in space and time from the circumstances of production, allows for the acousmatic reduction, ultimately an increased attention to the specificity of sound-in-itself. We should listen to the *objet sonore* blindly, ignoring who or what might have made it, with what materials, or for what purpose.

Just three years later, in 1951, John Cage spent some time in another cell—an anechoic chamber at Harvard. In the dead acoustic environment of the chamber, Cage experienced an epiphany. After a while, against the silence of the room, he became aware of two sounds, one high-pitched and the other low. Later, the technician on duty informed Cage that the sounds he heard were, respectively, his nervous and circulatory systems at work. Cage told the story repeatedly for the rest of his life. It is the creation myth of his aesthetics: an aesthetics summed up by his proclamation "let sounds be themselves."[1]

So, in one cell we have Greenberg insisting that painting zero in on its specific, immanent concerns and "eliminate from [its] effects . . . any and every effect that might conceivably be borrowed from or by the medium of any other art."[2] In the adjacent cell we have Pierre Schaeffer insisting that musique concrète concern itself only with the immanent features of sound, and John Cage insisting

1. John Cage, "Experimental Music," in *Silence* (Middletown, CT: Wesleyan University Press, 1973), 10.
2. Clement Greenberg, "Modernist Painting," in *Art in Theory: 1900–2000*, 775.

on the value of sound-in-itself. It is this adjacency to which this book is addressed. Because the practices, and the theories informing the practices, of the postwar arts are so inextricably entwined, we must attend to them in their multiplicity. The transition from Greenbergian modernism to what came next did not happen in painting alone nor, for that matter, in the visual arts alone. This transition can be seen as a symptom of a deeper epistemological and ontological shift from an Enlightenment worldview predicated on singular, essential values, to one predicated on plurality and contextuality. It should come as no surprise, then, to find the sonic arts dealing with the question of looking—or listening—*at* or *out* the window. What I want to suggest here is a sonic parallel to the solution suggested by the gallery art of the sixties, one that ignores the prepositional question, which is at its core a perceptual question—what to look at, or listen to—and focuses instead on the textual and inter-textual nature of sound. I suppose that, if we are fixated on prepositions, we could call it looking *about* the window, in both senses of *about*—*around* and *pertaining to*. This third way allows for sound's interactions with linguistic, ontological, epistemological, social, and political signification.

In the gallery arts, the conceptual turn after Marcel Duchamp adjusted the focus from an art of *at* or *out* to an art of *about*. This is what has been characterized as the turn from " 'appearance' to 'conception' " (Joseph Kosuth),[3] from "the era of taste [to] the era of meaning" (Arthur Danto),[4] and from the "specific" to the "generic" (Thierry de Duve).[5] When Rosalind Krauss distinguishes the work of the seventies from its predecessors, employing the term "postmodern," she is indicating the same turn. Krauss characterizes the postmodern arts as organizing themselves around, and concerning themselves with,

3. Joseph Kosuth, "Art After Philosophy," 1969, www.ubu.com/papers/kosuth_philosophy.html (accessed December 8, 2008).
4. Arthur C. Danto, "Marcel Duchamp and the End of Taste: A Defense of Contemporary Art," *Tout Fait: The Marcel Duchamp Studies Online Journal* 3, 200, www.toutfait.com/issues/issue_3/News/Danto/danto.html (accessed May 30, 2008).
5. Thierry de Duve, *Kant After Duchamp* (Cambridge: MIT Press, 1996), passim. See in particular chapter 3.

discourse rather than phenomena. The conceptual turn might be seen as coming to terms with a practice: an engagement with the vocabulary that defines and is defined by that practice's concern.

> It is obvious that the logic of the space of postmodernist practice is no longer organized around the definition of a given medium on the grounds of material, or, for that matter, the perception of material. It is organized instead though the universe of terms that are felt to be in opposition within a cultural situation.[6]

The blink of an eye lasts three hundred milliseconds. The blink of an ear lasts considerably longer. From birth to death, the ear never closes. The ever-openness of the ear is what this book is about. What follows is a hearing (both a listening and an investigation) of the sonic arts since World War II. More precisely, we will be *rehearing* the case of postwar sound, because an initial verdict has already been rendered. We will reexamine the legacy of Cagean aesthetics, wondering aloud if the initial judgments overlooked important motives and modes of operation. The critical issues revolve around the notion of the blink. For centuries, philosophers have been enamored of the ineluctable, indivisible duration of the blink of an eye—that moment-that-is-less-than-a-moment. In Danish, Søren Kierkegaard wrote of the *Oieblik*; in German, Friedrich Nietzsche, Edmund Husserl, and Martin Heidegger each wrote of the *Augenblick*. It seems inevitable that the ocularity of the metaphor would be taken up by art history and aesthetics, eventually finding what appeared to be its perfect application in the reception of minimalist sculpture's "specific objects" and "unitary forms." Thus, the blink of an eye—a central image in Husserl—points to phenomenology as the apposite theoretical rubric for decoding minimalism's apparent objectivity. By the time a second generation of interpreters

6. Rosalind Krauss, "Sculpture in the Expanded Field," in *The Originality of the Avant-Garde and Other Modernist Myths* (Cambridge: MIT Press, 1985; repr., 2002), 289.

turned their attention to minimalism, they had the advantage of work-
ing in the wake of a significant critique of phenomenological essen-
tialism, spearheaded by Jacques Derrida's deconstruction of Husserl.
Rosalind Krauss in particular seized on Derrida's dissection of the
Augenblick, developing a critical approach to minimalism based not
on a raw perceptual premise, but on *reading* the object as an element
in the expansive text of sculptural encounter.

Sound art, as a discrete category of artistic production, did not
come into being until the 1980s. At that time, the critical reception
of sound should have benefited from art history's hindsight. Instead,
a preponderance of sound theory followed the first generation of
minimalist criticism down the phenomenological cul-de-sac and now
finds itself hitting a wall. What this book intends to accomplish is two-
fold: (1) to recuperate the history of the sonic arts since World War
II by rehearing it for what it is: a practice irreducible to singularity or
instantaneity; and (2) to propose a way forward, out of the dead end of
essentialism, along a path blazed by the second-generation reception
of minimalism, connecting the sonic arts to broader textual, concep-
tual, social, and political concerns.

It is a convenient coincidence (some might say too convenient)
that the three events informing the structure of this book—Pierre
Schaeffer's initial experiments with musique concrète, John Cage's first
silent composition, and Muddy Waters's pioneering electric record-
ings—all occurred in the same year: 1948. These are not proposed
as hard, fast channels, strictly marshaling all the tendencies of the
post-war sonic arts. Instead, they are nominated as provisional prop-
erty lines, boundaries that ask, "What if we draw this line here?" with
the expectation that they will be moved, modified, erased, redrawn.
The hope is that thinking about these nearly simultaneous innovations
might make apparent otherwise overlooked lines of inquiry.

Though the conjunction of these three events is certainly con-
venient, it is probably not entirely coincidental. In the estimation
of Greenberg, 1948 also represents a turning point in the develop-
ment of the distinctly modernist, distinctly American form of painting

xx • In the Blink of an Ear

known as abstract expressionism. Whether or not we point specifi-
cally at Schaeffer, Cage, Waters, and Greenberg, or precisely at the
year 1948, it is evident that, in the period following World War II the
established relationships between artists, materials, traditions, and
audiences underwent a major revision. To track these changes, we
need to attend to the history of the gallery and the sonic arts, while
also maintaining contact with philosophical ideas employed by con-
temporaneous critical discourse.

What should have been obvious from the start is inherent in the
metaphor itself: the ear is oblivious to the notion of the blink. There
is no such thing as an earlid. The ear is always open, always supple-
menting its primary materiality, always multiplying the singularity of
perception into the plurality of experience. It is easy to see how the
blink might have made sense as a metaphor for reception in the visual
arts (even if it was eventually shown to be lacking). For the sonic
arts, however, it is utterly inapplicable. Yet the history of the sonic arts
appears to start from the presumption of the *Ohrenblick*, the blink of
an ear. This history suggests that, intentionally or not, sound missed
the conceptual turn. When the gallery arts branched off in the direc-
tion of Duchamp, so the story goes, the sonic arts stayed the course.
In music, and in what later came to be known as sound art, there is
an evident resistance to questioning established morphology, materi-
als, and media. There is a sense among practitioners and theorists
alike that sound knows what it is: sound is sound. I will try to reduce
this resistance by returning attention to works and ideas stubbornly
received in the untenable space of the blinking ear. The aim is to
rehear them, rethink them, reexperience them starting from a nones-
sentialist perspective in which the thought of *sound-in-itself* is literally
unthinkable. Against sound's self-confidence—the confidence in the
constitution of the sonic self—I propose a rethinking of definitions, a
reinscription of boundaries, a reimagination of ontology: a conceptual
turn toward a non-cochlear sonic art.

Duchamp famously championed a "non-retinal" visual art that rejected judgments of taste and beauty. In the decades since, Duchamp's example has been widely embraced and liberally interpreted. This is not to suggest that art was devoid of conceptual concerns before Duchamp, nor that art was struck blind in front of the urinal. But since the 1960s, art has foregrounded the conceptual, concerning itself with questions that the eye alone cannot answer, questions regarding the conditions of art's own possibility. The conceptual turn is not intrinsically an inward turn from gaze to navel gaze. Instead, conceptualism allows art to volunteer its own corpus, its own ontology, as a test case for the definition of categories. To question the conditions under which art can and should constitute itself is, by association, to question the existential sanctity of all categories and phenomena. To question the use of art is to question the use of any activity. As a result, what once could be comfortably referred to as "visual" art now overflows its retaining walls. What, then, to call it? The defining features of such practice no longer have to do with morphology, nor with material, nor specifically with medium. The only consistent indicator that binds these disparate practices is an indication, bestowed by some authority (artist, critic, or institution), that a given experience is meant to be received—primarily, if not exclusively—as art, and not as something else. In what follows, such practices will be referred to as the "gallery" arts. This is not meant to designate the gallery as the final arbiter of questions of art, but to suggest the gallery as a metonymic indication of the universe of terms and institutions that sanction artistic practices distinct from literature, dance, architecture, and, most crucially for our purposes, music.

If a non-retinal visual art is liberated to ask questions that the eye alone cannot answer, then a non-cochlear sonic art appeals to exigencies out of earshot. But the eye and the ear are not denied or discarded. A conceptual sonic art would necessarily engage both the non-cochlear and the cochlear, and the constituting trace of each in the other.

One probably does not have to choose between two lines of thought. Rather, one has to meditate upon the circularity which makes them pass into one another indefinitely. And also, by rigorously repeating this *circle* in its proper historical possibility, perhaps to let some *elliptical* displacement be produced in the difference of repetition: a deficient displacement, doubtless, but deficient in a way which is not yet—or is no longer—absence, negativity, non-Being, lack, silence.[7]

The "non" in non-cochlear is not a negation, not an erasure, not, as Derrida puts it, "absence, negativity, non-Being, lack." It is most definitely not silence. The non-cochlear and the cochlear "pass into one another indefinitely." In what follows there is no suggestion of an eradication of phenomena. Just as with the conceptual turn in the gallery arts, a non-cochlear sonic art would not—indeed could not—turn a deaf ear to the world. Conceptual art has been dealing with the problems of materiality and documentation for forty years. They are still in play, in part because any suggestion that we can move thoroughly beyond material, beyond phenomena, has been shown to be folly.

In the visual vernacular, concepts need to be brought to light. Thinking in terms of sound, in order to be recognized, ideas must be voiced, thoughts composed, strategies orchestrated. Images, objects, and sounds are indispensable. A non-cochlear sonic art responds to demands, conventions, forms, and content not restricted to the realm of the sonic. A non-cochlear sonic art maintains a healthy skepticism toward the notion of *sound-in-itself*. When *it*—whatever *it* is—is identified without question and without remainder, we have landed on a metaphysics, a belief system, a blind (and deaf) faith. The greatest defense against such complacency is the act of questioning. Conceptual art, "art *about* the cultural act of definition—paradigmatically, but

7. Jacques Derrida, "Form and Meaning: A Note on the Phenomenology of Language," in *Margins of Philosophy*, trans. Alan Bass (Chicago: University of Chicago Press, 1982), 173.

by no means exclusively, the definition of 'art,'"[8] is the aesthetic mode of such questioning. In questioning how and why the sonic arts might constitute themselves, I hope to lead the ear away from the solipsism of the internal voice and into a conversation with the cross talk of the world.

Everything is a conversation. We just start talking, unsure where we are going. Our starting points are altered by the process, and a final destination is not forthcoming and is hardly the point. What matters is the process of negotiation. Everything is a conversation, or as Heraclitus would have it, everything flows. In the flow that follows, I will say more than once that there is no definitive source of the conversation this book records. Even individual strands, if they could be unwoven from the overarching plaid, would not lead us back to a first cause. Meanings are always the product of the patterns and shadings of the crosshatch. The intertwining tangle of cross talk sends statements hurtling into one another's paths. Where lines intersect, meaning emerges. But even this is a simplification. The game of meaning is not played in two dimensions, but in the layer-upon-layer overlap of semantic fabrics. Lines intersect horizontally, vertically, diagonally, up, down, and across. Individual intersections rub with or against other intersections, creating additional lines of vibration: like colliding ripples in a lake, like pulsing sound waves, moving in and out of phase. Since I do not believe in the concept of "the final word" on a subject, this book is not one. It is a comment on a blog, a single locution in an ongoing conversation.

The language of a sonic practice distinct from music is only now emerging. Its vocabulary and syntax, its rhetorical tropes, slang, and regional dialects are still in the process of formation and standardization. The language of a nascent non-cochlear sonic practice is, needless to say, even less developed. But if the work of art can be conceived of as the simultaneous creation of a message and the

8. Peter Osborne, *Conceptual Art* (London: Phaidon, 2002), 14.

language of the message's transmission, then work in an as-yet-unestablished category of practice, such as sound art, presents significant challenges and opportunities. By engaging this conversation in its incipience, I hope to influence both the general conditions of its existence and the specific understanding of its aesthetic, cultural, and historical present.

This book was written amid the escalating reverb of the 2008 U.S. presidential campaign and finished just a few days after Barack Obama's miraculous victory. As I now engage in the strange circularity of the introduction, returning to the beginning to introduce what I have already written and what you have not yet read, I mention this turn of political events not incidentally. Although this book is ostensibly a book about the art and music worlds, it is by association a book about the whole wide world and how we live in it. A number of societal and political certainties have, at this moment in history, been thankfully exposed as *un*certain and subject to abrupt and sweeping change. This book similarly takes meanings and values as temporary constructs, the seemingly singular as always multiple, apparent inevitability as only apparent. It seems to me that, in the wake of this once-inconceivable upheaval of history, this perspective might now be more in play, more tangible. We'll see.

1

IN ONE EAR, OUT THE OTHER

The beginning is never the beginning. Before 1948, there was 1947, and so on. Nevertheless, thought finds it useful to indicate "here" or "there," "now" or "then." The thinking of this book accordingly begins in 1948, in three different places: the Office de Radiodiffusion-Télévision Française in Paris; the Muzak Corporation in Fort Mill, South Carolina; and the Macomba Lounge in Chicago. By taking up its task and its story in these three locations, this book starts to construct a claim: that something changed as a result of what happened in these three places, in this one year. What this book proposes is that the events in Paris, Fort Mill, and Chicago were the iconic symptoms of a change in music, a change to music as it had been conceived and practiced, primarily in Europe and North America. But just as the beginning is never the beginning, innovation never occurs in isolation. The changes in music, signaled in 1948 by these events, were echoed by (or were echoes of) similar changes occurring synchronously (or nearly so) in the visual arts and elsewhere in the West.

Because the beginning is never the beginning, we can cast back to something before the beginning, to the prehistory of the history with which this book is concerned. In the second decade of the twentieth century, we can identify the inklings of the changes we will locate in 1948: in 1913, Marcel Duchamp had the "happy idea to fasten a bicycle wheel to a kitchen stool and watch it turn";[1] Luigi Russolo published *The Art of Noise*, calling for a musical parallel to the "increasing proliferation of machinery";[2] and three years later, in 1916, Emmy

1. Marcel Duchamp, *The Writings of Marcel Duchamp*, eds. Michel Sanouillet and Elmer Peterson (New York: Da Capo, 1973; repr., 1989), 141.
2. Luigi Russolo, *The Art of Noise*, trans. Robert Filliou, Great Bear Pamphlet (1913; repr., New York: Something Else, 1967), 5.

Hennings and Hugo Ball opened the Cabaret Voltaire in Zurich, stag-
ing the initial events of what would come to be known as Dada.

It goes without saying that the beginning is never the ending. (At
the same time, every beginning is an ending.) The changes that rattled
the cages of art and music in the second decade of the twentieth cen-
tury—and that returned with renewed vigor (or to a more receptive cli-
mate) in 1948—staked a genuine and significant claim to the definition
and identity of each medium around 1960. This book will not provide
a detailed historical account of the earliest inkling of these changes.
We will, however, encounter Duchamp, Russolo, and Dada as they
were received by artists, musicians, critics, and theorists, beginning
in 1948 and continuing, with ever-increasing force, through the 1960s
and to the present day. This movement—if we allow ourselves to see
these various activities in the singular—derived its energy, the thrust
and direction of its momentum, from a motivated reassessment of
the formal, ideological, and ontological foundations of art history and
aesthetics. To begin to identify (i.e., understand) these motivations, it
is necessary to identify the state of art history and aesthetics, circa
1948. By artificially freezing this moment in time, we will avail our-
selves of that all-important "there" and "then" from which we can start
to trace a path to "here" and "now."

In the first month of 1948, *Partisan Review* published a piece
by the art critic Clement Greenberg entitled "The Situation at the
Moment." The diagnosis was not altogether upbeat:

> There is no use in deceiving ourselves with hope. Our most
> effective course is to confront the situation as it is, and if it
> is still bad, to acknowledge the badness, trusting in the truth
> as the premise of any improvement, and feeling a new secu-
> rity because of the very fact that we have met and verified
> the worst.[3]

3. Clement Greenberg, *The Collected Essays and Criticism*, vol. 2, *Arrogant Purpose*, ed. John O'Brian (Chicago: University of Chicago Press, 1986), 192.

What Greenberg called "the situation" was a public losing interest in abstract painting, resulting in the social isolation of the artist. At the same time, the paintings themselves were growing in scale, demanding larger canvases and exhibition spaces. "Abstract painting, being flat," he wrote, "needs a greater extension of surface on which to develop its ideas than does the old three-dimensional easel painting."[4] Greenberg goes so far as to supply a minimum size for an abstract canvas: "two feet by two"; anything less and the painting becomes "trivial." Pessimism and precision notwithstanding, what fuels abstract painting's physical expansion, for Greenberg, is its commitment to two-dimensionality. In 1948 he was already zeroing in on painting's characteristic flatness, a quality that, by 1960, he had decided was the one quality "unique and exclusive to [pictorial] art."[5] What Greenberg was already fully convinced of in 1948 was that modernist art—in order to "stay alive only by advancing"[6]—had to concern itself with "its own proper experience, . . . that part of experience that has to do with the making of art itself."[7]

Greenberg's convictions about the proper concerns of painting held considerable sway in 1948. His influence was actually so pervasive that it would hardly have been possible at the time to put brush to canvas or paper to typewriter (if the subject were art) without hearing—at least in some remote, quite possibly repressed, corner of one's mind—Greenberg's voice. Such clarity seems inconceivable amid today's polyphony of blogs and wikis. Whether or not we are lucky to find ourselves unable to apply a similarly dominant aesthetic—or even to imagine its possibility—depends on what, ultimately, we want from the arts (among the pairs of opposing candidates: consistency/diversity; authority/equality; answers/questions). What Greenberg wanted, first and foremost, was quality. Not only does he constantly

4. Ibid., 195.
5. Clement Greenberg, "Modernist Art," in *Art in Theory, 1900–2000,* eds. Charles Harrison and Paul Wood, new ed. (Malden, MA: Blackwell Publishing, 2003), 775.
6. Greenberg, *Collected Essays,* 2:218.
7. Ibid., 218–19.

assert his own assessments of quality and the grounds upon which they are based, he also frequently acknowledges (often begrudgingly) or disparages (often savagely) the tastes of other critics in the midst of discussion or debate. He calls T. H. Robsjohn-Gibbings, the author of *Mona Lisa's Mustache: A Dissection of Modern Art*, "very, very stupid," saying he "cannot tell the quality of one picture or piece of sculpture or school of art from another."[8] What's worse, Robsjohn-Gibbings "attacks modern art not on the score of its quality but only because of the social and ideological tendencies he attributes to it."[9] Despite identifying himself as an "ex- or disabused Marxist,"[10] Greenberg—at this point in his career, both an archformalist and an unrepentant connoisseur—was unwilling to compromise on the subject of aesthetic judgment. He could make no concessions to the anthropologists, the sociologists, the literati, and certainly not to what he called "the 'creative man' or aesthete,"[11] the emerging jacks-of-all-trades for whose benefit the terms "interdisciplinary" and "multimedia" would soon be invented.

For Greenberg, the experience of the artwork can be broken down into an encounter with three independent yet interrelated facets: content, subject matter, and form. Both chronologically and in terms of importance, content comes first and last. It is the feeling or impulse that motivates the artist to make the work. Content is also the impact or impression the work makes on the spectator. This content is communicated (in the simple, etymological sense of being shared) via the twin channels of subject matter and form. Subject matter is what the work is ostensibly *about*, what is depicted. In Greenberg's account of modernist art, the only proper subject matter is "the very processes or disciplines by which art [has] already imitated . . . the world of common, extraverted experience."[12] After dispensing with pictorial illusion,

8. Ibid., 200.
9. Ibid.
10. Ibid., 255.
11. Ibid.
12. Clement Greenberg, *Art and Culture* (Boston: Beacon, 1961), 6.

with depicting a three-dimensional world in two dimensions, modernist painting concerns itself solely with the unique conventions, characteristics, and materials of painting. Form, on the other hand, is the means by which subject matter is organized and content conveyed. While subject matter can be accounted for art-historically, form is a matter of aesthetics. Prior to both—and in the final analysis—content is art's raison d'être: "The unspecifiability of its 'content' is what constitutes art as art."[13] Greenberg believes that content cannot be encountered directly; form is the handle allowing content to be grasped. Taste is essential to Greenberg because it is the exercise of the capacity to judge content as it makes itself legible through form.

So where does that leave art in 1948? In a word, abstract expressionism. Okay, that's two words. And truth be told, there were lots of other words for it, including: "postpainterly abstraction," "action painting," and, matter-of-factly, "American-type painting." In 1955, Greenberg wrote:

> The years 1947 and 1948 constituted a turning point for "abstract expressionism." In 1947 there was a great stride forward in general quality. [Hans] Hoffman entered a new phase, and a different kind of phase, when he stopped painting on wood or fiberboard and began using canvas. In 1948 painters like Philip Guston and Bradley Walker Tomlin "joined up," to be followed two years later by Franz Kline. [Mark] Rothko abandoned his "Surrealist" manner; [Willem] de Kooning had his first show; and [Arshile] Gorky died.[14]

In addition to those named above, Greenberg vigorously championed the work of painters like Jackson Pollock, Robert Motherwell, Clyfford Still, and Barnett Newman. The best modernist painting had

13. Clement Greenberg, "Complaints of an Art Critic," *Artforum* 6, no. 1 (October 1967): 39.
14. Greenberg, *Art and Culture*, 219.

successfully jettisoned pictorial illusion and had set its sights on the flatness of the picture plane, on the physical reality of the picture's supports (canvas and stretcher), on the materiality of paint-as-paint. By April 1948, Greenberg's January pessimism had already lifted considerably. In a review of de Kooning's first solo exhibition, he declared: "Decidedly, the past year has been a remarkably good one for American art."[15] Whether presented—as he insisted—as a positivist description of the state of art, or—as he is more often read—as a normative prescription of how art *ought* to be, it was around this time that Greenberg's vision of modernist painting began to be stabilized in theory and realized in practice. For the next dozen years, abstract expressionism enjoyed its de facto status as the face and body of modern art. For much of that time, Greenberg seemed either to sit on modern art's knee, miming its concerns and motives, or conversely, to put words into the mouths of the works, making them obediently speak his mind.

"For years," said Pierre Schaeffer, "we often did phenomenology without knowing it."[16] This accidental phenomenology began in 1948, when Schaeffer, an engineer at the Office de Radiodiffusion-Télévision Française, began to experiment with phonograph discs in the ORTF radio studios. Phonograph discs allowed certain basic manipulations such as slowing or speeding the playback, but as magnetic tape technology—unknown outside Germany until after World War II—became available, Schaeffer experimented with running the tape backward at consistent speed, cutting it up, and reassembling it. Schaeffer was looking for a new way to construct music, a way that would bypass both traditional tonality and the atonal techniques of serialism and twelve-tone music: products of the so-called Second Viennese School and the dominant compositional aesthetic of the day.

15. Greenberg, *Collected Essays*, 2:228.
16. Pierre Schaeffer, as quoted in Brian Kane, *"L'objet sonore maintenant*: Pierre Schaeffer, Sound Objects and the Phenomenological Reduction," *Organised Sound* 12, no. 1 (Cambridge: Cambridge University Press, 2007): 15.

In the '45 to '48 period, we had driven back the German invasion but we hadn't driven back the invasion of Austrian music, twelve-tone music. We had liberated ourselves politically, but music was still under an occupying foreign power, the music of the Vienna school.[17]

Schaeffer pioneered the approach of musique concrète, a music of concrete sounds in the sense both of sounds of the world and of sounds as concrete, discrete parcels of material. Schaeffer referred to this discrete unit of sound as the "*objet sonore*," the sonic object. Such a sound is not treated as a note with a pitch value, to be combined—in adherence to the edicts of either the tonal or atonal systems—with other notes to create harmonic relations. The *objet sonore* is to be accepted for its sonic, acoustic properties; for its texture, its grain, for all the qualities it carries in excess of, or prior to, its traditional musical values. To accept the *objet sonore* thus, Schaeffer suggests that we should listen "acousmatically," without regard to the source of the sound. We should listen blindly, paying attention only to the characteristics of the sound, ignoring who might have made it, with what materials, for what purpose. Schaeffer borrowed the term *acousmatic* from the practices of Pythagoras, who lectured from behind a curtain in order to encourage his students (*akousmatikoi*) to focus attentively on his words and his words only, without consideration of his appearance, his gestures, his facial expressions. Musique concrète, as imagined by Schaeffer, asks us to listen similarly, from behind a metaphoric curtain, removed from the site and source of what we are hearing.

Such a perceptual prescription takes its cues from Edmund Husserl's phenomenology, a philosophical method much in vogue among the French intelligentsia of the 1940s. Later, in 1966, when he claimed to be an accidental phenomenologist, he still considered it

17. Tim Hodgkinson, "Interview with Pierre Schaeffer," *Recommended Records Quarterly Magazine* 2, no. 1 (1987), www.ele-mental.org/ele_ment/said&did/schaeffer_interview.html (accessed February 2, 2009).

"much better than talking about phenomenology without practicing it."[18] Just as phenomenology seeks to reduce the field of philosophical inquiry to only that which is available in perception, musique concrète calls for a "reduced listening" practice, concerned only with the immanent features of sound. Schaeffer's Pythagorean curtain is, of course, technology; the "blind" experience of listening to recorded sound, removed in space and time from the circumstances of production, allows for the concrète reduction, ultimately an increased attention to the specificity of the sound in question. In ancient times, the apparatus was a curtain; today, it is the radio and the methods of reproduction, along with the whole set of electroacoustic transformations, that place us—modern listeners to an invisible voice—under similar conditions.

Schaeffer was not the first to organize "concrete" sounds into a formal, artistic composition. That distinction may belong to Walter Ruttmann, whose Wochende (Weekend) was made in 1930. Preemptively agreeing with Schaeffer's acousmatic intentions, Ruttmann described Wochende as a work of "blind cinema." Ruttmann recorded real-world sounds—cars and planes, machines and everyday conversation, church bells and clinking glasses—onto the sound track of optical-sound film stock. Using a photoelectric cell, sound waves were converted into electrical waveforms and then into light waves, which were recorded onto the edge of the film before being converted back into electrical waveforms and sound during projection. Schaeffer's innovation was to work with sound as an independent medium—independent, on the one hand, of conventional musical values and organization and, on the other, of cinema, poetry, and narrative exigencies. The advent of readily available audio technology allowed Schaeffer to begin and end with sound, and in so doing, to invent a replicable technique and aesthetic.

Both technique and aesthetic are bound up in Schaeffer's notion of the sonic object, which might more easily be defined by what it is

18. Schaeffer, as quoted in Kane, "L'objet sonore maintenant," 15.

not than by what it is. It is not, for instance, the instrument that produces the sound. Schaeffer wants us to hear sounds with no consideration of their source. Nor is the sonic object a product of its media (phonograph disc, magnetic tape, CD, MP3). He points out that a few centimeters of magnetic tape can contain a number of sonic objects, and therefore the sonic object cannot be a product of the recording medium itself. The sonic object, he writes, is "a perception worthy of being observed for itself."[19]

In a 1986 interview with Tim Hodgkinson, Schaeffer says, "It took me 40 years to conclude that nothing is possible outside of DoReMi. . . . In other words, I wasted my life."[20] Try as he might, Schaeffer felt that he could not organize sound in a sensible way without recourse to tonality. Much of the recorded music of the last forty years testifies, in various ways, to the contrary, proving Schaeffer a less-than-prescient assessor of his own project. Recorded music has come to rely upon and build upon the ideas he theorized and put into practice. The piecemeal way in which recordings have routinely been made since the 1960s borrows from Schaeffer's technique. The overt *concrète* moves of everyone from the Beatles to Marvin Gaye to Pink Floyd to the Minutemen owe their genesis to his founding *concrète études.* One need look no further than the production techniques of Timbaland, the albums of Bjork, the genres of hip-hop, minimal techno, IDM, and the whole idea of sampling as a compositional method, to find active, full-force employment of Schaeffer's technique and aesthetic. Drew Daniel of Matmos (no stranger to appropriative cut-and-splice music making) has gone so far as to claim that *all* contemporary popular music is musique concrète due to the way it is constructed: using isolated bits of sound—sometimes sounds produced by the artists themselves, sometimes by others, sometimes amusical sounds—and digitally rearranging them based on their usefulness within a compositional framework.[21]

19. Pierre Schaeffer, "Acousmatics," in *Audio Culture: Readings in Modern Music,* eds. Christoph Cox and Daniel Warner (New York: Continuum, 2004), 78.
20. Hodgkinson, "Interview with Pierre Schaeffer."
21. Drew Daniel, e-mail post to Sonic Focus listserv, December 8, 2006.

The argument could be made that such practices are not sub-stantively different from the practices of pre-recording-age compos-ers who maintained in their heads a library of sound clips (i.e., the sounds of the instruments of the orchestra and the gestural uses of those instruments within the tradition of Western composition). In such a tradition, the composer's facility is that of accessing these clips and combining and arranging them into compositions—a prac-tice of virtual sampling, a practice for which Western musical notation is a kind of code or system-language. However—and this is where such an argument would fail—the components of this language are designed to capture only the individual sounds of the instruments of the orchestra and only within the parameters of the possible variations accounted for by the system itself (pitch, tempo, rhythm, dynamics, etc.) It is a mistake to think of Western staff notation as a system intended to express or communicate the possibilities of sound as such. Schaeffer's practice of musique concrète and his *objet sonore* address these limitations of notation by allowing sound compositions to be constructed from sound components without an intervening or translating mediator. Schaeffer's dream for musique concrète is this: the sound signifier signifies only itself; it does not point to some other signified that is meant to be brought forth by the signifying relation. Strictly speaking, Schaeffer's method, his aesthetic, relies on a dis-arming or suspending of semiotic activity in the listening experience.

Such a suspension again takes its cues from Husserl's phenom-enological method, specifically from the bracketing-out of seman-tic, historical, and semiotic considerations. *Epochē*, a Greek term employed by Husserl, describes a method that advances without con-sideration of the so-called real world. The Husserlian epochē allows the phenomenologist to make no distinction between fact and fiction, between real and imagined. Perceptual data are accepted as they are received and are analyzed without reference to time, place, inten-tion, or their method of production. For Schaeffer, this means that the sound object precedes any aural experience of it as "signal": "it is the

sound object, given in perception which designates the signal to be studied; . . . it should never be a question of reconstructing it on the basis of the signal."[22] The sound object is proposed as the ideal and objective form of the signal; the *essence* of any given heard-thing.

As Brian Kane notes, "Through a sleight-of-hand, phenomenology covertly places its ontology prior to experience, and then subsequently 'discloses' the ontological horizon *as if* it were already present—as if *its* ontology made experience possible in the first place."[23] Schaeffer's *concrète* reduction is no less essentialist, no less invested in the reversible flow of ontological-experiential relations. Acousmatic listening involves a naive, blank reception of the auditory. We are asked to let sounds in the door without first asking, "Who's there?" Pursuing the acousmatic epochē, we are then responsible for bracketing out all information that might shade our auditory experience with signification, with historical contingency, with social import. From this reduction, we can identify that which, within the sound, simply *is*. "I no longer try, through its intermediary, to inform myself about some other thing (an interlocutor or his thoughts). It is the *sound itself* that I aim at, that I identify."[24]

Thelonious Monk is purported to have said "simple ain't easy." And it ain't. The construction "in-itself" should always trigger an alarm. We have cause to be skeptical whenever a claim is made on behalf of "the (thing) itself," on behalf of the simple, obvious existence of something. Jacques Derrida's deconstruction of the "metaphysics of presence" (the Western philosophical tradition predicated on a belief in the existence of some baseline, *it*, underlying experience) began with a critique of the presumptions inherent in Husserl's theory of signs. As Derrida shows, Husserl's conviction that experience has some access to itself in "absolute proximity" is founded on the metaphysical conceit of presence. Presence assumes, at the very least, that we can

22. Schaeffer, as quoted in Kane, "*L'objet sonore maintenant*," 20.
23. Kane, "*L'objet sonore maintenant*, 21, with original emphasis.
24. Schaeffer, as quoted in ibid., 18, with added emphasis.

posit direct, inner experience of ourselves in a way that would render useless any sign, language, or mediation. This claim for the uselessness of signs for inner communication is, for Derrida, "the non-alterity, the nondifference in the identity of presence as self-presence."[25] Such nonalterity and nondifference is (literally) unthinkable for Derrida, for whom meaning of any kind is always a product of differentiation, of a process that distinguishes the thing-in-question (never simply itself) from all that it is not. Such a process always leaves a trace of the differentiating procedure, of all the things the thing-in-question is not. Thus the thing-in-question retains, constitutionally, the mark of otherness, alterity, difference. It is what it is by dint of what it is not. No thing-in-question is ever simply or obviously a thing-in-itself.

Again, this does not lead to the conclusion that for Husserl—or for Schaeffer, in turn—the thing-in-itself maintains a strict materialist existence. "Absolute proximity" is a quality of experience, not of the thing being experienced. The *objet sonore* is real—Schaeffer is unequivocal on this point—but it is real as a function (or perhaps as a product) of attention and, therefore, of *in*tention. Schaeffer's *Solfège de l'objet sonore* (*Music Theory of the Sonic Object*) endeavors, in part, to demonstrate the objective nature of the sound object, which remains identifiable even as its characteristics are electronically modified. "Variation is a technique for revealing *essence*."[26] Quite apart from the signal, quite apart from any question of fact or fiction, the sound object maintains its own reality as perceived by a listener. The sound object is that which maintains its identity, its essence, even as its particularities change, even as the perspective from which it is beheld changes. Husserl refers to perceptions formed from alterations of perspective relative to an object as "adumbrations." In his phenomenology, these adumbrations testify to the presence of an

25. Jacques Derrida, *Speech and Phenomena: And Other Essays on Husserl's Theory of Signs*, trans. David B. Allison (Evanston: Northwestern University Press, 1973), 58.

26. Kane, "*L'objet sonore maintenant*," 19, with original emphasis.

unchanging essence of the object, even as the constituent elements of individual perceptions differ. Just as Husserl's epochē confirms the object's singularity, Schaeffer's acousmatic reduction directs the listening activity in such a way as to debar all that might undermine its unity, its self-sameness. Yet without reference to signal, without recourse to determinations of fact, the sound object has no particular obligation to actuality. Brian Kane arrives at the inevitable conclusion: "Once Schaeffer commits to reduced listening, there can be no essential difference between imagined hearing and actual hearing."[27]

It does not seem too much of a stretch to find some common ground between Greenberg and Schaeffer. Just as Greenberg reduced painting to its essential element, jettisoning anything that wasn't fundamental to its constitution, excising anything that was shared with another mediums, so too did Schaeffer reduce music. If we strip away every characteristic of music, we find that, before it ceases to be music, it can afford the loss of every characteristic but one. We can find examples of essentially rhythmless music (Tony Conrad's drones, Alvin Lucier's "Music on a Long Thin Wire"), and we can find examples of music essentially bereft of pitch values constituting either melody or harmony (Merzbow, Lou Reed's *Metal Machine Music*). "Sound is an irreducible given of music," writes the musicologist Jean-Jacques Nattiez, "Even in the marginal cases in which it is absent, it is nonetheless present by allusion."[28] The sonic object requires no signal, yet Schaeffer still calls it the *sonic* object. This lack of material obligation allows Schaeffer to pursue the creative organization of sound—"music," if you will—without recourse or reference to the specific parameters or traditions of Music with a capital *M*. If what determines the sound's "value" (for now, let's set aside the term "meaning"—remembering, ultimately, it is the term we most want to engage) is not its singular pitch, or its pitch relative to

27. Ibid, p. 20.
28. Jean-Jacques Nattiez, *Music and Discourse: Toward a Semiology of Music*, trans. Carolyn Abbate. (Princeton, Princeton University Press, 1990), 67.

proximate pitches, or its relative placement in time, nor its loudness; if none of these characteristics are how we engage with the sound as a valuable construct, then the sonic object is free to come and go as it pleases. If it is present for appraisal, then its pesky physical properties are likely to mislead our perception. It is better, one would think, if the sound object maintained its distance from the encumbrance of signal. Can such a thing still be music? Reduced to its minimal, inaudible condition, can music survive *as* music? The *absence* of sound (thus silence) in a given context (an *intentional* context) retains the constituting trace of sound, according to the play of difference. The signalless sound object is made of (absent) sound. Music may proceed without the burden of materiality, without resolving the opposition of *physis* and *nomos*.

Perhaps I am forgetting—you are entitled to wonder—John Cage's eponymous four minutes and thirty-three seconds of silence? But *4' 33"* is, as many since Cage have reiterated, not about the absence of sound, not about silence in the way we commonly understand it. Instead, it is about a new understanding of silence as an unachievable state of noiselessness, as what Douglas Kahn has called "the impossible inaudible."[29] In chapter 6 we will discuss *4' 33"* as an engagement with the very material nature, and the very materials, of listening in more detail. For now, maintaining our focus on 1948, let's shift our locus from Pierre Schaeffer's Paris to Fort Mill, South Carolina—by way of Poughkeepsie, New York.[30]

It was in Poughkeepsie, at Vassar College in February 1948, that John Cage addressed the national intercollegiate arts conference, a gathering intended to explore the issue of "the creative arts in contemporary society." During his speech that day, presented as part of the conference's art and music panel (and later published as "A Composer's Confessions"), Cage unveiled "several new desires":

29. Douglas Kahn, *Noise, Water, Meat: A History of Sound in the Arts* (Cambridge: MIT Press, 1999), 158, passim.

30. As an aside, allow me to propose a formula of cultural understanding: focus, plus locus (perspective plus place plus time).

(two may seem absurd but I am serious about them): first, to compose a piece of uninterrupted silence and sell it to Muzak Co. It will be 3 or 4½ minutes long—those being the standard lengths of "canned" music—and its title will be *Silent Prayer*. It will open with a single idea which I will attempt to make as seductive as the color and shape and fragrance of a flower. The ending will approach imperceptibility.[31]

This is where Fort Mill, South Carolina, the home of the Muzak Corporation, comes in. Although it is not the least bit clear that Cage ever set foot in Fort Mill, there is reason to include it in our constellation of *theres* in the *then* of 1948. If *Silent Prayer* had ever been realized, it would have been broadcast across Muzak's "wired radio" network (Wired Radio being the original name of the Muzak Corporation).[32] Since it was to be silent, there would have been no "performance" per se. It would have happened everywhere and nowhere. The ostensible location of the performance, if we felt the need to identify it, could only be Fort Mill, from whence the silence would have issued (or, one could argue, Poughkeepsie, from whence the *idea* issued).

Silent Prayer (or the idea of it) predates *4' 33"* by four years. But just as Schaeffer was not the first composer of recorded sounds, Cage was not the first composer of silence. In 1897, Alphonse Allais composed his *Funeral March for the Obsequies of a Deaf Man*, which consisted of nine blank measures. Allais was known primarily as an author, poet, and humorist. This renders his work no less silent, but it probably accounts for its lack of recognition. Since Allais was not invested in the world of music, he had nothing to lose by such an intervention. His *Funeral March* could be seen as a satire of music rather than as a piece of music. This allowed it to be kept outside

31. John Cage, "A Composer's Confessions," in *John Cage: Writer*, ed. Richard Kostelanetz (New York: Cooper Square, 2000), 43.

32. David Owen, "The Soundtrack of Your Life," *The New Yorker*, April 10, 2006, www.newyorker.com/archive/2006/04/10/060410fa_fact?currentPage=2 (accessed February 2, 2009).

the music corpus, safely exterior to the tradition. The same, however, does not explain the exclusion of the "In Futurum" movement from Erwin Schulhoff's *Fünf Pittoresken* of 1919. Schulhoff was an accomplished Jewish Czech composer, a student of Debussy, responsible for more than thirty fully realized compositions. After the Nazi invasion of Czechoslovakia in 1939, Schulhoff was forced to work under a pseudonym. In 1941 he was captured while trying to flee to the Soviet Union. He was interned at Wülzburg concentration camp, where he died of tuberculosis in 1942. "In Futurum" is scored for solo piano, which is coincidental with the most well-known reading of *4' 33"*. But unlike the score for *4' 33"* (and for that matter, the score for Allais's *Funeral March*), the score for "In Futurum" is hardly a model of blankness.[33]

> There are long and short notated rests, triplet and quintuplet rests, and fast runs of thirty-second-note rests. There are fermatas, exclamation points, question marks, and in the middle and at the end, enigmatic signs that look like a hybrid of a half note and a smiley face. Most challenging of all is the opening direction to play 'tutto il canzone con espressione e sentimento ad libitum, sempre, sin al fine!' [the entire song with as much expression and feeling as you like, always, right to the end!].[34]

Regardless of who got there first, Cage's *4' 33"* is certainly the most famous and infamous, the most influential "silent" piece in the history of music. *Silent Prayer*, for obvious reasons (it was never realized), is not much discussed. But there may be reasons to attend to *Silent Prayer*, to how it may actually be more similar to Schaeffer's acousmatically reduced music than it is to *4' 33"*. Thinking through the

33. The notion of *the* score of *4' 33"* is in itself problematic since there are three vastly different extant scores for the piece.

34. Leo Carey, "Sh-h-h," *The New Yorker*, May 24, 2004, www.newyorker.com/archive/2004/05/24/040524ta_talk_carey (accessed February 2, 2009).

implications of *Silent Prayer* may help us understand *4' 33"* for what it was and, perhaps more important, for what it might have been.

In 1948 the Muzak network supplied "environmental music," meant to increase productivity and reduce absenteeism, to offices and factories across the United States. Clients included small companies as well as huge ones: Prudential Insurance, Bell Telephone, and McGraw-Hill Publishing. Cage's proposal, to "compose a piece of uninterrupted silence and sell it to Muzak Co.," is an uncharacteristic intervention into a commercial channel. Cage was fond of mixing sound sources from different cultural strata, sources with divergent uses and functions. But his approach, almost exclusively, was to bring the nonmusical into the concert hall: to turn radios into members of the orchestra, to employ hardware store ephemera and office supplies as addenda to the mechanics of the grand piano, to play a bathtub. It was far less common for Cage to locate his activities outside the circuits of serious music. The Western compositional tradition was, after all, his target. He sought to overturn the presumptions, habits, and hierarchies that had set music's agenda for three hundred years. But an intervention such as *Silent Prayer*, whatever its overall impact, would have little effect on "classical" music. This reason alone may account for Cage's failure to pursue *Silent Prayer* to realization and for his turning of his attention to the concert hall silence of *4' 33"*.

Still, it is difficult to square Cage's abandonment of *Silent Prayer* with his well-documented interest in subjects including indeterminacy, the relocation of music making from the site of composition to the site of audition, an agnostic listening practice, and the composer Erik Satie. Cage was a collector of the scores of Satie (1866–1925). As early as 1945, Cage had worked with and from a Satie score, arranging the first movement of Satie's *Socrate* for a Merce Cunningham dance, *Idyllic Song*. Cage was no doubt aware of Satie's *musique d'ameublement* (usually translated as "furniture music"), a collaboration with Darius Milhaud. First presented in 1920, *musique d'ameublement* was performed during intermission of a play by Max

Jacob. The spoken introduction to the music instructed patrons to "take no notice of it and to behave during the entr'actes as if the music did not exist. This music . . . claims to make its contribution to life in the same way as a private conversation, a picture, or the chair on which you may or may not be seated."[35] Compare this to the term "functional music," employed in a Muzak corporation description of its product's utility, "not as mere background music, but as a psychologically active, sonic accompaniment, carefully designed to remain below the threshold of common attention."[36]

One can easily imagine Satie making the same claim for his *musique d'ameublement* that Donald O'Neill, a former Muzak vice president, made for Muzak, calling it a "non-entertainment, . . . to hear, not listen to."[37]

What's more, Cage's long-standing interest in—indeed, championing of—indeterminacy as a compositional and performance strategy would certainly have found ready application and realization in *Silent Prayer*. Cage's compositional proposal includes the idea that "it will open with a single idea which I will attempt to make as seductive as the color and shape and fragrance of a flower. The ending will approach imperceptibility."[38]

Notwithstanding this "attempt," everything from the duration to the sonic content would be determined, not by Cage as composer, but by external forces: duration, by the standard length of a piece of "canned" music; sonic content, by the particular, unpredictable sounds of each individual environment in which *Silent Prayer* intervened in the flow of Muzak programming. One might read Cage's proclamation from the Vassar lecture less as a declaration of compositional intentions and more as a prediction of how such a period of

35. Quoted in Kahn, *Noise, Water, Meat*, 179.
36. Quoted in Ronald M. Radano, "Interpreting Muzak: Speculations on Musical Experience in Everyday Life," *American Music* 7, no. 4 (Winter 1989): 449–50.
37. Quoted in ibid., 450.
38. Cage, "A Composer's Confessions," 43.

silence might impose itself on the sensibilities of its audience: blossoming at first from within Muzak's static continuity but eventually receding into the quotidian and imperceptible regularity of the sounds of commerce or manufacturing.

This is not to suggest that by 1948 Cage had already developed his "mature" thoughts regarding silence: that what we think of as silence always includes unintended sounds. It *is* to suggest, however, that Cage may already have been attracted to nonintentional sounds and to recasting attention to the activity of listening quite apart from the activity of composing. If we agree that the downplaying of compositional intentionality and the privileging of the listener's role rank among Cage's major contributions to twentieth-century music, then we might conceivably see Cagean tendencies in Muzak itself. Ronald M. Radano states it plainly:

> Muzak topples art from its pedestal into the life of the everyday. It accomplishes what John Cage, the father of American postwar vanguardism, hoped to achieve with a highly radical musical language: to remove the composer's imprint from the score and disrupt traditional listening expectations, directing attention away from the artist toward the role and experience of the listener.[39]

Douglas Kahn has suggested that *4' 33"* approaches silence quite differently from *Silent Prayer*, which "was not a way to begin hearing and musicalizing the surrounding sound. If anything was meant to be heard, it was conventional silence—in this case, the absence of the sound of Muzak."[40] Still, it seems clear that the result of *Silent Prayer* would have been an increased awareness of one's sonic environment. Just as one becomes aware of the hum of the air-conditioning only when it turns off, the intrusion of *Silent Prayer* into the

39. Radano, "Interpreting Muzak," 458.
40. Kahn, *Noise, Water, Meat*, 182.

aural environment of Muzak would surely have drawn attention to the change in atmosphere: to the new presence of quiet (if not actual silence), to the absence of the sound of Muzak (as Kahn suggests), and to the Muzak itself. This newly encouraged consciousness of the Muzak content would function in two temporal directions. One would retrospectively "hear" the Muzak that had been playing, suddenly attentive to what had previously existed as unheard ambience. One would also be activated as a listener, prospectively, to when the Muzak returned, undoubtedly listening more sensitively—if only temporarily—to the content of the programming after the end of *Silent Prayer.*

> The broad appeal of Muzak suggests that, unless we reject it entirely, we need another approach, one that comments on its effect, its function, and the kinds of responses it elicits. When interpreting Muzak, we must focus on the listener rather than the object, observing the ways in which programmed arrangements shape sonic environments and, in turn, public perceptions of everyday life. Indeed, I would argue that Muzak is important chiefly because it places the responsibility of making a meaningful experience in the hands of the listener.[41]

In what may be nothing more than a bit of inspired apocrypha, it is said that in 1989 the rock guitarist Ted Nugent (also known as the "Motor City Madman") made a ten-million-dollar bid for the Muzak Corporation, hoping to purchase the company so that he might erase all their tapes. One is tempted (probably unadvisedly) to see this as *Silent Prayer* writ large, as a permanent insertion of silence into the Muzak circuit. In the end, though, sound always prevails over silence: in response to Nugent's failed buyout, the Muzak Corporation created a treacly version of his 1977 hit, "Cat Scratch Fever."

41. Radano, "Interpreting Muzak," 449.

In 1948, all roads led to 3905 South Cottage Grove Avenue. How else would one explain the convergence—at the Macomba Lounge, a neighborhood bar on Chicago's South Side—of the brothers Phil and Leonard Chess, Polish Jews who had immigrated to the United States in 1928, and McKinley Morganfield (aka Muddy Waters), who arrived in Chicago in May of 1943 from the Stovall plantation near Clarksdale, Mississippi? Yet it was hardly just these three men that came together, after hours, at the Macomba. They also carried on their proverbial backs the traditions of their respective diasporas. The Chess brothers embodied Ashkenazi Jewish flight from the metastasizing anti-Semitism of Eastern Europe to the merciful anonymity of big American cities. Muddy Waters exemplified the journey of African-Americans from their recent ancestors' enslavement in the American South to the "liberation" of institutionalized racism, segregation, and torturous low-paid labor on Southern plantations and then to the eventual migration to New York, Detroit, and Chicago, the latter a city whose African-American population increased 77 percent during the 1940s.[42]

The Chess brothers and Muddy Waters carried with them other threads of their cultures and of the shared culture of newly arrived inhabitants of big-city, postwar America. The Macomba may not have been the crossroads of the Robert Johnson myth, where he swapped his soul for blues prowess. It may have been a more pedestrian crossroads, where the traditions and aspirations of a few people—and a few peoples—collided and colluded, in the process inventing not just a new form of popular music, but also a new form of the American myth of the iconoclast, the cowboy, the rebel. Then again, perhaps something like souls had been exchanged for material reward. As African-Americans found their music being captured and sold by white entrepreneurs, they lost control of their cultural capital. What's worse, it could be argued that this Faustian bargain

42. Nadine Cohodas, *Spinning Blues into Gold: The Chess Brothers and the Legendary Chess Records* (New York: St. Martin's Press, 2000), 19.

resulted, unwittingly, in the loosening and eventual severing of the social tether the music provided to the blues singers' own communities and traditions.

In 1947 Leonard Chess invested in the fledgling Aristocrat label, hoping to grab a piece of the emerging market for so-called "race records." (It wasn't until 1949 that *Billboard* changed the name of its "race music" chart to "rhythm and blues".)[43] The music Chess heard Waters play at the Macomba was, in itself, a product of the journey from rural South to urban North. Aristocrat released Waters's 1948 single, "I Can't Be Satisfied," backed with "I Feel Like Going Home," a version of a song that had made the rounds back in Coahoma County, Mississippi, and traveled north with Waters. When Son House recorded it in 1930, he called it "My Black Mama." When Robert Johnson cut it in 1936, it was known as "Walkin' Blues." Waters himself recorded two versions for Alan Lomax in 1941, and at that time called the song "Country Blues." "I Feel Like Going Home" repeats the chord progression and most of the lyrics of these earlier renditions. Waters even retains the repetitive bent-single-note opening of the Johnson and House versions. Most of what makes the 1948 version different, most of what allows it to blaze a new trail in the expansion of American music, follows from a simple technical fact: electricity. The string bass accompaniment—provided by Ernest "Big" Crawford—is still acoustic. But electricity forces the performance to adapt. Not only does Waters swap his acoustic guitar—the iconic instrument of the Delta blues—for an electric guitar, but also—unlike the previous recordings, captured (sometimes literally) in the field—"I Feel Like Going Home" is a modern studio recording.

An individual microphone is dedicated to each of the instruments: one each for Waters's voice, Crawford's bass, and Waters's guitar (or, more accurately, for the guitar amplifier). The result is a new embodiment of sonic space. In the song's previous recordings, all apparently

43. Ibid., 106.

made with a single microphone, a natural hierarchy of proximity is established. All volumes being equal, those sound sources that are closest to the microphone are loudest. The performer is aware of this and alters his volume accordingly. In "Walkin' Blues," Robert Johnson's voice can be heard tracing a dynamic-acoustic shape just as clearly (maybe even more clearly) as tracing a melodic line. The volume of his voice rises and falls according to compositional and emotional exigencies. There are times when the voice must take precedence, must ostentatiously draw the listener's attention. Other times the voice better achieves its goals by retreating into the folds of the guitar's chords, camouflaged within its voicelike bottleneck glissandos. Recorded by one microphone, Johnson's dynamics indicate a perceived acoustic space: the distance of the voice from the microphone, that distance relative to the distance of the guitar from the microphone, and as a result, a sense of the size and perhaps even the shape and materials of the room. Needless to say, this is merely a *perceived* acoustic space, bearing no verifiable indexicality to the actual space of performance.

The range of the signification that contributes to such perception is significantly expanded by Waters's amplifier and additional microphones. The amplifier conveys the buzz of the strings with the same fidelity as the major chord. The quietest and the loudest all register. The microphone is both sensitive and agnostic. Aimed at the speaker cone or the vibrating string or the larynx, it makes no distinction between the phlegm in the throat and the words of the song. The agnosticism of the microphone enables the singer to indulge in the details of the voice: sibilance, distortions, sighs, whispers, the click and crunch of particular consonants, the hollow allowances of vowels. Waters's distinctive singing style emanates from the back of the throat, making audible use of all the fleshy components of the mouth, tongue, cheeks, uvula, and lips. His vocal personality relies on an intimacy possible only in close, quiet quarters, or under the microphone's conspicuous magnification. We are in no position to

say whether he leaned as hard on these qualities when performing in acoustic settings. But the singing on his recorded work—the majority of which features a band and electric instruments—dwells in the phlegmy folds of the vocal apparatus. He targets the syllables that milk the effect of these sounds, hanging longer than seems necessary (longer than would seem advisable for other singers) on *m*'s and *n*'s, on swallowed vowels. Already on "I Feel Like Going Home," his first recording on electric guitar, he dwells on the *ing* in "morning," dragging out the nasal consonant buried between the *n* and the *g*.

The advent of microphonic singing is generally seen as ushering in the era of "intimate" vocal technique. This term is not usually used to suggest what I'm describing here in Waters's singing, but rather to refer to the whispering, confidential styles of singers like Billie Holiday and Frank Sinatra. Counterintuitively, microphony's expanded dynamic field closes down the sense of perceived space. As each instrument occupies its own dimension, the sense of a collective space of performance is lost. This reads as intimacy, a space big enough for only two: singer and listener. On "I Feel Like Going Home," the interactions of the three independent sound spaces—those of the voice, guitar, and bass—relocate the song to the compressed nonspace we call speakers (or headphones). The resulting intimacy is made not of proximity, but of distinct-yet-connected spaces and situational identities. Ian Penman observes:

> The "intimacy" of microphonic singing is also the distanced "take" of recording and, thereby, transmission and reception at a distance. Intimacy is also the first step toward the promiscuous impersonality of a record buying public; of both the homogeneous "they" of popular reception and the Song's pivotal and ambiguous "you."[44]

44. Ian Penman, "On the Mic," in *Undercurrents: The Hidden Wiring of Modern Music*, ed. Rob Young (London: Continuum, 2002), 29.

Understood this way, electric, microphonic, amplified record-ings are early instances of virtual experience. Without connection to a perceivable space, microphonic recordings of amplified instru-ments begin to detach themselves from the specifics of time. Even if Muddy Waters's recording was not a multitrack production—in which musicians played their parts at different sessions, synching with previously recorded performances—it sounds to the contempo-rary ear as if it might have been. There is an indication of synchrony: a single time when these three sound sources occupied the same space and engaged in a collaborative activity. But we, as educated twenty-first-century listeners, are skeptical of such indications. Not only is the listener's experience virtual, but the listener's perception of the production process also establishes a virtual relation between the musicians. More than a few observers have written about how the microphone and amplification changed the way music was per-formed and produced. But few have noticed how modern recording has changed the way music is perceived by listeners. Regardless of the actual circumstances of production, a recording is received and made sense of as a pieced-together construction, which creates "a new economy of absence-presence in its neoteric circuitry."[45]

"I Can't Be Satisfied" b/w "I Feel Like Going Home" was dis-tributed throughout Chicago on a Friday in June 1948. By Saturday evening not a copy was to be had. One record seller at the Maxwell Street Market had hiked the price from seventy-nine cents to a dollar ten and limited sales to one per customer. Apparently even Waters, identifying himself as the singer, was denied a second copy.[46] The record's success convinced Leonard Chess that there was a market for "race music" in general, and for Muddy Waters in particular. By 1950 Leonard Chess had bought out his partners at Aristocrat, moved his brother, Phil, from the Macomba to the label, and renamed the business Chess Records. With Muddy Waters at the top of the roster,

45. Ibid., 30.
46. Cohodas, *Spinning Blues into Gold*, 19.

Chess cornered the market on the electric blues as it evolved into rock and roll. Jackie Brenston's "Rocket 88," considered by many to be the first wholehearted rock-and-roll song, was Chess catalog number 1458, released in May 1951.[47] Bo Diddley released his first single, the eponymous "Bo Diddley" b/w "I'm a Man," in April 1955 on Checker Records, a Chess offshoot, home also to the Moonglows and Little Walter.[48] Chess released Chuck Berry's "Maybellene" in July 1955.[49] Muddy Waters's electrified country blues opened the door, and Chess Records ushered rock and roll out onto Cottage Grove Avenue, then to Chicago, America, and the world.

"I Feel Like Going Home" amplifies a familiar country blues, altering its production, aesthetics, and reception. But one common denominator underpins all the ways electricity intervenes in the evolution from country blues to electric blues to rock and roll. The employment of electricity is always a matter of maximizing distribution. Muddy Waters preferred the stripped-down mode of the Delta blues, accompanying himself, solo, on the acoustic guitar. The reason Waters turned to the electric guitar inevitably had to do with wanting to be heard, and to be heard by as many people as possible: "in order to be heard in the noisy clubs and taverns of Chicago [it was necessary] to take up an amplified instrument."[50] Yet the electric guitar distributes the music only as far as the back of the club. To move the music down the street, out of the neighborhood, beyond the city, coast to coast, and worldwide requires the interdependent electric media of recordings and radio. Leonard Chess amplified the change that Muddy Waters initiated, distributing on record and via radio the sounds of a new electrified form of a music that had, until then, been race specific and strictly regional.

47. Ibid., 59.
48. Ibid., 105.
49. Ibid., 117.
50. Peter Guralnick, *Feel Like Going Home: Portraits in Blues & Rock 'n' Roll* (New York: Vintage, 1981), 72.

Forty-one hundred forty-seven miles away in Paris, Pierre Schaeffer was realizing that electronic media are innately acousmatic, blind to their sources. This is not to suggest that anyone was mistaking Waters's recordings for the work of a white man, but there is a big difference between dropping by the Macomba on a Saturday night and dropping the needle into the grooves of Aristocrat 1305 in the privacy of your living room. An encounter with a recording allows the virtual curtain to remain intact between performer and listener. It would not be long before white audiences peeked behind the curtain and then tore it down. By the mid-1960s Waters's audiences had become so predominantly white that he complained to Peter Guralnick, "I don't hardly play for a black audience anymore."[51] Waters's situation was not unusual. Rock and roll's shift from black to white can be pinpointed with great specificity to the moment when Elvis Presley's contract was sold by Sam Phillips's fledgling Sun Records to MCA in November 1955 for the then-unheard-of price of $35,000. RCA booked Presley on *Stage Show*, the Dorsey Brothers' television show, and took out full-page ads in *Billboard*. Over the course of the following year, Presley had eight separate million-selling records. He topped the *Billboard* sales charts, not with just one song but with four, leaving previously popular artists to fight it out for fifth place.[52] Again, this cultural crossroads is the site of dual and dueling mechanisms: it is the location of a wanton transaction in which African-Americans lost possession of a part of their cultural heritage and, in the process, were swindled out of one payday after another (Chuck Berry was coerced into sharing composer credit for "Maybellene" with the DJ Alan Freed). It is also the source of the inexorable energy by which an underdog music asserted the unique capacities of its form in the struggle for cultural, aesthetic, and economic purchase.

51. Ibid., 87.
52. Cohodas, *Spinning Blues into Gold*, 145–46.

2

BE MORE SPECIFIC

Where do we go from here? Towards theatre.
　　　　　　　　　—John Cage, "Experimental Music" (1957)

Much of the best work being produced today seems to fall
between media.
　　　　　　　　　—Dick Higgins, "Intermedia" (1966)

What lies between the arts is theatre.
　　　　　　　　　—Michael Fried, "Art and Objecthood" (1967)

It's never easy to put one's finger on change. The pages of the cal-
endar have a tendency to slip from one's grip, the certainty of one date
contradicted by another. Places are similarly buttery, escaping the
grasp of inevitability or melting under the heat of scrutiny. Vocabulary,
on the other hand, proves a more reliable indicator of shifts in think-
ing. Identifying the *moment* of transition from Greenberg's modernism
to whatever came next (let's use the term "postmodernism," for now,
hoping to justify and refine it as we proceed) may be best achieved
through an attention to terms. The use of the word "theatre"—first in
the positive sense intended by Cage in 1957, and later in the nega-
tive sense intended by Michael Fried in 1967—points as vigorously
and as surely as any other sign to a decade of revision. This chapter's
three-headed epigram is meant to convey that movement, with Dick
Higgins's term "intermedia" stitching together Cage's optimism and
Fried's fear of the in-between. In many ways, "intermedia" is synony-
mous with, or exemplary of, what Fried called "theatre."
　　Clement Greenberg's monarchical aesthetics reigned for some
two decades. His conception of what would constitute modern art

33

came to seem so natural as to be accepted more as commandment than idea. As always, this naturalism ends up looking suspect. There's nothing so obvious that it's obvious. On closer inspection, Greenberg's modernism turns out to be less monolithic and, to its credit, less consistent than its decades of conveyance would have us believe. I say "to its credit" because the inconsistencies of Greenberg's writings are evidence of his honest engagement with the intricacies, subtleties, and problems of the art of his time. Although he aspired to be persuasive and was not above bullying others to succeed, he appears not to have bullied himself very much. It is easy to identify whole branches of Greenberg's critical project that arise out of his dissatisfaction with the available answers (his own included) to new or gnawing questions.

Perhaps the most persuasive—and, ultimately, the most problematic—of Greenberg's conceptions was the necessary specificity of modernist painting, sculpture, and, by implication, each of the distinct fields of artistic practice: music, dance, film, poetry, and fiction. By his reckoning,

> a modernist work of art must try, in principle, to avoid dependence upon any order of experience not given in the most essentially construed nature of its medium. . . . The arts are to achieve concreteness, "purity," by acting solely in terms of their separate and irreducible selves.[1]

Greenberg's argument for specificity is not, contrary to the most common accounting of his aesthetics, confined to painting.

Greenberg actually makes rather grand claims for sculpture in 1948: "I now see sculpture's chance to attain an even wider range of expression than painting."[2] This is significant for our concerns in that sculpture—as theorized, for instance, by Rosalind Krauss as an

1. Clement Greenberg, "The New Sculpture," in *Art and Culture: Critical Essays* (Boston: Beacon, 1961), 139.
2. Ibid., 141.

"expanded field"—defines the parameters of gallery practice over the past sixty years to a greater extent than does painting. Greenberg was right about sculpture, but not for the reasons he had in mind. It was Fried, Greenberg's disciple, who in 1967 would more accurately diagnose the inherent qualities granting sculpture something like a competitive advantage.[3] Fried was an incredibly astute diagnostician, indexing all the symptoms, behaviors, and implications associated with the new sculpture, circa 1967. The problem is that what Fried thought he identified as the disease, others—notably Donald Judd, Robert Morris, and Krauss (betraying her Greenbergian upbringing)—recognized as the cure. This group, joined by scores of their contemporaries and followed by a subsequent generation, proved ascendant. The modernist art Fried sought to defend—an art first singled out, named, and theorized by Greenberg—had run up against its limit. In retrospect, it seems inevitable, simply a matter of time, that Greenbergian modernism would hit the wall of "literalism," as Fried called it. Modernist art's limit was built into its constitution.

Later in 1967, Greenberg deals specifically with monochrome canvases. He first mentions the 1951 paintings of Rollin Crampton, and then Robert Rauschenberg's 1953 all-white and all-black paintings, noting that from the first to the second, "What was so challenging . . . had become almost overnight another taming convention."[4] The aesthetic leap represented by a blank canvas (implied, if not fully engaged, by the monochrome) is something that Greenberg was never willing to acknowledge. Thierry de Duve dances around it without ever landing squarely on it or its implications. The blank canvas is not just the last step in the journey away from pictorial illusionism. It actually is the abandonment of the problem of both illusionism *and*

3. Michael Fried, "Art and Objecthood," in *Art and Objecthood: Essays and Reviews* (Chicago: University of Chicago Press, 1998).

4. Quoted in Thierry de Duve, *Kant after Duchamp*, October Books (Cambridge: MIT Press, 1996), 223; originally in Clement Greenberg's "Recentness of Sculpture" (1967), repr. in *Minimal Art: A Critical Anthology*, ed. Gregory Battcock (Berkeley: University of California Press, 1995).

the preoccupation with pictorialism. The blank canvas works in the register of Duchampian non-retinality. Greenberg could not abide it, precisely because it toys with the line between the retinal and the non-retinal. The fact that it *also* functions historically, logically, and aesthetically as the last step in the journey away from pictorial illusionism reveals something crucial: the history of art that licensed Greenbergian modernism always contained, within its very premises, the urge to move beyond visuality to the concerns of what would come to be known as conceptualism.

Modern art, it turns out, was never about the specificity of media: that was merely a symptom. Modern art was actually about abdication of both illusionism *and* pictorialism. That it proceeded through pictorial stages on its journey is a purely historical necessity. As de Duve observes: "All works . . . need to be linked to their specific history in order to be plausible candidates for aesthetic appreciation."[5] Art, like everything else, must move in calibrated steps in order to maintain its identifiability. Although Duchamp and his contemporaries were all responding to the same aesthetic problems, Duchamp's answers were decidedly different from theirs. It would take nearly half a century before the interrupted circuit he initiated would make contact on the other side. Passing through this circuit is the early twentieth-century rejection of single perspective, the subjective, and the static object. Duchamp's circuit bypasses the cul-de-sac of abstract expressionism, which mistook this rejection as a formal issue, solved via flatness, materiality, and media specificity. Duchamp siphoned off the power of modernism's original combustions, energizing first Jasper Johns and later, more securely and more incontrovertibly, the conceptual artists of the 1960s and '70s.

The circuit connecting Duchamp to Joseph Kosuth, Robert Morris, Bruce Nauman, and others allows us to see that the original pressures exerted by the artistic movements of the early twentieth century

5. de Duve, *Kant after Duchamp*, 223.

sought to move beyond the specificity pinpointed by Greenberg into an expanded/expansive artistic practice unbeholden to media-historical constraints; untethered by material demands, unrestricted by the frame, perspective, and planarity of the pictorial. Kosuth, speaking of the conceptual practices of the midsixties, explicitly claimed that "art is conceptual and not experiential."[6] In other words, the *work* of the work of art happens, not in the materials, not at the site of the object, not at the locus of encounter, but in an elsewhere/elsewhen engagement with ideas, conventions, and preconceptions—with the modes of art-as-art, which is the same as with modes-as-modes. This is what Kosuth indicates when, starting in 1966, he subtitles all his work "art as idea as idea."[7] This, it appears, is what modernism always wanted: to direct the art experience away from the phenomenal encounter. Greenbergianism, fixated as it is with the material demands of media and experience, turns out to be a red herring.

This leaves us with the problem of what to do with the art and ideas that fall between the two stools: between Greenberg's modernist art and the conceptual art that, beginning in the late 1960s, completes Duchamp's circuit. This is the art to which Michael Fried responded in "Art and Objecthood," art that is most commonly grouped under the umbrella of minimalism but is also known, variously, as "ABC art," "primary structures," by Judd's appellation "specific objects," and by Fried's critical term "literalist art." Nested in Fried's idea of literalism is the notion that minimalist sculptures simply are: what you see is what you get. Judd does not disagree; his use of the term "specific" for his objects implies much the same thing: that this object standing before you (which is a different suggestion than "you are standing before it") does not point elsewhere to another thing, another experience, another emotion. This object *is*, plain and simple. Yet we know that nothing is so plain that it's plain. Nothing's so simple that it's simple.

6. Joseph Kosuth, as quoted in Lucy Lippard, *Six Years: The Dematerialization of the Art Object from 1966 to 1972* (New York: Praeger, 1973; repr., Berkeley: University of California Press, 1997), 114.
7. Ibid.

Nevertheless, de Duve ignores such skepticism. In discussing Judd's relationship to Greenberg's modernism, to the specificity of a medium, de Duve states simply, "The experience of such objects is phenomenal, says Greenberg, and Judd agrees."[8] But Greenberg declares:

> Minimal Art remains too much a feat of ideation, and not enough anything else. Its idea remains an idea, something deduced instead of felt and discovered. The geometrical and modular simplicity may announce and signify the artistically furthest-out, but the fact that the signals are understood for what they want to mean betrays them artistically.[9]

Perhaps even more telling is a footnote that Greenberg includes at the end of this passage:

> Darby Bannard, writing in *Artforum* of December, 1966, has already said it: "As with Pop and Op, the 'meaning' of a Minimal work exists outside of the work itself. It is a part of the nature of these works to act as *triggers* for thought and emotion preexisting in the viewer. . . . It may be fair to say that these styles have been nourished by the ubiquitous question: 'But what does it mean?' "[10]

Both Greenberg's "Recentness of Sculpture" and Fried's "Art and Objecthood" appeared in 1967. They indicate a substantive difference in the two critics' receptions of minimalism. Greenberg, contrary to de Duve's claims, doesn't accept the merely phenomenal nature of a minimal sculpture. For him, these works are not phenomenal enough. They are not perceptible enough, not available and evident in the here

8. de Duve, *Kant after Duchamp*, 232.
9. Greenberg, "Recentness of Sculpture," in *Minimal Art*, 183–84.
10. Ibid., 184 n1.

and now upon which a phenomenological reception would depend. Rather, they indicate the space and time of deduction, a space and time always receding into displacement and deferral. Such works are not simply or merely present, as Judd suggests. Their ontology is a product of "what they want to mean."

All this is not to suggest that de Duve's reading of Greenberg is thoroughly unfounded. Immediately following the above quotation from "The Recentness of Sculpture," Greenberg goes on trying to dismiss minimalism as being overly apparent, immediately available, without "aesthetic surprise."[11] But his argument is constantly haunted by echoes of his acknowledgment of minimalism's status as idea. Fried's reception of minimalist sculpture is more willing to recognize its essential phenomenality. It is this recognition that causes Fried so much indigestion. In accepting Fried and Judd's point of agreement (as we shall see, they disagreed wholeheartedly on the implications of such phenomenality), de Duve defines the minimalist break as a move from a responsibility to the specific materials and modes of a medium (e.g., flatness in painting), to art-in-general, a practice that partakes neither of the traditions of painting nor of sculpture. This, for de Duve, is the locus of rupture. Remaining skeptical of claims for the thing that simply is thus means that we cannot—*should* not—take Fried and Judd at their word. Nothing is "merely phenomenal." Refuting these claims of phenomenality pushes the rupture to an earlier moment, a more fundamental understanding of minimalism's relation to modernism. The break occurs before any claim of phenomenality and is instigated by the untenable nature of any such claim.

Music has always functioned according to Greenbergian precepts. As a practice, music is positively obsessed with its media specificity. Only music includes, as part of its discursive vocabulary, a term for the foreign matter threatening always to infect it: "the extramusical." Even

11. Ibid., 184.

at the height of modernism, painters did not have a name for extrapainterly elements; filmmakers do not worry about the extracinematic. But in music as an academic, artistic, and performance discipline, there is a perceived need to identify—often to eliminate—aspects of production, reception, or discussion that are not specifically manifest in material form. The intramusical (simply referred to, in music parlance, as "music") is captured either in the inscription of notation, or in specifically quantifiable, audible phenomena. Only what avails itself of the assignment of specific musical values (i.e., pitch [and pitch relations], meter, tempo, dynamics, instrumental voicing) is proclaimed internal to the proper concerns of music. All else is extramusical.

To an extent that Greenberg might have envied, music has—since at least the advent of notation—existed as effects quantified as "values" (in both senses of the word). The institutions of Western music (including notation, instrumentation, concert protocol, the consolidation of music's theoretical methods) have captured music in and as a numerical sign system: a system in which phenomena are signified as values of pitch (A 440), harmony (thirds, fifths, octaves), duration (whole notes, half-note rests, dotted quarter notes), and rhythmic organization (3/4, 4/4, 6/8). This valuation of musical effects represents (e)valuation of certain effects, of certain musical elements, over others. The impact of the trio of musical events of 1948 (Pierre Schaeffer, John Cage, and Muddy Waters) was to "devalue" music (again in both senses of the word), returning to the encounter of effects and affects. This is not to imply that, as of 1948, music cannot be captured semiotically—quite the contrary. It simply indicates that the quantitative approach (which, in the process of precisely identifying certain musical phenomena, allows others to escape) would prove to be unsympathetic to new musical forms, including "musique concrète," indeterminacy, and rock and roll. As an alternative, a qualitative, discursive form of musical analysis suggests itself. Unfortunately, few within the institutional music world have proven open to such a suggestion.

Greenberg's modernism was not devised as an explicit application of traditional musical values to painting and sculpture. But by the

time of Greenberg's ascendance, music had held a privileged position in the pantheon of the arts since at least 1873, when Walter Pater had famously declared that all the arts aspire to the condition of music. In a formulation that anticipates Greenberg, Pater writes, "In all other [nonmusical] works of art it is possible to distinguish the matter from the form, and the understanding can always make this distinction, yet it is the constant effort of art to obliterate it."[12] Painting and poetry were thought, first and foremost, to envy music's purely internal referentiality, its disinclination (if not its very inability) to indicate referents outside itself. Music had no obligation to point to the world and, as a result, did not find itself beholden to that world. Music alone could fold its form into its materials, and its materials into its form, rendering them not just indistinguishable but also identical. In "Art and Objecthood," Michael Fried pointedly reverses the formula, declaring:

It is above all to the condition of painting and sculpture— the condition, that is, of existing in, indeed of secreting or constituting, a continuous and perpetual *present*—that the other contemporary modernist arts, most notably poetry and music, aspire.[13]

One now reads this as a performative bit of wishful thinking; an attempt to make it so simply by declaring it so. But in its hopefulness is a succinct definition of what, in Fried's view, is peculiar to painting and sculpture, what makes them (in 1967) ascendant practices: it is their *presentness*, their ability to freeze and hold a particular moment and to extend it infinitely forward and backward in time. Painting and sculpture, Fried claims, assert the dominance of the now over the past and the present. In an abstract painting, for example, the now of each painterly gesture hangs, ever present, as a constitutive feature of the work and of any experience of the work. It is precisely this sense

12. Walter Pater, "The School of Giorgione," in *The Renaissance: Studies in Art and Poetry* (London: MacMillan, 1912), 135.
13. Fried, "Art and Objecthood," 146.

of the phenomenological now and its implication of indisputable self-identicalness that Jacques Derrida would famously deconstruct in his *Speech and Phenomena*, published, incidentally, in 1967, the same year as Fried's essay.

We will return in some detail to Derrida's critique of phenomenology, but for now let's focus on Fried's declaration, intended to establish a bulwark against the incursions of minimalism, as put forward in Donald Judd's essay "Specific Objects," published in *Arts Yearbook* in 1965, and in Robert Morris's two-part "Notes on Sculpture" published in *Artforum* in 1966 and 1967. What were the minimalists doing and saying that made Fried so uneasy? Morris's ideas about sculpture establish a specific theoretical and practical rationale for minimalism's expanded situation. In the process, and somewhat inadvertently, Morris indicates and justifies—one could argue he *invents*—a form of artistic practice that finds its most natural material origins in the sonic.

In "Notes on Sculpture, Part 2," Morris advocates what he calls the "public mode" of sculpture. Largely a product of scale, the public mode creates a distance between the subject and the object. "A larger object includes more of the space around itself than does a smaller one."[14] The greater distance required of a larger object "structures the . . . public mode [and] it is just this distance between object and subject that creates a more extended situation, for physical participation becomes necessary."[15] It is precisely this aspect of Morris's program that Fried objects to and characterizes as "theatrical." The theatrical is what at least acknowledges, or at worst (in Fried's view) is activated by, the presence of the viewer. Modernist painting and sculpture resolutely refuse such a relationship. And theatricality, for Fried, poses the single greatest threat to the art he and Greenberg championed. "Theatricality," he wrote, is "at war today, not simply with

14. Robert Morris, "Notes on Sculpture, Part 2," in *Continuous Project Altered Daily: The Writings of Robert Morris* (Cambridge: MIT Press, 1993), 13.

15. Ibid.

modernist painting (or modernist painting and sculpture), but with art as such."[16] Fried finds this war raging on various fronts: theater itself resists its own theatricality in Brecht and Artaud; cinema evades the theatrical without directly confronting it (rendering it, in Fried's judgment, "not a *modernist* art");[17] and, most crucially, modernist painting (e.g., Jules Olitski and Morris Louis) and sculpture (David Smith and Anthony Caro) engage theatricality head-on.

With the benefit of forty years of hindsight, it now seems clear that, if a war did take place in the late 1960s; if that war was between modernist and theatrical forms of art; and if theatricality is a fundamental aspect of the conceptual, performance, body-art, and relational practices that followed—then theatricality carried the day, and then some. But it would be a funny kind of war in which one side knew what was right and the other side thought that "right" ought always to be qualified with scare quotes. The avatars of Greenbergian modernism would fight for what art should be. The minimalists, conceptualists, Fluxists, and so forth started from the premise that art as a category, as an idea, as a practice, was not a knowable origin, a stable activity, or a predictable telos, but rather a site of contestation. Rosalind Krauss begins her essay "Notes on the Index" with these sentences: "Almost everyone is agreed about '70s' art. It is diversified, split, factionalized."[18] This is what passed for consensus in the decade following Fried's war—not simply because no idea or movement was able to subdue the others, but because notions of singularity and correctness no longer seemed applicable. This inconclusiveness was revealed in poststructuralist theories of authorship and differential meaning. Its relevance to lived life seemed suddenly irrefutable in light of the variform world of quickly changing news, fashions, and

16. Michael Fried, "Art and Objecthood," in *Minimal Art: A Critical Anthology*, ed. Gregory Battcock (Berkeley: University of California Press, 1995), 139.
17. Fried, "Art and Objecthood," 141, with original emphasis.
18. Rosalind Krauss, "Notes on the Index, Part 1," in *The Originality of the Avant-Garde and Other Modernist Myths* (Cambridge: MIT Press, 1985; repr., 2002), 196.

trends: Watergate one day, miniskirts the next, plus détente, disco-theques, smiley faces, oil crises, pet rocks, Patty Hearst. Whatever illusions of certainty, universality, and immutability had existed in the 1950s, they had been shaken throughout the '60s. By the seventies they had disintegrated, replaced by an acceptance of the view that culture is a construct, history is a story, values are manufactured, truth is temporary and local.

In "Notes on Sculpture, Part 2," Morris advocates what he called "unitary forms," sculptural structures that eschew any internal part-to-part relations. Instead, unitary forms leverage the relationship of viewer to object, object to environment, environment to viewer. Morris is interested in displacing relationships from purely internal and struc-tural concerns to "the expanded situation," in which the space of the work is enlarged to account for the viewer and the circumstances of encounter.[19] In Fried's idiom, the expanded situation is synony-mous with theatricality. Fried complained, "Everything [the beholder] observes counts as part of the situation and hence is felt to bear in some way that remains undefined on his experience of the object."[20] The expanded situation represents a new constitution and conduct of the sculptural object, which now must "perform" for, or interact with, the viewer and the environment—both components of the expanded situation. This use of the word "expanded" to mean a broader defini-tion of what constitutes a given practice prefigures similar employ-ment in Gene Youngblood's *Expanded Cinema* (1970)[21] and Rosalind Krauss's "Sculpture in the Expanded Field" (1978).[22] So in addition to "theater" and the notion of a media space "in-between," we might look to "expanded fields" and "expanded situations" as indications of the transitions afoot.

19. Morris, "Notes on Sculpture, Part 2," 17.
20. Fried, "Art and Objecthood," 144.
21. Gene Youngblood, *Expanded Cinema* (New York: E. P. Dutton, 1970).
22. Krauss, "Sculpture in the Expanded Field," in *Originality of the Avant-Garde*, 277–90.

Robert Morris, *Box with the Sound of Its Own Making*, 1961. © 2009 Artists Rights Society (ARS), New York/VBK, Vienna. © 2009 Robert Morris / Artists Rights Society (ARS), New York. Courtesy Leo Castelli Gallery, New York.

In 1961, the expanded field of sculpture measured nine and three-quarters cubic inches. Robert Morris's *Box with the Sound of Its Own Making* expands its "situation" and relationships in time at least as much as it tests them in space. The *Box*, as its name suggests, is a walnut box, nine and three-quarters inches in each dimension. The box contains a small speaker that plays a three-hour audiotape recording of the sounds made as Morris constructed the box. The history of *Box* includes two notable events. It debuted, so to speak, as a kind of musical performance at a concert organized in 1961 by Henry Flynt at Harvard, which also included works by La Monte Young and Richard Maxfield. That same year, *Box* was also the focus of a private audience with John Cage, who came to see it in Morris's apartment and apparently sat through the entire three-hour recording.[23] The expanded situation in which Cage would have found himself would have been one in which he, the spectator, would shuttle back and

23. Branden W. Joseph, *Beyond the Dream Syndicate: Tony Conrad and the Arts after Cage* (New York: Zone Books, 2008), dealing extensively with Flynt, Young, Tony Conrad, and their music and art activities of this period.

forth in time, between the time of viewing/listening and the time of making. This is a situation in which "the object is but one of the terms in the newer esthetic."[24]

For Morris, it is important that the viewer be "more aware than before that he himself is establishing relationships as he apprehends the object from varying positions and under varying conditions."[25] In the case of *Box*, these varying positions would be positions in time rather than space, moving between conditions of production versus reception. Past and present, making and perceiving, thus become conflated in experience. This situation would seem to parallel Husserl's notion of phenomenological "adumbration," in which an object is perceived from multiple perspectives, yet understood—precisely because of the constancy of certain features—to be one and the same object with a set of essential qualities. However, this parallel is limited by disjunctions between spatial and temporal perspective. In Husserl's adumbration, the subject must change position relative to the object. But in the kind of time-based adumbration initiated by Morris's *Box*, the shift in perspective is a product of the inexorable movement of time. Neither the subject nor the object must act upon an intention; neither must move or shift. With *Box*, Morris discovers that sound recommends itself as an ideal medium for such temporal adumbration. Sound initiates its own nonintentional, perspective-neutral shifts in the relation of subject to object. Because sound is immersive, it inevitably creates an environment that is simultaneously and irredeemably a product of an interaction not just between spectator/auditor and object/sound source, but also includes a third component: situation. The situation is a product of time, context, expectation (protention), and memory (retention).

The series of letters Morris exchanged with John Cage between 1960 and 1963 testify to Morris's explicit interest in Cage's aesthetics.[26] But even without such evidence, it would be easy to connect the dots. As an alternative to Greenbergian specificity, Cage sought to

24. Morris, "Notes on Sculpture, Part 2," 15.
25. Ibid.
26. See Robert Morris, "Letters to John Cage," *October* 81 (Summer 1997): 70–79.

blur boundaries between music, theater, installation, dance, painting, and poetry. Morris's *Box* is both the sound of a sculpture and a sculpture of sound. It is a very early, if not *the* earliest, example of a work existing simultaneously, equally, as sculpture and as sound work.[27] As such, Morris's *Box* also provides the earliest example of how such work might constitute its ontology. *Box* indicates where an expanded sonic practice might locate its values and how it might organize its relationships to and between process and product, the space of production versus the space of reception, and the time of making relative to the time of beholding.

In the 1960s, with the rise of protoconceptual work, and in the 1970s, as conceptualism stakes its claim to a central position in the gallery arts, these concerns become primary. Morris's *Box* suggests both how the gallery arts and the sonic arts might similarly benefit from a focus on these concerns, and how sound suggests itself as an already dematerialized medium in which issues of time, process, and reception are unavoidably in play. In addition to these concerns, *Box* also opens gallery practice onto concerns previously exclusive to music, such as the relation of the score to the performance, the mediation of a performer/interpreter, and the explicit temporal extension of musical materials. All of these concerns certainly were part of Cage's ongoing interrogations.

Morris's "Blank Form" is a manifesto-as-artwork (or vice versa) from 1961, originally conceived for inclusion in La Monte Young and Jackson Mac Low's *An Anthology of Chance Operations Concept Art Anti-Art Indeterminacy Improvisation Meaningless Work Natural*

27. Some would nominate the work of Bernard and François Baschet, who began making their "sculpture *sonores*" in the late 1950s. But their works have more in common with Harry Partch's self-invented musical instruments—certainly unconventional, even sculptural, but primarily designed to produce specific sounds. Jean Tinguely, most commonly considered a sculptor, made his *Mes étoiles—concert pour sept peintures* in 1958, three years before Morris's *Box*. Though this is a sound-producing sculptural object, I argue that it likewise is a machine to make music and therefore does not rely equally and independently on its sonic and its sculptural components.

Disasters Plans of Action Stories Diagrams Music Poetry Essays Dance Construction Mathematics Compositions.[28] Morris, disenchanted with the burgeoning Fluxus movement—with which Young, Mac Low, and consequently *An Anthology* were associated—pulled his contributions from *An Anthology* before its publication.[29] "Blank Form" is a text piece, both a set of instructions for making something and something that has been made. In this sense it functions like the text scores and works being produced by Fluxus-associated artists and others around this same time. Presaging the idea of "situation," voiced six years later in "Notes on Sculpture, Part 2," "Blank Form" represents an expansion of the sculptural field.

> So long as the form (in the broadest possible sense: situation) is not reduced beyond perception, so long as it perpetuates and upholds itself as being objects in the subject's field of perception, the subject reacts to it in many particular ways when I call it art. He reacts in other ways when I do not call it art. Art is primarily a situation in which one assumes an attitude of reacting to some of one's awareness as art.[30]

It is apparent that Morris is trying to hang on to two incompatible ideas. First, he insists that form not be "reduced beyond perception," an assertion that, despite its ambiguous phrasing, we take to mean form that remains within the boundaries of perception. This is clarified by the proposal that form "upholds itself as being objects in the

28. La Monte Young and Jackson Mac Low, *An Anthology of Chance Operations Concept Art Anti-Art Indeterminacy Improvisation Meaningless Work Natural Disasters Plans of Action Stories Diagrams Music Poetry Essays Dance Construction Mathematics Compositions* (self-published, 1963; 2nd ed., Munich: Galerie Heiner Friedrich, 1970).

29. Barbara Haskell, *Blam! The Explosion of Pop, Minimalism, and Performance, 1958–1964* (New York: Whitney Museum of American Art, in association with W. W. Norton, 1984), 100.

30. Ibid.

subject's field of perception." But then Morris states that art "is primarily a situation in which one assumes an attitude of reacting to some of one's awareness as art." This is hardly a matter of "objects in the subject's field of perception." As we will see, this is an aesthetic ground staked out in accordance with Merleau-Ponty's (and *not* Husserl's) phenomenology, in which the certainty of perception is a foothold from which the subject may construct conventional or differential perspectives, meanings, and worlds. Merleau-Ponty's method informs Morris's ideas about the expanded situation of the circumstances of artistic encounter. "Blank Form" also exhibits some of the same recursivity evident in *Box with the Sound of Its Own Making*. Both works are simultaneously the product of a process, the documentation of that process, and a set of instructions for the replication of that process. Both might be seen as an example of what could be called "retrospective composition," in which the act of composition follows the act of performance (which itself is an act of protoreception). In *Box* the "score" for the sound material of the work is only available (constructable) after the performance/production of the box. This conundrum is produced by the intrinsically problematic nature of the idea of a score. The investigation of this problem, initiated by Cage, reveals the implicit a posteriori ontology of the score, which must always follow from some material realization of itself (even if that realization is immaterially located in the mind's ear of the composer). The score as a founding document of *re*-creation has no stable temporal status. It is both precedent and descendent of realization. The score always arrives after the fact, to dictate the fact.

The ostensible, unwritten score for *Box* (something like "Record the sound of building a walnut box and play the recording back from inside the box") is indeterminate relative to the material realization of the project. The score generates unpredictable material results that— taken for artistic sound, or in Cage's expanded sense, for music— seem to demand their own score. In concretizing the specific values

of the resulting sound (pitch, duration, dynamics, placement in time, etc.) a secondary score would negate the fundamental ontology of the piece, which is not a generator of specifically organized sounds but rather a box that contains the sound of its construction. Such a secondary score would actually be revealed as merely a recording, and any performance following such a score would be revealed as an act of mimicry, of "covering"—in the musical sense—the original. Performing a score, on the other hand, is not seen as an act of covering an original, but of reanimating inert matter. Each act of performing a score is seen as a *new*, if second order, act of creation. The unnotated instructions for the construction of the box are also the implicit score for the recorded sounds emanating from the box. By the same token, a set of ears conditioned to the meaning of the sounds of carpentry could conceivably reconstruct the box based on the instructions—the score—provided merely by the recorded sounds of its initial construction. Morris's *Box* makes explicit what Cage's practice implies: the score is never simply an initiation but always also an iteration. This is yet another aspect of the mythic nature of originality deconstructed so thoroughly by Rosalind Krauss.[31] The musical heritage of repertoire is highly unoriginal. Which is to say it is, like all other modes of artistic production, a process of assimilation, reflection, and correction; of response to, and commentary on, the cultural, political, and aesthetic currents of the times and places in which it is produced and received.

Morris's engagement with this kind of recursivity—with process that doubles back on itself to both constitute, and be constituted by, its product—was not limited to "Blank Form" and *Box*. One of the other word pieces for *An Anthology* (1961) reads:

Make an object to be lost.

31. See Krauss, "The Originality of the Avant-Garde," in *The Originality of the Avant-Garde*, 151–70.

Put something inside that makes
a noise and give it to a friend
with the instructions:

"To be deposited in the street
with a toss."

This piece, dated the same year as *Box*, shares many of its concerns. Both locate sound in the interior of an object. In both cases, the sound is incidental: neither sound is included exclusively, or even primarily, for its auditory-aesthetic qualities (even Morris was surprised when Cage actually sat down and *listened* to *Box* in its entirety).[32] But "Make an object to be lost" pushes the infinity of its regress beyond the closed loop of process and product, past and present. In existing exclusively as score, without realization, "Make an object to be lost" creates an open, infinite system. It is both and neither process and/or product. In addition to past and present, it most provocatively engages the future: the text calls eternally for realization. A performance of the piece would not exhaust the score; it would still call for another realization and another, ad infinitum. This is another feature of the score. It is never satisfied. Consistent with poststructuralist theories of language beginning to reach English readers around this time, the score forever defers a final, stable realization. In this sense, "Make an object to be lost" falls squarely within the practice of text scores being produced at the time by artists and musicians with whom Morris had both intimate and casual acquaintance.

The meaning and value of such practice has been theorized in various ways. Most famously, perhaps, Lucy Lippard has described

32. Robert Morris, as quoted in Joseph, *Beyond the Dream Syndicate*, 117; originally part of an interview with Jack Burnham, November 12, 1975; see Joseph, *Beyond the Dream Syndicate*, 395n36.

the result as the "dematerialization of the art object."[33] The move to text-based works was one aspect of what has been described as the move from "'appearance' to 'conception,'"[34] from "the era of taste [to] the era of meaning,"[35] and from the "specific" to the "generic."[36] The thought common to each of these characterizations—and a thought that can be applied without much resistance to each example of a word piece, text score, or event score—is that such work initiates what has come to be known as Conceptual Art. Whatever resistance might be offered would come from one of two fronts. The first front would propose that all art is conceptual to greater or lesser degrees. And while this is certainly true, the point is that work categorized as Conceptual (with a capital *C*) emphasizes its concepts, *expressly* at the expense of other aesthetic aspects. The second front of resistance is more significant in terms of tracing the historical trajectory of conceptualism's theoretical implications, insisting that Conceptual Art began, in all but name, in the second decade of the twentieth century with Marcel Duchamp's unassisted readymades.

In *Beyond the Dream Syndicate*, Branden Joseph's invaluable study of Tony Conrad, Henry Flynt, La Monte Young, Robert Morris, and John Cage form such as the text score is described as "disclosing its essence (whether oppressive or liberatory) as a power effect."[37] Joseph takes issue with claims that dematerialization leads "toward nothingness, transcendence, or liberation (from the gallery space or commodity form)."[38] On the contrary, he believes that such work is a "pure technique of power . . . [leading] toward the operation of discipline

33. Lippard, *Six Years: The Dematerialization of the Art Object*.

34. Peter Osborne, *Conceptual Art* (London: Phaidon, 2002), 13.

35. Arthur C. Danto, "Marcel Duchamp and the End of Taste: A Defense of Contemporary Art," *Tout-Fait: The Marcel Duchamp Studies Online Journal* 1, issue 3 (December 2000), www.toutfait.com/issues/issue_3/News/Danto/danto.html (accessed February 2, 2009).

36. de Duve, *Kant after Duchamp*, passim; see especially chapter 3, "The Readymade and the Tube of Paint."

37. Joseph, *Beyond the Dream Syndicate*, 188; in this passage Joseph is specifically discussing text scores of Tony Conrad and Henry Flynt.

38. Ibid.

or control."[39] This reading, indebted to Foucault, is not without validity but only illuminates the work when applied in a limited capacity. In its most basic formulation, the terms "discipline" and "control" are applied as structures (as strictures) of making. Rather than initiating another construct, or producing what Joseph calls a *"representation"* (Joseph's italics), the score "molds the receptive (subjective) situation itself."[40] The score *is* the work; the only thing with which the beholder and the composer/artist both interact. The score, then, brings its own set of capacities and incapacities to bear upon the composer's freedom within the medium. This is the discipline of individual disciplines. And it is a fact (perhaps, one would say, a *material* fact) of even the most dematerialized of disciplines.

In a more expansive application of the terms, text scores impose discipline and control by enacting instantiated power relations. Traditionally in music, the composer directs the actions of performers within a set of generally agreed-upon parameters. Text scores, then, offer an unmediated "circuit" between composer and beholder (surely not the right word in this context, but how shall we name this role?), putting the composer in an empowered position over the beholder without the filtering, interpreting presence of the performer. One implication of Joseph's formulation is that a text score is less like an offering and more like a command. The composer/artist tells the beholder what to do, what to think. Joseph is careful to allow that the text score allows for benevolent dictatorship. Still, the suggestion is that what is created is a hierarchy in which power flows in one direction only. But unlike the codified, institutional context of traditional composed music, text scores do not (or at least in the early 1960s *did* not) come loaded with habituation and ramification. Most recipients of text scores have not been trained and acculturated to accept the instructions of the maestro and to execute them according to a predetermined skill set. The beholder who ignores or contravenes a

39. Ibid.
40. Ibid.

given text-score instruction does not risk losing her or his job. The command is issued from another place and time. There is no issue of face-to-face refusal no risk of public failure.

Text scores, as a prime example of conceptualism, do not state facts so much as question them. Every command is followed by a silent, parenthetical "why?" "Whatever else it may be, conceptual art is first and foremost an art of *questions*."[41] Even in text scores written in the imperative, there is an implicit invitation to contravene the authority underwriting the text. Some text scores invite this contravention by suggesting resistance, others by taunting absurdity, others by engaging impossibility, others by allowing for an infinity of interpretations. Peter Osborne makes a distinction between the ideality of concept and the materiality of linguistic form and/or performative realization:

> The unity of the work is rendered ideal by its dispersal across an irreducible plurality of instantiations across different media, including documentary forms; while it is the performance character of the instructed event as "action" that imparts to this ideality a linguistic form.[42]

It would seem equally true to suggest that an ideality emerges from the impossibility of providing or even theorizing a "correct" performative reading of a given score. The conceptual, once it has been let loose in the space of the work, inhabits it, saturating all the material and immaterial aspects of the work. If it is true that all works of art are to some extent conceptual, that extent is largely a product of the application of the term. Thus, a work prized chiefly for non-conceptual attributes can be "détourned" (to reapply a term of the Situationists) by placing it under the conceptual rubric. Sherrie Levine's

41. Osborne, *Conceptual Art*, 14, with original emphasis.
42. Ibid., 22.

rephotographing of classic Walker Evans photographs enacts precisely this transformation.[43]

So, rather than creating a one-way power flow, text scores disperse power in all directions, at all levels of engagement, flowing equally toward and away from all involved. Within the context of engagement with a text score, everyone always has the prerogative to accept, decline, evade, reverse, censure, or satirize the instructions. These are not options typically available to either empowered or disempowered subjects (or institutions). Faced with a text score, the ultimate power-negating alternative is always in play: one may fail to recognize, exercise, or obey the inherent discipline and control. This is never an option in truly hierarchical power structures.

Chapter 6 (below) deals at length with George Brecht's "Incidental Music," which is exemplary of the kind of conceptual, text-based work being produced everywhere and by everyone (or so it seemed) in New York in the early 1960s. Much of this work emanated from the composition class that John Cage taught at the New School for Social Research from 1957 to 1959. His students included, among others, Brecht, Allan Kaprow, Al Hansen, Dick Higgins, and Alison Knowles. Cage himself got into the text score act in 1962 with *0' 00"*, which refers back to *4' 33"*, upping the recursive ante. The score for *0' 00"* reads: "In a situation with maximum amplification (no feedback), perform a disciplined action."[44] Cage's initial performance was an act of the kind of retrospective composition exemplified by Morris's *Box* and "Blank Form." Cage wrote out the score by using a pen outfitted with a contact microphone, thereby turning the writing of the score into the performance, or the performance into the writing of the score. In either case, the score is nonexistent until its first performance is realized. In

43. One can trace this idea back to Duchamp's famous example of a "reciprocal readymade": using a Rembrandt as an ironing board. Such an act would certainly be seen (at least post-Duchamp) as an artistic act, allowing the non-conceptual Rembrandt to function conceptually.

44. Cited in Joseph, *Beyond the Dream Syndicate*, 405n21; observe the use of the term "situation."

Beyond the Dream Syndicate, Joseph pays great attention to the deluge of text scores meant to problematize the status of the score, the temporal relations of composition to performance, and performance to reception. Among those discussed are Flynt's *The Instructions for This Piece Are on the Other Side of This Sheet* (1961), in which the verso is either blank or displays the same text, and *The Instructions for This Composition Are on the Other Side of This Strip* (also 1961), in which the title is printed on a Möbius strip; Young's *An invisible poem sent to Terry Jennings for him to perform* (1960); Conrad's *The instructions for performing this piece follow* (1961), which is written in a circle so the word *The* is preceded by the word *follow*; Conrad's *This Piece Is Its Name* (1961); and Ken Friedman's *Mandatory Happening* (1966): "You will decide to read or not read this instruction. Having made your decision, the happening is over."[45] In this context we might also consider some of George Brecht's event scores, including *Word Event* (1961), consisting of the word "Exit"; *Saxophone Solo* (1962), simply the word "Trumpet"; or *Event Score* (1966): "Arrange or discover an event. Score and then realize it." Similarly related are many other scores by Fluxus artists, including Dick Higgins, Takehisa Kosugi, Alison Knowles, Nam June Paik, and Yoko Ono.

Whether one thinks of such scores as instructions for, or works of, music, or what I will insist on calling gallery arts, this sort of dematerialized, conceptual practice certainly poses a challenge for Greenbergian modernism. It is curious to recall that what can now be seen as Fried's last-gasp defense of modernist art in "Art and Objecthood" was written not in response to the advent of such metapractices but in response to minimalist sculpture, which now seems, paradoxically, quite sympathetic to a Greenbergian aesthetic. The practices emanating from Cage's New School class (and

45. Ken Friedman, "Mandatory Happening," in *Fluxus Performance Workbook*, ed. Ken Friedman, Owen Smith, and Lauren Sawchyn (Performance Research e-Publication, 2002), 41, www.thing.net/~grist/ld/fluxusworkbook.pdf (accessed February 2, 2009).

thus perhaps best classified simply as "composition") were widely adopted by artists and musicians in and around Fluxus, beginning as early as the late 1950s. Allan Kaprow and George Brecht both attended Cage's class, carpooling into Manhattan together from New Brunswick, New Jersey.[46] Both Kaprow's *Eighteen Happenings in Six Parts* and Brecht's earliest event scores date from 1959.

Furthermore, 1961 was a particularly fecund year for the early production and theorization of such work. As already noted, Morris's *Box with the Sound of Its Own Making*, "Make an object to be lost," and "Blank Form" all date from that year, as do Brecht's *Incidental Music* and *Paragraphs, Quotations, and Lists* (included in *An Anthology)*; Dick Higgins's *Danger Music* pieces; Yoko Ono's earliest instruction paintings (including *Painting for Burial*, *Painting for the Skies*, *Painting to Shake Hands*, and *Painting for a Broken Sewing Machine*); Jackson Mac Low's *Piano Suite for David Tudor and John Cage*; Walter De Maria's *Column with a Ball on Top* (included in *An Anthology*); Ben Vautier's four pieces, *Radio*, *Theft*, *Police*, and *Smile*; and Emmett Williams's *Duet for Performer and Audience*. It is illuminating to recognize that 1961 was also the year in which Henry Flynt coined the term "Concept Art" in an eponymous essay, and the year of publication of the culminating, encompassing aesthetic statements from Greenberg (*Art and Culture*) and Cage (*Silence*).

But again, it is not these text-based artworks to which Fried responded. Instead, it was in what Fried dubbed "literalism"—Donald Judd's "specific objects" and Morris's "unitary forms"—that he identified the theatricality waging war against modernist sculpture and painting. What Fried finds so threatening is literalism's explicit movement out of its own formal specificity. Contrary to Greenbergianism—which, taking its cues from Kantianism, locates the *work* of the work wholly within its constructed elements—the literalist object accepts its role as part of a larger ensemble of experience. This ensemble (the

46. Julia Robinson, *George Brecht Events: A Heterospective* (Cologne: Walter König, 2005), 308.

"situation") certainly includes the object itself, perceived not as an assemblage of internally interrelated parts but as what Morris called a "gestalt."[47] The situation, however, also includes components that Greenberg and Fried excluded from the artwork proper. First among these, in most accounts, is the spectator, or "beholder" (Fried's preferred term). In Fried's view, the beholder was not modernist art's concern. That's not to say that the paintings of Jackson Pollock or the sculptures of David Smith were not meant to be exhibited, but rather that an explicit incorporation of the body and perception of the beholder was not a consideration in the making-for-exhibition of the works. In other words, these paintings and sculptures answered to exigencies of form and process. If a relation were evident in the canvas or the sculpture, it would be the relation of formal ideality to formal reality, or possibly of maker to material (think of Hans Namuth's famous film of Jackson Pollock), not of material to beholder, and certainly not of maker to beholder.

The expanded situation necessarily implicates space in the equation. The solution, so to speak, in which both object and beholder are suspended, is the space they share. This sharing is hardly neutral. The physical parameters (volume, shape, materials) of the space are determined in part by what occupies it. Sensory aspects of the situation are also effected by space: light and shadow impact visual perception; auditory experience is effected by the height of ceilings, the reflectivity of surfaces, and so on. Less quantifiable particulars are also in play. Spatial environments influence psychical experience and encourage or discourage varieties of social interaction. The built environment especially and always embeds its own semiotics of power, history, and economics.

Greenberg's virtual obsession with flatness as the essential concern of modernist painting was, remember, not a disavowal of

47. The term "gestalt" first appears in Morris's writings in "Notes on Sculpture, Part 2," originally published in *Artforum* in 1966 and reprinted in *Continuous Project Altered Daily*, 11–21; see, for example, 16.

figuration but an abandonment of spatial illusionism. By the time of Fried's "Art and Objecthood," space was still a concern, but ultimately it was theatricality's consideration of the beholder that posed the greatest risk to modernist formalism. Theatricality is a playing to—or more damningly, a playing *for*—its audience. One might imagine that Fried's objections are based on an Adornian critique of kowtowing to popular tastes or aesthetic mob rule, but Fried never makes this argument. His concern, consistent with Greenbergian-Kantian formalism, would appear to have more to do with how the artwork is constituted than with how it interacts prospectively or retrospectively with the world. Indeed, the debate between Greenberg-Fried on one side, and Judd-Morris on the other, is most commonly read as being played out almost entirely in terms of formalist issues: the modernist view is concerned with the composition of the work as the outcome of the relationships created internally by its constitutive elements; the literalist position is concerned with a larger formal construct that includes the object as one of the constitutive elements implicated in a structural relationship. Modernist art evades "objecthood" (Fried's other bugbear term) by being the active (or enacted) site of internal relations. On the other hand, a specific object or a unitary form courts objecthood. For Fried, this crosses the line from art to mere thing, in the process abdicating aesthetic responsibilities. For Judd, and even more so for Morris, the gestalt of the literalist object allows it to be but one thing in a network of relations, a network with the potential for alteration, change, and movement based on modifications of the dimensions of its constituent relations. So if the spectator changes position in space relative to the object, the situation has shifted. Likewise, if the object is exhibited in two different spaces or times, it will yield two different baseline situations.

This certainly opens the door of Morris's "expanded situation," allowing time into the consideration of the work. Time, in turn, introduces history, which introduces the additionally expanded situation of culture: of sociality, politics, gender, class, and race. At the beginning

of the 1960s, Morris's work (including *Box with the Sound of Its Own Making*, "Blank Form," and his performance collaborations with the Judson Dance Theater) engages with the expanded situation without explicitly referencing the world outside the work. His work was not overtly concerned with politics or sociality. Nevertheless, Morris was actively involved in a number of political issues at the time and clearly saw art in general and his art in particular as having sociopolitical responsibilities. It is difficult to take Morris's appeals to phenomenology as a motivating and explanatory model for his work and square them with his involvement in the "Lebenswelt" (lifeworld) beyond his unitary forms. His theoretical justifications, as for instance expressed in his essays "Some Notes on the Phenomenology of Making: The Search for the Motivated" (1970) and "Some Splashes in the Ebb Tide" (1971), seem more consistent with the work and legacy of Judd. Morris's engagement with phenomenology is far from dogmatic, allowing a broader and more inclusive reading of both phenomenology and his body of work.

3

THE PERCEPTION OF PRIMACY

The first solo museum show is no place to start. Such a show almost always functions as confirmation of a consensus already arrived at—if not always complete. But Robert Morris presents an unusual case in that his production changed so frequently and considerably from the beginning of the 1960s, when he began to exhibit, to the end of the decade, when he had his first solo museum shows. The first of these, at the Corcoran Gallery of Art from November 24 to December 28, 1969 (then at the Detroit Institute of Arts from January 8 to February 8, 1970), represented a fidgety retrospective of sorts, including both existing and new works. While the Corcoran show was not the first opportunity to critically assess Morris's oeuvre, the exhibition catalog included an ambitious essay by Annette Michelson that, in many ways, set the agenda for the subsequent critical reception of Morris.

Michelson situates the course of Morris's artistic journey between the twin stars of Charles Sanders Peirce and Maurice Merleau-Ponty and what she sees as their common concern for perception. In Merleau-Ponty, this preoccupation is clear enough. His phenomenology is predicated on what he called "the primacy of perception." To assign a similar perspective to Peirce takes a little more doing, but Michelson identifies a Peircean perceptualism in his notion of "epistemological firstness." This critical perspective was picked up and endorsed by Maurice Berger in his book-length study *Labyrinths: Robert Morris, Minimalism, and the 1960s*, published in 1989. Thus this phenomenological reading of Morris's sixties production maintained its currency for more than two decades. Michelson writes of "confronting sculptures such as those by Robert Morris":

Every aspect of that experience—the "reduction" on which it is posited, its reflexiveness, the manner in which it illuminates the nature of our feeling and knowing through an object, a spatial situation, suggests an aesthetic analogy to the posture and method of phenomenological inquiry, as it is familiar to us in the tradition of contemporary philosophy.[1]

In Pierre Schaeffer's version of Husserlian phenomenology, the apprehension of what appears to us in our perception is a singular and simple act. Michelson's account equates this Schaefferian/Husserlian procedure with Peirce's idea of "firstness." But for Peirce, the phenomenal encounter is necessarily more complex. At the very least, it includes the components he describes as "firstness" *and* "secondness," and a thorough account of Peirce's phenomenology would necessarily include "thirdness" as well. A close look at Peirce's "phaneroscopy"— his term for what has come to be known as phenomenology—exposes Michelson's reading as incomplete; not so much a misreading as an underreading. She equates firstness with presentness. But for Peirce firstness is a matter of qualities that exist not in the object, not in the subject, but as *potential* attributes of objects and of their perception by subjects. "Remember," Peirce writes, "that every description of it must be false to it."[2] Firstness is related both to idealism and to something like Chomskyan universal grammar: qualities, as Peirce describes them, are slots waiting to be filled by particular potentials. "A quality is a mere abstract potentiality," and it is an error to hold that "the potential, or possible, is nothing but what the actual makes it to be."[3]

On the other hand, secondness in Peirce is a matter of fact, of actuality. It is possible to think of secondness as more closely related to what phenomenology seeks.

1. Annette Michelson, "Robert Morris: An Aesthetics of Transgression," in *Robert Morris* (Washington, D.C.: Corcoran Gallery of Art, 1969), 43.

2. Charles Sanders Peirce, "A Guess at the Riddle," in *Peirce on Signs*, ed. James Hoopes (Chapel Hill: University of North Carolina Press, 1991), 189.

3. Charles Sanders Peirce, *Philosophical Writings of Peirce*, ed. Justus Buchler (New York: Dover, 1955), 85.

We find secondness in occurrence, because an occurrence is something whose existence consists in our knocking up against it. A hard fact is of the same sort; that is to say, it is something which is there, and which I cannot think away, but am forced to acknowledge as an object. . . . The idea of second must be reckoned as an easy one to comprehend. That of first is so tender that you cannot touch it without spoiling it; but that of second is eminently hard and tangible.[4]

If one wants to leverage Peirce in the way Michelson does, then a fuller account of both firstness and secondness seems to be warranted. There is also a very good argument to be made for applying Peirce's notion of thirdness to Morris and to the sonic practices we will examine in subsequent chapters. Peirce says that, although firstness and secondness "satisfy the mind for a very long time," eventually "they are found inadequate and the Third is the conception which is then called for."[5] Thirdness is the bridge that connects the first to the second, potential to actuality, ideality to reality. Thought of in this way, thirdness brings to mind Kierkegaard's description of consciousness:

If ideality and reality in all naivete communicated with one another, consciousness would never emerge, for consciousness emerges precisely through the collision, just as it presupposes the collision. Immediately there is no collision, but mediately it is present.[6]

Consciousness is collision. Consciousness is mediation. Thirdness is mediation. To approach it by way of a different metaphor, thirdness is the solution in which both the first and the second are suspended,

4. Peirce, "A Guess at the Riddle," 189–90.
5. Ibid., 190.
6. Søren Kierkegaard, *Fear and Trembling / Repetition*, ed. and trans. Howard V. Hong and Edna H. Hong (Princeton: Princeton University Press, 1983), 274–75.

the solution that allows them to constitute, and be constituted by, thought, experience, and what Peirce refers to as "every state of the universe at a measurable point of time."[7] Put simply, thirdness is relation. At various times Peirce characterizes the following as thirds: process, moderation, sympathy ("that by which I feel my neighbors' feelings"), signs, representations, generality, infinity, continuity, diffusion, growth, intelligence, and dynamics. Thirdness itself is relative, always a product, an effect—and, at the same time, a stimulus, a provocation and a facilitation, of the first and the second. "There is no absolute third, for the third is of its own nature relative, and this is what we are always thinking, even when we aim at the first or second."[8]

So, due to its nature as encounter, even an encounter with firstness is an encounter with thirdness. This is not to suggest that Michelson's readings of Peirce and Morris should be jettisoned completely. For one thing, her insight into the theological nature of the notion of presence is invaluable. She rightly sees modernism too as partaking of, or wishing to partake of, this theological presentness. Michelson displays great critical instincts in attempting to read Morris vis-à-vis Peirce. But she doesn't take the interaction between the two, between Peirce's theory and Morris's praxis, far enough. The entirety of Morris's output of the 1960s constitutes a powerful investigation and advocacy of the primacy of thirdness—of process, of relation, of encounter, in the gallery arts.

Michelson claims that the effect of Morris's work in the 1960s was to "renew the terms in which we understand and reflect upon the modalities of making and perceiving." Morris achieved this renewal by "developing, sustaining a focus upon the irreducibly concrete qualities of sensory experience."[9] This suggests an effect on thirdness through a manipulation of firstness as Michelson conceives of it: an amalgam

7. Peirce, "A Guess at the Riddle," 192.
8. Ibid.
9. Michelson, "Robert Morris: An Aesthetics of Transgression," in *Robert Morris*, 7.

of Peircean firstness and secondness, presented as an immediacy. And while Peircean phenomenology might allow for such an effect, Michelson's reading of Morris, with its emphasis on the senses, on the concrete, and on firstness, seems misguided. It might be more illuminating to focus on the active form of the gerunds "making" and "perceiving," on the relations inherent in these activities between artist, material, and convention on the one hand and between beholder and what Morris called the "situation" on the other. In other words, Morris's 1960s' output might best be considered in terms of thirdness, in terms of relations.

It is easier to think in the mode of firstness when considering the work with which Morris is most associated: the gray-painted plywood, steel mesh, fiberglass, and mirrored polyhedrons he made between 1961 and 1968. These sculptures (supported by a series of essays Morris published in *Artforum* under the title "Notes on Sculpture," parts 1–4) aligned him with the burgeoning movement of sculptural minimalism. Michelson was parsing Morris at the same time she was coming to grips with the meaning and importance of the movement, judging the work as it was happening without the benefit of critical hindsight. Her perspective helped to forge the consensus on Morris and minimalism. Not only is Morris now accepted as a bona fide high minimalist, but phenomenology is also regularly employed as the critical crowbar for cracking open his oeuvre and the truths of the movement. This holds even for Maurice Berger, whose book represents an explicit attempt to recuperate Morris's politics from his formalist reception.

Morris's phenomenological games hoped that the relationship between the art object and the viewer might be more or less democratic—free of the social and cultural hierarchies of art-world institutions such as the museum.[10]

10. Maurice Berger, *Labyrinths: Robert Morris, Minimalism, and the 1960s* (New York: Harper & Row, 1989), 93.

What Berger is indicating is a revision of the structure of aesthetic relations (thirdness), removing the museum from the position of principal power and replacing it with more egalitarian interactions. Berger's concerns throughout the book have little to do with phenomenology—in Michelson's sense of Peircean firstness. Accordingly, for Berger, he does not write strictly of phenomenology but of "phenomenological games," and elsewhere of a "phenomenological imperative" necessitated not by a loyalty to Peirce or Merleau-Ponty but by a commitment to "Herbert Marcuse's radical concepts of freedom and desublimation."[11]

Morris's practice is thirdness itself. It could be argued that it makes more sense to align his work in the 1960s with Cage, conceptualism, relational aesthetics, and many of the concerns that have been similarly overlooked in latter-day sound practice than with Donald Judd and Tony Smith (with whom he is often compared and grouped). For instance, it would seem easier to think in the mode of thirdness about a piece like *Box with the Sound of Its Own Making* than about a piece like *Column*, also from 1961. But *Column* maintains a more telling relationship with thirdness than is immediately apparent. *Column*, as its name suggests, is a rectangular plywood column, painted gray, eight feet by two feet by two feet. Both *Box with the Sound of Its Own Making* and *Column* are, at first glance, geometric sculptural forms made of wood. Considered visually, they diverge at the level of surface or finish. *Box* is unpainted, its seams undisguised, the screws of its construction clearly visible. *Column*, on the other hand, is painted and finished to hide its seams and screws. *Box* is apparently handmade, *Column* apparently manufactured. At another level, which we might call experiential, *Box* obviously differs from *Column* due to the audio recording playing from within its geometry. But the experiential status of *Column* is more complicated than a photograph is able to

11. Ibid., 12.

convey. The first exhibition of the piece took place as part of a concert organized by La Monte Young at the Living Theater in New York on February 5, 1962. The sculpture was assigned a seven-minute performance slot in the program of the evening's activities. *Column* started off standing vertically on the stage. After three and a half minutes, Morris, positioned offstage, toppled it with a string, bringing the sculpture to a horizontal position, where it lay for the remaining three and a half minutes.

As Berger has noted, *Column* engages much more than form and phenomenological percept:

> The notion of temporality and passage would contribute to the dissolution of formalism's romance with idealized form and time. In the end, Morris's metaphoric toppling of the pillars of late Modernism announced an important shift within the American cultural scene as the art object appeared to be dissolving into a field of choreographic gestures.[12]

As it turns out, *Column*, a seemingly straightforward geometric sculpture, engages thirdness in very explicit ways, introducing performativity, experiential duration, physical movement, temporal form, memory, and anticipation into the sculptural encounter. Echoing Michelson's keyword, Berger cites these introductions as "transgressions" of sculptural modernism. From a different aesthetic/ideological position, Fried would agree, referring to these transgressions as "theatrical" and fretting over their implications.

Michelson's assessment of Morris is an attempt to dissuade Fried (and his ilk) from his concerns. She argues that Morris maintains a relationship with formalism predicated on an engagement with "epistemological firstness," a term that could be translated into Greenbergian terminology as something like "material specificity"

12. Ibid., 48.

or, at a more basic level, simply as "formalism." Fried worries about theatricality, most certainly an example of thirdness. But Michelson argues against Morris's theatricality and for a firstness which would ironically, given her emphasis on transgression, bring Morris back into the Greenbergian/Friedian fold.

Let's think again about the properties *Column* introduces into the sculptural encounter: performativity, experiential duration, physical movement, temporal form, memory, and anticipation. In addition to being native to theatrical experience, these properties are also common to musical experience. Some are arguably more specific to music than to theater. Experiential duration is foregrounded in music, since musical events create and simultaneously inhabit a time specific to their artistic employment. Although dialogue in a play or film exists in and marks time, it also indicates another diegetic time, a referential time. Music, on the other hand, marks only its own structural time, its time of performance. Similarly, temporal form is not material, linguistic, narrative, historical, or psychological form: it is not representative or mimetic form. Form in music is made *in* time and *of* time. Time may be a factor, a consideration, in theater, film, literature, sculpture, and dance, but none of these media invest as much of their form in time itself. As a result, memory and anticipation, retention and protention, are key to the creation and reception of musical form. One must recognize a theme in repetition and in variation, must recall a previous instance of a fragment of melody, must develop a time-based understanding and anticipation of rhythmic content—one must do this to construct (or reconstruct) the architecture of a composition and a performance.

When we think about *Column* in this manner—whether we consider it theatrical, transgressive, musical, or something else—we realize that there may be another way to interact with Morris's later, more static minimal sculpture. Pieces such as the four mirrored cubes (1965), or the two and three plywood L-beams exhibited together in different positions and orientations (1965 and 1967), assume some

of the same properties as *Column* and *Box*. Both present a deceivingly geometric, static, even minimal facade, only to reveal more play in their situation of encounter. The mirrored cubes are *merely* geometric, static, and minimal, until a spectator walks close enough to be reflected in one of the cube's surfaces. From particular angles, reflections double themselves. From other angles, they initiate an infinite regress, in the process referring to the art-historical trope of the mise en abyme (the reflection of a scene within its artistic representation). These angles are not dictated solely by the work nor simply by the movement and changing perspective of the spectator relative to the work. They are a function of the situation as a whole: of subject, object, space, light, time, and the subjective actions of other spectators. Similarly, the L-beams function like an oversized, three-dimensional version of the Müller-Lyer illusion in which two lines of identical length appear to be different lengths due to additional features such as an inward- or outward-pointing arrowhead. The forms of the L-beams demand comparison. Are they identical? How do their different positions and orientations affect the spectator's perception of each form individually and of the ensemble? Again, these questions and answers—in other words, the experience of these works—are products of the relation of spectator to work. The experience of these works is the experience of relations, of mediation, of process: of thirdness.

Whether Michelson focused on phenomenology as a result of conversations with Morris or came to these conclusions independently, by the end of the decade he had embraced the notion, at least to the extent of using the term in his 1970 essay "Some Notes on the Phenomenology of Making: The Search for the Motivated," and in later essays, including "Some Splashes in the Ebb Tide" (1973):

> The strategy [the general movement from painting to sculpture in the midsixties] moved into a number of modalities, each of which played a variation on the structuralist theme

of surrounding a given process with systematic developmental rules to produce wholeness and completion. This strongly phenomenological strategy of activities seeking natural limits, regulations, and closures through the release of what was systematic in the alignment between the properties of actions and physical tendencies of a given media seemed to know neither rest nor fatigue, traversing as it did object art, Process art, all kinds of documentations of nature and culture, and all kinds of performances, including music.[13]

It is clear that Morris's use of the term "phenomenology" is not strictly Husserlian/Schaefferian. Nor does it agree with Michelson's sense of Peircean firstness. When he uses the term, here and elsewhere, he is referring to an engagement with a preexistent relation of activity to media—he is interested in how material allows itself to be formed, the compromises demanded by wood and, steel—and felt, in terms of how it might be manipulated. This is already a relation to a relation; the artist relating to the relation of media to its workability and physical tendencies. But what Morris explicitly seeks (what, according to him, many artists were seeking at the time) is an understanding of "natural limits, regulations, and closures."

Contrary to Michelson, Morris's use of the term does not suggest "an aesthetic analogy to the posture and method of phenomenological inquiry, as it is familiar to us in the tradition of contemporary philosophy." "Phenomenology" is a complicated term and a complicated philosophical method. The term has meant many things to many people at many times. More crucially, phenomenology is not a completed project. Its parameters and concerns expand periodically. Still, it is safe to say that Morris's "phenomenology" is not, ultimately, about epistemological firstness. Nor is it simply about the *epochē*, the reduction to what appears in perception.

13. Robert Morris, "Some Splashes in the Ebb Tide," in *Continuous Project Altered Daily: The Writings of Robert Morris* (Cambridge: MIT Press, 1993), 129–30.

Morris's use of the term "phenomenology" does have something in common with the philosophical project of Maurice Merleau-Ponty. Again, Michelson makes the connection:

Acknowledging sight as more and other than seeing, he [Morris] proposes that we take serious account of the fact that "to perceive is to render one's self present to something through the body," suggesting that we recognize that "if it seems to subsume a particular set of impressions under a general concept, then in the face of the evidence we must either re-examine our notion of "understand" or of "the body." Knowing, then, is the body's functioning in a given environment.[14]

The quotes in Michelson's text are from lectures delivered by Merleau-Ponty at the Collège de France in the 1950s. In another lecture, at the Société française de philosophie in 1946, Merleau-Ponty asserts the idea of the title under which the lecture was later published, "The Primacy of Perception":

The certainty of ideas is not the foundation of the certainty of perception but is, rather, based on it—in that it is perceptual experience which gives us the passage from one moment to the next and thus realizes the unity of time. In this sense, all consciousness is perceptual, even the consciousness of ourselves.[15]

This conception of consciousness disagrees with Kierkegaard's (cited above). Kierkegaard finds consciousness in the friction between ideality and reality, in the awareness of the difference between the

14. Michelson, "Robert Morris: An Aesthetics of Transgression," in *Robert Morris*, 45.
15. Maurice Merleau-Ponty, "The Primacy of Perception and Its Philosophical Consequences," in *The Phenomenology Reader*, ed. Dermot Moran and Timothy Mooney (London: Routledge, 2002), 436.

two. "Consciousness emerges precisely through the collision, just as it presupposes the collision. Immediately there is no collision, but mediately it is present." It is only in the mediation of difference—a process of perception, analysis, comparison, and interpretation—that consciousness can emerge, constituted by and constitutive of perception. Peirce imagines it similarly: firstness (qualities) precedes secondness (actuality). Qualities (not exactly ideas, but still immaterial constructs) precede perceptual experience. Thirdness is where the two are brought into useful relation. Peirce actually conceives of "the consciousness of ourselves" quite differently than does Merleau-Ponty. For Peirce, the "man-sign," as he calls it, is the product of a semiotic relationship with the self. We are not *immediately* conscious of ourselves, but *mediately*—through the interventions of signs, representations, and extraperceptual processes of differentiation and identification—we arrive at something like identity.

> Consciousness, being a mere sensation, is only part of the *material quality* of the man-sign. Again, consciousness is sometimes used to signify the *I think*, or unity in thought; but this unity is nothing but consistency, or the recognition of it. Consistency belongs to every sign. . . . The fact that every thought is a sign, taken in conjunction with the fact that life is a train of thought, proves that man is a sign. . . . Thus my language is the sum total of myself; for the man is the thought.[16]

To his credit, Merleau-Ponty is willing to accommodate complexities beyond the primacy of perception. Michelson neglects his expansiveness in the same way she underreads Morris's and Peirce's phenomenological perspectives. Even though Merleau-Ponty's model installs perception at the base of his existential hierarchy, he

16. Charles Sanders Peirce, "Some Consequences of Four Incapacities," in *Peirce on Signs*, 83–84.

acknowledges that perception is not the be-all and end-all of his phe-nomenological concerns:

> The idea of going straight to the essence of things is an inconsistent idea if one thinks about it. What is given is a route, an experience which gradually clarifies itself, which gradually rectifies itself and proceeds by dialogue with itself and with others.[17]

Merleau-Ponty means to indicate the complexities of history and culture. He calls his book *Phenomenology of Perception*, a "prelimi-nary study,"

> which must then be applied to the relation of man to man in language, in knowledge, in society and religion, as it was applied in this work to man's relation to perceptible real-ity and with respect to man's relation to others on the level of perceptual experience. We call this level of experience "primordial"—not to assert that everything else derives from it by transformations and evolution (we have expressly said that man perceives in a way different from any animal) but rather that it reveals to us the permanent data of the problem which culture attempts to resolve.[18]

For art history, art theory, and art practice, the critical question is where to focus one's attentions: on the primordiality of perceptual experience, or on the "problem which culture attempts to resolve," the problem of "the relation of man to man in language, in knowledge, in society and religion"?

Despite Annette Michelson's underreadings of Morris, Peirce, and Merleau-Ponty, many of the most influential critics of the 1970s

17. Merleau-Ponty, "Primacy of Perception," 443.
18. Ibid., 446.

and '80s adopted and extended her line of inquiry. Specifically when applied to minimalism, perceptual and phenomenological approaches proved flexible and fecund. But at the same time, critics concerned with minimalism's meanings and modes were discovering and utilizing poststructuralist and semiotic methods adapted from theorists such as Roland Barthes, Michel Foucault, and Jacques Derrida. These critical approaches and the insights they engendered problematized phenomenology while highlighting the importance of Merleau-Ponty's critical distinction between perception and culture.

Rosalind Krauss, the cofounder with Michelson of the journal *October*, explicitly identified the connections: "The history of modern sculpture coincides with the development of two bodies of thought, phenomenology and structural linguistics."[19] In the critical reception of the gallery arts, a balance was struck. The contemporary responses to minimalism, and then to conceptualism, notably in the pages of *October*, sought to accommodate perceptual experience in the fashion prescribed by Merleau-Ponty: as the "permanent data" of which signifying relations are constituted. By 1983, fourteen years after Michelson's catalog essay on Morris, Krauss contextualized minimalism's use of phenomenology within the art-historical transition from abstract expressionism. Krauss sees minimalism as arising from and in some ways continuing Greenbergian modernism's rejection of pictorial illusionism. Understanding Merleau-Ponty's perceptual data as "the meanings that things present to a given point of view"[20]—as the product of a relation between an object, a subject, and a situation (Peircean thirdness)—Krauss writes, "The *Phenomenology of Perception* became, in the hands of the Americans, a text that was

19. Rosalind Krauss, *Passages in Modern Sculpture* (Cambridge: MIT Press, 1977; repr., 1981), as cited in Hal Foster, "The Crux of Minimalism," in *The Return of the Real: The Avant-Garde at the End of the Century* (Cambridge: MIT Press, 1996), 43.

20. Rosalind Krauss, "Richard Serra, a Translation," in *The Originality of the Avant-Garde and Other Modernist Myths* (Cambridge: MIT Press, 1985; repr., 2002), 263.

consistently interpreted in the light of their own ambitions toward meaning within an art that was abstract."[21] This isn't equivalent to Greenberg's replacement of illusionism with formalism. Krauss, once a Greenbergian herself, takes a broader view of abstraction. For her, abstraction as manifest in minimalism relocates the site of relation from the internal space of the work to the external space of exhibition; from the time of production to the time of reception. Ultimately, she is committed to reading minimalism through linguistic, ontological, epistemological, social, and political signification. It is via this reading that Krauss extends the lines of influence from abstract expressionism to conceptualism, institutional critique, and the appropriative practices of the 1980s.

In her 1983 essay on Richard Serra, Krauss points to a significant wrinkle in *thing-itself*-centered phenomenology. Serra's film *Railroad Turnbridge* (1976), which translates his sculptural engagement with time-based experience into the medium of film by holding a steady gaze from the bed of a turning railroad bridge, reverses the usual Serra formula, allowing the steel structure to move in tandem with the viewer, rather than asking the viewer to navigate a static steel form. For Krauss, this reversal exposes the core of Serra's methodological concerns. His stalwart resistance to figuration (a Greenbergian inheritance) necessitates the conclusion that to fix the work in time or space is to create an image. The conclusion that time and space are inexorably linked, arrived at not by means of relativity, but strictly in accordance with Merleau-Ponty, implicates phenomenological space with experiential time, replete with history, narrative, relations, and a whole host of Peircean thirds that evade, exceed, and finally erase any simple attachment to the *thing itself*.[22]

21. Ibid., 264.
22. Krauss's essay on Serra appeared in the catalog of his first solo exhibition in France at the Centre Pompidou in 1983. Her critical tactic is to introduce Serra in relation to Giacometti and to compare and contrast the relationships of each of their practices to phenomenology. See ibid., 261–74.

Perspective is everything. This explains why Morris adopted an aesthetics of thirdness and Krauss theorized the "expanded field of sculpture" in 1978, eleven years after Morris wrote of "the expanded situation." Both turn toward Merleau-Ponty's account of phenomenological method and away from Husserl's. Krauss's critical position is more explicit: in her essay on Richard Serra, she quotes from *The Phenomenology of Perception* to discredit the value implied in claims of a godlike, objective, geometric perspective as genesis and telos of minimalist and early conceptualist work: "For God, who is everywhere, breadth is immediately equivalent to depth. Intellectualism and empiricism do not give us any account of the human experience of the world; they tell us what God might think about it."[23]

Merleau-Ponty is significantly less committed than Husserl to an essentialist position invested, on the one hand, in the inviolability of the *thing itself*, or, on the other, in the irreducibility of subjective perceptual experience. Of the former, Merleau-Ponty builds his model up from the foundation of perceptual certainty, rather than positing original or final value in a notion of self-confirming presence. Merleau-Ponty is not as dogmatic as Husserl, instead thinking of the subject as one node in the complex circuitry of culture. The point, ultimately, is to address the "problem which culture attempts to resolve."[24] Merleau-Ponty's phenomenology is a bottom-up method of addressing cultural issues: issues of language, of knowledge, of society.

Nor is it a coincidence that Krauss rejects Husserl along lines established by Derrida in *Speech and Phenomena*. In an essay first published in 1990, Krauss directly applies a Derridean reading of what she diagnoses as a pervasive case of perceptualism in the field of art history. Krauss's essay, entitled "The Blink of an Eye," takes its title, almost verbatim, from chapter 5 of *Speech and Phenomena*, "Signs and the Blink of an Eye." Krauss's aim here is to establish a reading of Duchamp—most pointedly of his *Large Glass*—that conflates the

23. Merleau-Ponty, as quoted in ibid., 270.
24. Merleau-Ponty, "Primacy of Perception," 446.

pure ocularism favored by many art historians with a psychology of a desire-in-vision and a readable form of retinal semiotics. To pave the way for such a project, Krauss first knocks out the supporting struts of a phenomenological art-historical method. She does this by pointing Derrida's critique of Husserl at what she sees as the art historian's traditional point of departure: that painting "will be the mimetically truthful double of any transverse plane in the original field of vision."[25] Such faith in painting is predicated upon a more fundamental faith in the fidelity of perspective that includes both a vanishing point and a viewing point. This viewing point—less often discussed, less often *located* within the logic of perspectival space—assumes a self-confirming eye and an inviolable moment of vision. Krauss calls it "a concentration at *this* end into the infinitely short duration of the 'now,' a present which is—as it achieves its limit—indivisibly brief and thus irreducibly unassimilable to time."[26]

Krauss's critique of traditional art history starts with a critique of the acceptance of the painting as a "natural sign." In Krauss's view, this acceptance—which is tantamount to promotion—grants painting a primordial status as an object endowed with all the truth and specificity of a natural object. The art historian (and by association, the painting) "has little use for any of those moves, arguments, theories, that have long since acted to reorient the human sciences around the structural conditions of the sign, the operations of the signifier, the properties of discourse."[27] Art history exhibits a stubborn resistance to reading paintings as signifying constructs, as texts. In referencing Derrida's dismantling of Husserlian phenomenology, Krauss hopes to show that art-historical methodology is based on similarly untenable presumptions. Husserl proposes that in the indivisible moment of the now, experience occurs in "absolute proximity" to itself. No language,

25. Rosalind Krauss, "The Blink of an Eye," in *The States of "Theory": History, Art, and Critical Discourse*, ed. David Carroll (Stanford: Stanford University Press, 1990), 176.
26. Ibid.
27. Ibid., 175.

no signification, no representation is necessary to establish the self-presence of the now and the self-evidence of experience. Derrida paraphrases Husserl: "If the subject indicates nothing to himself, it is because he cannot do so, and he cannot do so because there is no need of it."[28]

The painting is like Husserl's subject in the certainty of self-presence in the now: it has no need of the mediation of signs. Krauss, citing Derrida, characterizes this concept of the now as "myth, spatial or mechanical metaphor, and inherited metaphysical concept."[29] The obvious, the apparent, the selfsame are called into question and rethought as products of signifying processes—processes that must, by definition, take place in time. The simple, straightforward nature of the self-evident is revealed as complex, tangential, and evident only through the constitution of mechanisms residing outside any established boundaries of self. This movement—in which meaning is arrived at not by means of identification and consistency but by differentiation—arises from Ferdinand de Saussure's linguistics and finds its most radical and influential voicing in Derrida's term "differance" (*différance*). This intentionally misspelled, homophonic neologism practices what it preaches, making its meaning in part (because meaning is only ever made in part) in differentiation from the common word "difference" (*différence*).

For Krauss, this is a damning indictment of traditional art history's confidence in the "natural sign" of the art object. If any act of meaning making, of reading, of interpretation, must necessarily rely on the *trace* of the other, of nonidentity, in order to accomplish its task, then investment in the self-evidence of the painting is wasted on the empty promise of abundance. To dismantle Husserl's model, Derrida finds the tools he needs within the model itself. Husserl wants to reserve space in the now for memory—what he calls "retention." He carves

28. Jacques Derrida, *Speech and Phenomena and Other Essays on Husserl's Theory of Signs*, trans. David B. Allison (Evanston: Northwestern University Press, 1973), 58.
29. Krauss, "Blink of an Eye," 176.

out what amounts to an exception to the instantaneousness of the now in order to allow retention to exist as a primordial form of experience, as "real" and unmediated as direct experience. But for Derrida, and for Krauss in turn, this allows time and differance into the now, meaning that the now must be a product of differential meaning making, a product reliant on the mediation of signification.

As soon as we admit this continuity of the now and the not-now, perception and nonperception, in the zone of primordiality common to primordial impression and primordial retention, we admit the other into the self-identity of the *Augenblick*; nonpresence and nonevidence are admitted into the *blink of the instant*.[30]

Derrida's critique is here balanced upon the fulcrum of repetition. He wonders how Husserl can retain his notion of primordiality and his rejection of the need for mediation through signs, while at the same time proposing self-sameness and retention. The latter are predicated on the possibility of repeating a form, to confirm form by confirming its essential qualities. This is the purpose of Husserl's procedure of adumbration, in which an object is perceived from multiple perspectives, yet understood as one and the same object, precisely because of the constancy of certain features. This confirming revisitation means that, in order to make a claim of presence, something else, a process of signification and differentiation, must happen first.

Does not the fact that this bending-back is irreducible in presence or self-presence, that this trace or difference is always older than presence and procures for it its openness, prevent us from speaking about a simple self-identity *"im selben Augenblick"*?[31]

30. Derrida, *Speech and Phenomena*, 65, italics as original; Krauss, in "Blink of an Eye," quotes this whole passage.
31. Derrida, *Speech and Phenomena*, 68.

Arriving, as did others, at the term "postmodern," Krauss set out to distinguish the work of the 1970s from its predecessors:

> It is obvious that the logic of the space of postmodernist practice is no longer organized around the definition of a given medium on the grounds of material, or, for that matter, the perception of material. It is organized instead though the universe of terms that are felt to be in opposition within a cultural situation.[32]

As if to echo Merleau-Ponty's critical distinction between the "primordiality" of perceptual experience and the "problem which culture attempts to resolve," Krauss locates the modern-postmodern rupture in the difference between a concern with a medium's material versus a concern with its terms; a difference between *physis* and *nomos*, between matter and discourse. It becomes apparent that Merleau-Ponty's phenomenology—as opposed to Husserl's more essentialist version—allows artists and critics alike to loosen the grip of Greenbergian materiality and medium specificity, opening the doors of practice and theory onto a wider range of concerns. Merleau-Ponty allowed Morris and Krauss (as paradigmatic examples) to retain material and media as fundamental starting points from which to investigate culture, language, knowledge, and society. Material is transformed from the *thing itself* into a stand-in for *things in general*, including human things. The management of artistic material becomes an allegory of sorts for the management of worldly material: property, wealth, people, animals, resources, institutions.

Krauss's most explicit statement on the phenomenology informing minimalism comes in a 1973 *Artforum* essay, "Sense and Sensibility: Reflection on Post '60s Sculpture." She begins from across a certain philosophical divide, summarizing the notion of "protocol language"

32. Rosalind Krauss, "Sculpture in the Expanded Field," in *Originality of the Avant-Garde*, 289.

in the methodology of logical positivism. Especially on this point, it is easy to see logical positivism and phenomenology as emblems of the split between analytic philosophy in the first instance and continental philosophy in the second. Logical positivism, as employed by Rudolf Carnap, and phenomenology, as inherited and developed by Martin Heidegger, each hold that "no outside verification is possible of the words we use to point to our private experiences."[33] The implications of this thought would be put to vastly different use by analytic and continental philosophers as the breach between the two schools widened. But at the early stages of the separation, both sides can be seen to accept this fundamental premise. Krauss works from both sides of the philosophical dispute to attack the same problematic suppositions being used to motivate and justify minimalism. Her argument in "Sense and Sensibility" passes through the notion of intentionality common to both the logical positivists and the phenomenologists.

Although she doesn't mention Merleau-Ponty until the seventh page of the essay, her recourse to his phenomenology is crucial. Husserl is never mentioned. But it is his essentialist phenomenology against which Krauss is arguing. The turn initiated by Robert Morris's practice and Krauss's theory—from a straightforwardly perceptual minimalism in which the work is a "natural sign," to a culturally and historically instantiated and engaged minimalism in which the work is a nexus of signification—broadly mirrors the evolution of phenomenology from Husserl's original conception to the expanded conceptions of Heidegger and Merleau-Ponty. Perhaps the most important aspect common to these evolutions is the expansion of the understanding of the self beyond an auto-identical, auto-confirming form of experience to a sense of self predicated on the connection with other selves.

The revelation of this leads away from any notion of consciousness as unified within itself. For the self is understood

33. Rosalind Krauss, "Sense and Sensibility: Reflection on Post '60s Sculpture," *Artforum* 12, no. 3 (November 1973): 46.

as completed only after it has surfaced into the world—and the very existence and meaning of the "I" is thus dependent on its manifestation to the "other."[34]

In this context, Krauss discusses Morris's three L-beams from 1965. She opposes the reading of the L-beams as an experience of working through the difference of each of the L-beams' positioning to arrive at the understanding of their sameness. Instead she suggests:

> No matter how clearly we understand that the three Ls are identical, it is impossible to really perceive them—the one upended, the second lying on its side, and the third poised on its two ends—as the same. The *experienced* shape of the individual sections depends, obviously, upon the orientation of the Ls to the space they share with our bodies.[35]

In other words, Krauss is rejecting Husserl's central methodology of adumbration, asserting that such a move cannot achieve its stated aim. Even if the object is identical, our experience of it is not. The meaning we might take from the object is read, is understood, is felt, not to be a result of sameness, but a result of difference. Krauss's turn is a turn *from* Husserl, *through* Merleau-Ponty, *to* Derrida. Thus she reads minimalism—Morris in particular—as an instance of Derridean differance played out in forms—forms, not as simple, specific, or unitary, but as complexes of differential signification. By the same token, the role of the artist/author must be reimagined in light of this understanding of minimalism. To borrow terms Peter Osborne has used to describe different approaches to conceptual art, "exclusive" or "strong" minimalism would posit an artist/author whose private, internal, intentionality is the cause of the work. In conceptualism, Osborne applies the term to the work of Joseph Kosuth, connecting his practice

34. Ibid., 49.
35. Ibid.

to the same "long-discredited logical positivism" that Krauss indicts in connection with minimalism.[36] The alternative is the *inclusive* or *weak* version of a mode of practice. (Sol LeWitt is Osborne's example in conceptual art.) In reading minimalism through Merleau-Ponty and Derrida, Krauss establishes an inclusive strain of minimalism: a strain with Robert Morris as its founder and figurehead.

Hal Foster, a student of Krauss's, adopted her position on many of these questions, carrying it forward into the 1990s. Discussing minimalism, he echoes Krauss's echo of Merleau-Ponty:

The *normative* criterion of *quality* is displaced by the *experimental* value of *interest*, and art is seen to develop less by the *refinement* of the given forms of art (in which the pure is pursued, the extraneous expunged) than by the *redefinition* of such aesthetic categories. In this way the object of critical investigation becomes less the essence of a medium than "the social effect (function) of a work" and, more importantly, the intent of artistic intervention becomes less to secure a transcendental conviction in art than to undertake an immanent testing of its discursive rules and institutional regulations. Indeed, this last point may provide a provisional distinction between formalist, modernist art and avant-gardist, postmodern art: to compel conviction versus to cast doubt; to seek the essential versus to reveal the conditional.[37]

This schema, arising from the art criticism of the 1960s and '70s and summed up by Foster, describes a (if not *the*) predominant understanding of the transformations of the gallery arts from the late

36. Peter Osborne, "Conceptual Art and/as Philosophy," in *Rewriting Conceptual Art*, ed. Michael Newman and Jon Bird (London: Reaktion, 1999), 58.
37. Foster, "Crux of Minimalism," 57–58.

1960s onward. All the distinctions line up taxonomically and make sense of the messy, heteromedial, disjunctive practices of the 1970s. Converted into a table, one column displays the characteristics of formalism/modernism while the other presents the equivalent features of avant-gardism/postmodernism:

Formalism/Modernism		**Avant-gardism/Postmodernism**
normative	←→	experimental
quality	←→	interest
refinement	←→	redefinition
essence of a medium	←→	social effect of a work
transcendental conviction	←→	immanent testing
compel conviction	←→	cast doubt
essential	←→	conditional

This is the break that Fried foresaw and feared, the break that Morris and Krauss worked for and welcomed. The question—still being debated—is whether minimalism, as the pivotal moment in this transition, should be seen as the culminating gesture of formalism/ modernism or as the initiating move of avant-gardism/postmodernism. Foster calls it the "crux," the point of convergence, divergence, and emergence. It is *both* the end of modernism and the start of postmodernism. In Jean-François Lyotard's sense of the term, it is the "différend," the "phrase" (in Lyotard's parlance) that cannot be squared with either formalism/modernism or avant-gardism/postmodernism without unfairly negating its relevance to the other side. Minimalism is the phrase that belongs equally to what came before and what came after. But it cannot serve both masters simultaneously. It must toggle, beholden only to one or the other in any given "phrase regimen" (again, Lyotard's term). Minimalism is both the bridge and the break between modernism and postmodernism. It is the last of the former

and the first of the latter. We will leave it in this unstable status, reserving the right to refer to it in all its inconclusiveness as we proceed.

It is clear now that gallery practice, throughout the 1970s and into the '80s, had accepted "those moves, arguments, theories" that expanded art's concerns beyond Greenbergian mediality and materiality to issues of textuality, conceptualism, signification, subjectivity, epistemology, and sociality. Krauss's critique of art history in the late 1980s takes issue specifically with art historians' unwillingness to meet contemporary practice on its own terms. A similar unwillingness has continued to pervade theorizations of the sonic arts, from early post-Cage experiments to the inception of sound art as a discrete and nonmusical practice in the 1980s and to the reception of contemporary work of the past decade and a half. Unlike what we have witnessed in the gallery arts, much practice in the sonic arts has maintained a deeply instantiated resistance to the textual, the grammatological, the conceptual. Since the late 1960s, gallery practice has adopted a broadly accepted and deeply felt skepticism for the artwork as a "natural sign"; yet many sonic practitioners continue to find solace in the naturalism of sound.

Our aim is to identify instances of this resistance to conceptual modes in the historical progress from music to a sonic practice distinct from music. At the same time, we will locate the roots of the naturalism and the perceptualism that continues to dominate the philosophical-aesthetic agendas being pursued by sound practitioners and theorists alike. Perhaps most important, we will examine the reception of certain key works of sonic practice since 1948. These works, most often interpreted along naturalist/perceptualist lines, have consistently been stripped of their most important implications. An alternative reading is suggested by Krauss's critique of 1980s art history and by Foster's schema of the modern/postmodern rupture. Such a reading, informed by the conceptual turn in the gallery arts, proposes a vastly different history of the sonic arts of the last sixty years; a history rooted not in Husserl's phenomenology, not in Cage's

naturalism; but in Peirce's thirdness and Derrida's differential grammatology. Such a history starts from a skepticism of metaphysical presumptions, rejects claims of originary or teleological motivations, and locates its value, its avenues of ingress and egress, in the unresolvable relational complexity of language, culture, and intersubjectivity.

4

OHRENBLICK

Aristotle believed that flies could spontaneously generate from animal dung. Such is the persuasiveness of the apparent. The apparent would have it that sound is purer than vision; sound is not as susceptible to being deceptively manipulated; sound is a direct encounter with waves created by the sounding objects, a physical phenomenon, an actual vibration of the body. Looking back to our beginning—not *the* beginning, of course, but the beginning posited at the start of this book—we can detect in Schaeffer, in Cage, in Waters, the trickles of what would become these streams of thought. It is disappointing to recognize the lateness of significant theoretical approaches to sound and noise. Luigi Russolo's *Art of Noises* of 1913 is more a polemic and how-to manual than a theoretical text. But his *intonarumori*, or noisemakers, put his ideas of constructed noise into artistic practice. Walter Ruttmann's *Wochende* (1930) is a soundtrack to a "blind film," assembled on the audio track of visual film stock. The events of 1948 witness a coalescing of new modes of sonic practice. Why, then, do we not see significant theoretical engagements with this practice and its implications until decades later?

Equally confounding is the fact that the earliest significant engagements come not from musicologists or art historians but from media theorists (Marshall McLuhan, Friedrich Kittler) and an economist (Jacques Attali). It was not until the 1990s—some forty-plus years after Schaeffer first spliced tape to fashion an art of concrete sounds—that a sonic aesthetics, distinct from a musical aesthetics, began to establish itself theoretically. Still, we find a dearth of serious thinking on the subject. What does exist and begins to express a consensus bases its interpretive schemata and assessments of value on presumptions similar to those of art history's misguided initial

91

engagements with minimalism. Sonic theory circa 2009 is poised to chase (and/or lead) its quarry down the same dead-end avenues of thought. Why the theorization of sound took so long to develop is a question we will bypass in order to address a more pressing concern: Why does sonic theory insist on pursuing the essentialist, phenomenological route already tested and largely rejected by art-historical accounts of minimalism?

To propose yet another nonbeginning from which to start, in his book *The Gutenberg Galaxy*, Marshall McLuhan began to draw distinctions between visual and acoustic experience as early as 1962. Broadly, McLuhan attributes a reordering of human beings' perceptual faculties to the advent of moveable type and of widely available printed matter. Print culture—in conjunction with the development of Renaissance perspective—emphasizes the visual to the detriment of other senses, including the tactile and the aural. This perceptual reorganization catalyzes a cognitive reorganization along linear and perspectival lines: visually centered cognition orders itself sequentially: horizontally, like words on a page, or vertically, like two-dimensional representations of space. Such reconditioning of perceptual and cognitive sensibilities necessarily relegates sound to a secondary position, with little metaphoric or organizational influence over the ordering of thought and experience. McLuhan imagines that the lifeworld before Gutenberg was organized by aural experience. What McLuhan refers to as "acoustic space" is holistic, immersive, nonlinear. Against the "fragmentation of the human psyche by print culture,"[1] McLuhan sets the "sensuous complexity" of the auditory.[2] If print culture spurs humans toward individualization, auditory culture would have "thrown" (the use of Heidegger's term is intentional) individuals into a collective space of implicated, imbricated experience.

McLuhan's characterization of the acoustic conjures an essentialist primitivism. In 1989 he wrote:

1. Marshall McLuhan, *The Gutenberg Galaxy: The Making of Typographic Man* (Toronto: University of Toronto Press, 1962), 32.
2. Ibid., 124–26.

For the caveman, the mountain Greek, the Indian hunter (indeed, even for the latter-day Manchu Chinese), the world was multicentered and reverberating. . . . Acoustic imagination dwelt in the ebb and flow, the *logos*.[3]

To dwell in the acoustic rather than the visual is to be more closely connected to nature; to God, or the gods. Visual space, which has been "for several thousand years, at least, man's sensorium, or his seat of perceptive balance, has been out of plumb."[4] There is something wrong, and we had best get back to the essence, which is auditory experience. McLuhan's experiential essentialism of the acoustic is confirmed by recourse to a similarly suspect anthropological primitivism: "Acoustic space structure is the natural space of nature-in-the-raw inhabited by non-literate people."[5] In particular, McLuhan points to studies of the people of the Trobriand Islands in the South Pacific, focusing on their conception of time. "[The anthropologist Edmund] Carpenter advises us that the Trobriand Islanders only recognize now, the eternal present."[6] McLuhan also cites research by Dorothy D. Lee, who reports that the Trobrianders have completely different names for an indigenous yam as it matures from sprouting to ripeness to rotten. The name of the object changes rather than the adjectives appended to the consistency of the name. The conclusion is that the Trobrianders see the yam as a new object—a new construct of sense data—at every state of its maturation. The yam's degree of ripeness is the central attribute of its objecthood. Thus, what we would describe as a different stage of ripeness of the selfsame yam would for the Trobriander constitute a new object altogether.

This conception of time—in which one resides in the eternal present—sounds eerily like Husserl's phenomenological time, similarly

3. Marshall McLuhan, "Visual and Acoustic Space," in *Audio Culture: Readings in Modern Music*, ed. Christoph Cox and Daniel Warner (New York: Continuum, 2004), 68.
4. Ibid., 68–69.
5. Ibid., 71.
6. Ibid., 70.

reduced to the infinite and infinitesimal now. Likewise, the Trobrianders' focus on the object as it appears to us in our perceptions is a doppelgänger for Husserl's phenomenological reduction. And when McLuhan writes "acoustic space requires neither proof nor explanation,"[7] it rings the same false tone as when Husserl says the subject has no need of signs to indicate himself to himself. Between Pierre Schaeffer's overt Husserlianism and McLuhan's inadvertent phenomenological affinities, engagements with sound remain rooted in a perceptual essentialism. This tack is likely motivated by the second-class citizenship of sound in the community of senses. Always in vision's shadow, sound must shout to be heard. Hyperbolic assertions draw attention, close the gap, stake claims. McLuhan and others see the visual as corrupted by its privileged position in alienated society. To turn to the aural is to turn away from power . . . or so it would seem. In fact, to redress the imbalance of power, such a turn must covertly justify and assert itself as a turn *to* power. The appeal of a statement such as "the meek shall inherit the earth" is that it promises power, not that it accepts the virtues of powerlessness. For McLuhan, sound is more natural, closer to the origin or essence of being, than sight. The leading, next-generation media theorist Friedrich Kittler starts from McLuhanesque assumptions about media and message, integrating Foucauldian, Lacanian, and Derridean theoretical and historical models to build a more sophisticated media matrix. From Lacan, Kittler borrows the distinction between the symbolic and the real. In his *Gramophone, Film, Typewriter* (1986), technological reproduction is described as an encounter with the real. "A reproduction authenticated by the object itself is one of physical precision. It refers to the bodily real, which of necessity escapes all symbolic grids."[8] Visual and sound recordings, as exemplary instances, are not obligated to resemble a preexistent referent. Instead, they are

7. Ibid., 71.
8. Friedrich Kittler, *Gramophone, Film, Typewriter*, trans. Geoffrey Winthrop-Young and Michael Witz (Stanford: Stanford University Press, 1999), 12.

products of an object: of light in the case of photography; of sound waves in the case of phonography. In this sense, they are purely indexical: the physical imprint of a material catalyst, *not* the iconographic likeness of an external referent. Sound recordings, then, are instances of encounters with real phenomena. For Kittler, this makes them, in and of themselves, instances of the real.

The symbolic, conversely, has no status as, or material connection to, the real. The symbolic is a translation, a transformation, a transubstantiation of the real into a mediated grid of signs. Language is such a grid. The keys of the typewriter (or the computer keyboard) render this in remarkably literal fashion. The real, says Kittler, in order to reach us, must pass through "the bottleneck of the signifier."[9] In so doing, it is compressed, reduced, quite likely shorn of its most substantive fleece. In short, the sign fleeces the real. For Kittler, the real is matter and the symbolic is information.[10] Thus the speaking voice is only signifying when forming recognizable words. The ums, ahems, coughs, swallows, and hiccups before, between, and around words are not the symbolic but the real, as are accents, impediments, and tics. We ignore the real in everyday conversing, filtering out noise in favor of signal. The neutral ear and tongue of technology, on the other hand, have no such filters and convey the feral real with the same fidelity as the domesticated symbolic. "Only the phonograph can record all the noise produced by the larynx prior to any semiotic order and linguistic meaning."[11] This technophenomenological attitude has implications for any artistic engagement with sound. Instead of significant sound—sound that functions according to one or another symbolic grid (speech, music, sound accompanying visual material)—the phonograph is a neutral technology, delivering "acoustic events as such."[12] Kittler detects a nascent interest in such acoustic events in the work of Richard Wagner as early as 1854—some twenty years

9. Ibid., 4.
10. Ibid., 16.
11. Ibid.
12. Ibid., 23.

before the Frenchman Charles Cros formulated the principles of pho-
nography and Thomas Edison realized Cros's "musical dream of the
too short hour."[13] In Wagner, Kittler detects a "historical transition
from intervals to frequencies, from a logic to a physics of sound."[14]
Whether this transition had secured a toehold in 1854, who knows?
As we have seen, beginnings are slippery slopes. Lacking Kittler's
alpine fortitude, I feel safer in saying that the transition had gained
more significant, identifiable traction ninety-four years later, by the
significant events of 1948.

Kittler goes on to critique the development of Western music the-
ory for its exclusion of the auditory real:

> First, there was a notation system that enabled the transcrip-
> tion of clear sounds separated from the world's noise; and
> second, a harmony of the spheres that established that the
> ratios between planetary orbits (later human souls) equaled
> those between sounds.[15]

Kittler is staking out the frontline of a battle waged initially by Russolo,
and later by Schaeffer, Cage, and Waters: the battle for the definition
of music, the constitution of its materials, and the method of ascrib-
ing values to those materials. This battle derives from the same fric-
tions I described in chapter 2: Music has—since at least the advent
of notation—existed as effects quantified as "values" (in both senses
of the word). The institutions of Western music (including notation,
instrumentation, concert protocol, the consolidation of music theo-
retical methods) have captured music in and as a numerical sign sys-
tem, a system in which phenomena are signified as values of pitch
(A 440), harmony (thirds, fifths, octaves), duration (whole notes, half-
note rests, dotted quarter notes), and rhythmic organization (3/4, 4/4,

13. Charles Cros, "Inscription," as quoted in ibid., 22.
14. Kittler, *Gramophone, Film, Typewriter*, 24.
15. Ibid.

6/8). This valuation of musical effects represents (e)valuation of certain effects, of certain musical elements, over others.

For Kittler, this generative friction is a battle between the real and the symbolic. And there is no doubt that he grieves the reduction of music to sign system. In his account, Kittler includes an anecdote recorded by Rainer Maria Rilke in 1919: Rilke recalls an experience he had while attending anatomy lectures in Paris, studying the structure of the human skull. In particular, he found himself drawn to the lines in the bone caused by the fusing of the plates of the skull during infancy. These lines—the coronal suture—reminded Rilke of another line he had experienced as a much younger student, when his teacher had led the class in the construction of a rudimentary phonograph from a cardboard funnel, wax-paper membrane, and clothes-brush-bristle stylus. Inscribed in a layer of candle wax by the bristle stylus, the students' funnel-amplified sound appeared as a squiggly line: an inscription conjured years later for Rilke by the fused fissure of the coronal suture. Pursuing a line of thought (the figure is nearly literal) with "incredulity, timidity, fear, awe," Rilke imagines playing the groove of the coronal suture with a phonographic stylus: "What would happen? A sound would necessarily result, a series of sounds, music."[16] Rilke imagines the resulting music as a "primal sound" and extends his thought experiment:

> What variety of lines, then, occurring anywhere, could one not put under the needle and try out? Is there any contour that one could not, in a sense, complete in this way and then experience it, as it makes itself felt, thus transformed, in another field of sense?[17]

16. Ranier Maria Rilke, "Primal Sound," as quoted in Kittler, *Gramophone, Film, Typewriter*, 41.
17. Ibid.

This Rilkean fantasy is related by Kittler with significant intent. It announces the dream of unified sensory experience; of "completing," to use Rilke's verb, the experience of phenomena. The implication is that there is a completeness in nature and that our sense of incomplete experience, insufficient understanding, is a product of our inadequate perceptual faculties. Apparently the unenlightened person is merely the one who has not put together the pieces of the sensory puzzle, who has not discovered the organic wholeness that is the real. Rilke yearns to bridge "the abysses which divide the one order of sense experience from the other."[18] Kittler comes to the rescue: "In today's media networks, algorithmically formalized data streams can traverse them all."[19] Sense perceptions are revealed as nothing more than neutral data flows. Equally neutral technology—the phonograph—can provide the bridge of Rilke's dreams.

At first blush, Rilke's neo-Romantic sensibility and Kittler's postmedial, technological perspective could not be more different. Yet it is not for nothing that Kittler balances much of his argument on Rilke's fulcrum. Both ground their convictions, their desires, in a sense of experiential essentialism. For Rilke, poetry offers a passage through the thicket of disjunction and occlusion characteristic of the individual's experience in the modern world. Beneath all that (at the foundation, deeper, purer), resides a metaphysical essence. Rilke's view suggests that a unification of the five senses would enable a holistic, immersive consciousness, allowing "ever more active and more spiritual capacity."[20] Kittler's essentialism cloaks itself in the neutrality of media. But that neutrality is, itself, an impossible position of transcendence. The friction upon which Kittler seizes—between intervals and frequencies, between a logic of sound and a physics of sound—moves backward from the symbolic grid of music. The intervals and logic

18. Rilke, "Primal Sound," as quoted in Kittler, *Gramophone, Film, Typewriter*, 42.

19. Kittler, *Gramophone, Film, Typewriter*, 49.

20. Rilke, "Primal Sound," as quoted in Kittler, *Gramophone, Film, Typewriter*, 42.

of Western music create a closed symbolic system. As discussed in chapter 2, the extramusical is denied entry. This is a process of bracketing out that resembles the phenomenological reduction. And music's fundamental understanding of its own meaning-making processes rests on similar premises of self-identity. Western music's understanding of itself is inadvertently Husserlian. Though meaning is made in time and as a product of rhythmic and harmonic relations, music as a language seeks to retain its absolute proximity to itself. Any process of differance is thought to occur only within the narrowly proscribed boundaries of music-as-such. Like the triplet monkeys covering their eyes, ears, and mouth, music vainly resists semantic interaction with "outside" influences. This is music's impossible dream. Batoned sentries stand down the barbarians at the gates.

Recoding sound as frequencies and physics does not significantly revise its semantic schemata. A deeply rooted Husserlianism inheres, although Kittler doesn't want to call it that. "Literary scholars, still believing in the omnipotence of philosophers, choose to relate Rilke's inner world space to Husserl."[21] If it's omnipotence that we're indicting, we could find it in the claims that Kittler makes for data streams, traversing the abysses between sight and sound, between touch and taste, between thinking and feeling. Data, by this account, can go anywhere, take anything/everything on its shoulders. Personally, I think the literary scholars and philosophers were on to something. Rilke's poetic intuitions are based on faith in a fundamental stratum of experience, on some essential ontological state, a metaphysics. His aesthetic seeks to reset the cognitive machinery to that baseline state. Such convictions can be identified in Husserl's inheritance to Heidegger, who looked to poets like Hölderlin and Rilke as thinkers beyond the common ken. Kittler shares these convictions, though they may be less overt, masked by recourse to media rather than metaphysics.

21. Kittler, *Gramophone, Film, Typewriter*, 43.

Kittler's interest in Rilke's anecdote of the coronal suture is an interest in authorless media streams. "It is no longer necessary to assign an author to every trace, not even God."[22] This is a kind of antimetaphysics, a negative theology: positing a universality of data that precedes any communicative intent, any transmitter, any receiver. This would be the all-knowing, all-seeing, the omnipotent itself. But messages, if that's what we're after (and I would argue that Kittler certainly is, if only in the McLuhanesque sense of media-as-message), are context dependent. Contextless data is gobbledygook (even at the level of media-as-message). The translation of the coronal suture into phonographic sound erases the contextual markers that make the initial signal readable. The suture may be authorless, but it is not readerless, not contextless. Perhaps to a physiologist, the coronal text might convey information from the palimpsest of the skull: about the brain it once housed, the body of which it was part, the family from whom it descended. But to drop a phonographic needle into the suture's groove is meaningless. As sound, it no longer maintains any connection to the conditions that produced it. As sound, it is contextless data, pure noise. And let's be clear that, contrary to apparent understanding, only noise is capable of purity. Signal, a product of traces and differance, is always impure, always shot through with the impurity of the other. Signal is never selfsame, never in absolute proximity to itself. Caroline A. Jones has made a similar argument about the uses of EEG output in artworks. Discussing Janine Antoni's *Slumber* (1994), Jones writes,

There is nothing universal about such "form" [the EEG readout of Antoni's brain during sleep] . . . the fantasized universality of pure form, and the liberation signified by informe, both give way to what one could call discursively determined form. Only a neurologist can properly read the "form" that

22. Ibid., 44.

otherwise appears so "formless." Such artworks acknowl-
edge that the making of meaning can never be global and
universal, and can never be detached from an intersubjective
frame that is necessarily both local and specific.[23]

Am I being fair, contesting some of Kittler's claims in the context
of a discussion of art? Kittler makes an effort, on numerous occa-
sions, to make a distinction between media and art. He is concerned,
he says, with the former. But the discussion to which he is contributing
is not exclusive to media; how could such exclusivity be enforced? It
has profound implications for art as well. And both media and art are
certainly implicated in the broader categories of culture and experi-
ence. Even the most abstract thought and the most radical concep-
tual art must be conveyed. The means of conveyance is media. What
Kittler has to say must also be thought of in terms of art. His own
text testifies to the fact, citing examples from Goethe, Kafka, Pink
Floyd, Jimi Hendrix, Stéphane Mallarmé, and Rilke. His arguments
sometimes even shadow art history, as when he claims that the ease
and faithfulness of phonographic reproduction made poetry obsolete.
Poetry, as what Kittler calls a "mnemotechnological" form, could not
compete with the phonograph's memory for names, places, verbal
constructions, stories, lessons, philosophies, and so forth.

Under these circumstances, writers are left with few options.
They can, like Mallarmé or Stefan George, exorcise the
imaginary voices from between lines and inaugurate a cult of
and for the letter fetishists, in which case poetry becomes a
form of typographically optimized blackness on exorbitantly
expensive white paper.[24]

23. Caroline A. Jones, "Form and Formless," in *A Companion to Contemporary
Art since 1945*, ed. Amelia Jones (Malden, MA: Blackwell Publishing, 2006),
141.
24. Ibid., 80.

This formula reproduces the art-historical notion that photography hastened the obsolescence of painting as the privileged recorder of reality, forcing painters to turn to abstraction as a mode of practice both specific to painting and unlikely to be cannibalized by photographic technology. But this misses an important point of phonography's success and an important distinction between it and photography. Audio recording, despite Edison's best intentions and predictions, has prospered primarily as a conveyor of a preexistent form of art and entertainment. Music didn't come into being with recording. Instead, recording technology was trained upon music and used to dissemi-nate and corporatize it. Photography, on the other hand, has not been used primarily as a medium of capture for a preexisting artistic form. One might say, adopting Kittler's terms, that phonography has been, nearly from the outset, a conveyor of an already symbolic form, while photography has been accepted culturally as a conveyor of the real. Yet that common understanding is equally mistaken: even the pho-tographic lens, trained on a landscape or the subject of a portrait, inevitably engages the symbolic realm. We read photography as text. Photography has been training us in this reading procedure as we have been reinventing it to coincide with our understanding and desires. The photograph's situation as text can only be understood via the symbolic, bringing Kittler's understanding of the relation of phonogra-phy to poetry even closer to that of photography and painting.

Elsewhere, discussing Cocteau and the Beatles, Kittler equates the real with realism, and realism with high-fidelity recording.[25] It is curious that, in many cases, the higher the fidelity, the more uncanny the listening experience. As a result, it is not uncommon for listen-ers to find old, technologically primitive recordings, of Delta blues players, for example, more authentic than new studio productions or digitally remastered versions of the originals. A whole subgenre of indie (independent) rock sought to parlay the apparent veracity

25. Ibid., 99.

of rudimentary recording into an unpolished aesthetic of the real. Incidentally, this movement, composed largely of American bands like Sebadoh, Pavement, and Guided by Voices, went by the name lo-fi (low fidelity). These examples turn Kittler's observations on their heads. The "real" that passes through our speakers when we listen to Robert Johnson's 1937 recording of "Hell Hound on My Trail" or the Silver Jews' 1993 "Welcome to the House of the Bats" is not a mute perception of phenomena in absolute proximity to themselves. In both recordings, the hiss, the reduced frequency range, the distortion, the wildly inconsistent dynamics—these are neither neutral nor simply "real." Instead, such sonic artifacts are understood by listeners as signs, as constituent elements in a complex symbolic grid of sound recording. In each case they may indicate different things. History, intention, and legend are also part of the symbolic grid. We hear the distortion of Johnson's singing as the inadvertent product of inferior (and probably portable) equipment and of the lack of experience of a singer who had never before sung into a microphone. We hear the distortion of the Silver Jews' singer, David Berman, as the wholly intentional product of an aesthetic of rebellion and rejection within the established code (the word is not incidental) of rock-and-roll recording. But these readings are surely acts of willful ignorance on the parts of listeners. Can we definitively rule out intention in the case of Robert Johnson? Can we be sure that he didn't hear an earlier take with distortion and decide that he liked it enough to re-create the effect? Can we be sure there wasn't an alternate take that was discarded in favor of the released take, perhaps due to the effect of the distorted vocal? On the other hand, can we be sure that David Berman didn't record his vocals as best as he could, given his knowledge and equipment? Can we be sure that he recognized his performance as the product of a substandard recording? Such possibilities still cannot prevent us from reading the text of the recording: not just the words, not just the music, not even just the "grain" of the voice—Barthes's valuable

addition to the perceived content of audio recordings—but also the expanded *situation* of the recording.

This is where we have been headed. The expanded situation of sound is the idea that I have been trying to bring into play—thought by thought, example by example—since the start of this book. It might have been quicker simply to turn to thinkers who take this situation for granted. But to this point, what I have tried to do is prepare the ground for the arrival of their thoughts, overturning the soil of the apparent and the habitual, so that the implications of thinking sound-beyond-sound and/or sound-without-sound might take root.

It took an economist to establish music as a symbolic form. Jacques Attali's 1977 book *Noise: The Political Economy of Music* takes quite a different approach to recorded sound and how it functions. Attali is concerned with music per se, not with the broader categories of recorded sound or the sonic arts. Contra Kittler, he hears recorded music as fundamentally symbolic. The change wrought by recording technology and by the commodification of recordings was to transform the ritualistic value of music into exchange value. In either case, music is, in its very ontology, symbolic. "In fact, it [music] has no usage in itself, but rather a social meaning expressed in a code relating to the sound matter music fashions and the systems of power it serves."[26]

Just as Attali's conception of music is opposed to Kittler's, it is also opposed to Western music's idea of itself as a hermetic code. Attali sees music functioning, not in the manner of linguistics as imagined in a vacuum by Saussure, but relationally and functionally. Musical meaning is thus produced in the mode of Derrida's grammatology.

The musical message has no meaning, even if one artificially assigns a (necessarily rudimentary) signification to certain

26. Jacques Attali, *Noise: The Political Economy of Music*, trans. Brian Massumi (Minneapolis: University of Minnesota Press, 1985), 24.

sounds. . . . In fact, the signification is far more complex. Although the value of a sound, like that of a phoneme, is determined by its relations with other sounds, it is, more that that, a relation embedded in a specific culture; the "meaning" of the musical message is expressed in a global fashion, in its operationality, and not in the juxtaposed signification of each sound element.[27]

Attali characterizes efforts to constitute a theory of music as language as "no more than camouflages for the lamest kind of naturalism."[28] A similar conclusion could be drawn regarding Kittler's professed loyalty to the "real."

This is not to suggest that Attali's schema is not without its faults. His perspective is, at heart, that of a Marxist economist (from 1981 to 1991, he served as an adviser to the French president François Mitterand). As such, he is focused on assessing music's value in terms of categories, such as use and exchange, that may in truth have only a little to do with its function, ontology, or effects. What's more, his thought is influenced by the anthroposociological perspectives of thinkers such as George Bataille, Michel Leiris, and Claude Lévi-Strauss. From Bataille in particular he adopts a hyperbolic sensitivity to symbolic social violence. For instance, Attali describes music as a metaphoric enactment of ritual murder, of sacrifice. Still, unlike Kittler, Attali understands music as a social activity embedded in a code and as a social code embedded in activity. Music is constituent of, and constituted by, the relations included in its expanded situation: sociality, gender, class, race, politics, and power. To understand music, one must understand much more than music. "What must be constructed, then, is more like a map, a structure of interferences and dependencies between society and its music."[29]

27. Ibid., 25.
28. Ibid.
29. Ibid., 19.

One of Attali's recurring formulations is that music, in the best examples, is a message being composed at one and the same time as the language in which the message is conveyed. The commodified product of the music business, on the other hand, seeks to repeat messages already received, digested, and therefore comfortable and comforting. In the case of pop music, this creates a difficult tension between the repeatability of the forms of pop and the innovation of the "pop artist": "Thus they [author-performers like the Beatles or David Bowie] continue to play the eternal role of music: creating a form of sociality. But in repetition that passes for identity, and no longer for difference."[30] The resulting tension threatens not just music, but also the sociality engendered by pop. Coded, then, as commodity, this sociality falls under the influence of capital and its brokers, creating a power relation that Attali fears.

The alternative, in which Derridean "différance" is retained, offers its own difficulties. Attali finds this drama played out in the compositional move away from the repetitious comfort of tonality during the middle decades of the twentieth century:

> Since the abandonment of tonality, there has been no criterion for truth or common reference for those who compose and those who hear. Explicitly wishing to create a style at the same time as the individual work, music today is led to elaborate the criterion of truth at the same time as the discovery, the language (*langue*) at the same time as speech (*parole*). Like science, music then moves within an increasingly abstract field that is less and less accessible to empiricism, where meaning disappears in abstraction, where the dizzying absence of rules is permanent.[31]

The better analogy, as I have suggested, is with Derridean models of language and meaning. Indeed, the dizzying absence of rules is

30. Ibid., 119.
31. Ibid., 113.

permanent. But that is not the same as believing that "meaning disappears in abstraction." Attali mentions Derrida only once and in passing. So, to read him through Derrida is something of an imposition. Nevertheless, this reading makes available a method for thinking about sound's expanded situation.

An expanded sonic practice would include the spectator, who always carries, as constituent parts of her or his subjectivity, a perspective shaped by social, political, gender, class, and racial experience. It would necessarily include consideration of the relationships to and between process and product, the space of production versus the space of reception, the time of making relative to the time of beholding. Then there are history and tradition, the conventions of the site of encounter, the context of performance and audition, the mode of presentation, amplification, recording, reproduction. Nothing is out of bounds. To paraphrase Derrida, there is no extra-music.[32]

And this goes equally for other forms of sonic practice. One could easily argue that sound art, as a discrete practice, is merely the remainder created by music closing off its borders to the extramusical, to any instance of *parole* that could not be comfortably expressed in the *langue* of the Western notational system. Instances of non-Western music would not be sound art. Although they may employ specific features, such as microtonalities not represented in the Western octave, these features can still be understood and, to some extent, represented in a way that is legible to Western musical methods. Sound art is art that posits meaning or value in registers not accounted for by Western musical systems. Unlike sculpture, and to a lesser extent, cinema, music failed to recognize itself in its expanded situation. Instead, it judged the territory adopted by the expansion as alien and excluded it tout de suite. The term "sound art" suggests the route of escape, the path of least resistance available to this errant

32. Derrida's famous proclamation "Il n'y a pas de hors-texte" is translated as both "There is nothing outside the text" and "There is no outside-text." See Jacques Derrida, *Of Grammatology*, trans. Gayatri Chakravorty Spivak (Baltimore: Johns Hopkins University Press, 1974), 158.

practice. The gallery-art world, having already learned the trick of expansion and the assimilation of once-excluded modes, proved a more hospitable homeland for much of the sound practice of the late 1980s, 1990s, and 2000s.

I trust I don't need to draw too much attention to the political analogies suggested by this account. Let me simply say that, just as the expanded situation of a given practice includes and is created by social, political, gender, class, and racial exigencies, so too are the responses of institutions, the attitude of a field of cultural activity, the acceptance by critics, academics, and practitioners of a version of a discipline's history. The expulsion from music of sound art is both analogous to politics and *is* politics. Likewise, the acceptance of sound art into the spaces and discourse of the gallery arts is politics in theory and in practice. As such, the history I am detailing here and the revision I am suggesting have implications beyond the apparently limited scope of which tag we append to a practice, which institutions host it, and which critics have a territorial stake in examining it. There is no outside the text, nor is there a safe haven inside the text.

It is impossible to say precisely when and where the expansion of music began. Satie's *furniture music*? Russolo's *intonarumori*? Cage's *4' 33"*? Have we not by now abandoned the dream of beginnings? Max Neuhaus's *Listen*, first presented in 1966, is certainly an expansion of Cage's already expanded notion that all sounds can be music. Neuhaus's expansion, however, moves beyond elasticizing existent musical categories and, instead, expands the master list of categories. Cage's *4' 33"* takes place in a concert hall, at a piano, with a score. Neuhaus's *Listen* consists of leading a group of spectators out of the concert hall and into the streets of lower Manhattan, pausing at certain fruitfully noisy locations to engage in the activity of the piece's title.[33] The trope of the walk figures prominently in the history of sound art. Neuhaus's literal march out of the concert hall echoes

33. Max Neuhaus, "Listen," www.max-neuhaus.info/soundworks/vectors/walks/ LISTEN/ (accessed February 2, 2009).

figuratively in sound art's ramble away from music. The psychogeo-graphic activity of the "sound walk," now a recognized subgenre of sonic practice, conjures the traditions of the *flâneur*, who strolls the city simply to experience it, and the situationist practice of the *dérive*, or purposeless walk through the city.

"What we can't say we can't say, and we can't whistle it either."[34] This was the response of the philosopher Frank Ramsey to Wittgenstein's dictum "That of which we cannot speak we must pass over in silence." As with Rilke's coronal suture phonography, Christina Kubisch's *Electrical Walks* propose that it is possible to encounter a phenomenon—in this case electromagnetism—and to "complete . . . and then experience it, as it makes itself felt, thus transformed, in another field of sense."[35] Kubisch is among the first generation of practitioners whose work didn't have to make the categorical transi-tion from another medium to sound art. Kubisch's career coincides almost exactly with the formation and recognition—in Germany, at least—of sound art as a distinct category of art making. She partici-pated in what is widely held to be the first dedicated sound art exhibi-tion, "Für Augen und Ohren," at the Akademie der Künste in Berlin in 1980. In 2003 she initiated a series of works under the title *Electrical Walks*. These walks, presented in Germany, England, France, Ireland, Sweden, Switzerland, Slovakia, Spain, Japan, and the United States, guide the spectator through the streets of cities and towns, equipped with a pair of specially designed headphones that amplify the hums, buzzes, and gurgles of electromagnetic fields. The piece is enacted by the spectator, who has the option of following a route prescribed by Kubisch or of exploring the city according to her or his own whims. By altering one's proximity and position relative to lighting,

34. Frank Ramsey, as quoted in *The New Wittgenstein*, ed. Alice Crary and Rupert Read (London: Routledge, 2000), 17.
35. Rilke, "Primal Sound," as quoted in Kittler, *Gramophone, Film, Type-writer*, 41.

wireless networks, radar systems, antitheft security devices, surveillance cameras, cell phones, computers, streetcar cables, automated teller machines, neon advertising, public transportation networks, and the like, the spectator engages a range of timbres, intensities, and rhythms. Kubisch and others have discussed this work in terms of revealing a hitherto hidden aspect of the city. The suggestion is that these sounds constitute a kind of secret about—or secret life of—the city. The service provided by Kubisch is not the one typically assigned to composers, painters, and poets, but rather that of scientists, educators, and whistle-blowers: to alert us to the presence of previously undisclosed facts.

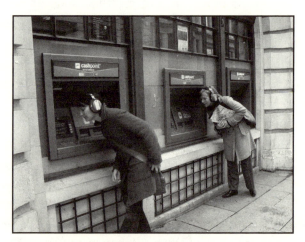

Christina Kubisch, *Electrical Walk Birmingham:* Ikon Gallery, Birmingham, UK. July 25–October 1, 2006. Photo: Helen Legg. Courtesy Christina Kubisch.

But again, just as with Rilke, this longed-for completeness is a fantasy. Not only can it not be achieved with Kittler's "algorithmically formalized data streams," but the aspiration of reattaching the limbs of experience is based on a faulty, unsupportable presumption of the wholeness of a body (spiritual, natural, epistemological, or

phenomenal). Contrary to a phenomenological conception in which these systems and their Kubisch-revealed sounds are adumbrated perspectives of a single entity with a consistent essence, I cannot imagine or name the body to which both would belong. From Aristotle's *praedicamenta* to Deleuze's "wasp-orchid," philosophers have looked to parse experience and phenomena according to categories that give meaning to groupings, constituencies, and bodies. The suggestion that the city-as-body is revealed by Kubisch's headphones ignores disparities in register, function, and intention. (Though we could conceivably ascribe an intention to the machines and systems, it is hard to imagine how the same could be claimed for the specific sounds "discovered" by Kubisch's headphones.) What we have, at some fundamental level, is an encoding problem: the key that encodes these messages, first turning electrical/mechanical processes into voltage signals, is not the same as the key used to decode them as sound. The output of the process is in a different language, indeed a different informational paradigm, than the input. To "read" the work as if it is conveying a message—as if it is the product of a legible intention—seems forced.

If, as some would have it, there are experiences that could be characterized as prelinguistic, then the minute we think or speak them, we rip them from this "pure" state, corrupting them with language. This is problematic on two fronts. First, this idea of inevitable linguistic corruption, analogous to the Christian notion of original sin, would locate most of human experience in falsity or impurity. The concretization of ideas, perceptions, or experience would be tragically contaminated. This is not to argue that language is pure or transparent, but to make a more practical argument. The anthropologist Mary Douglas has defined dirt as "matter out of place."[36] As we are discussing sound, it seems equally plausible to say that noise is sound matter out of place. The implication is that an order, natural or otherwise, pervades human

36. See Mary Douglas, *Purity and Danger* (London: Routledge, 1966).

conceptions of material (visual, sonic, physical, etc.). When a bit of matter falls outside that order or in the wrong state or place within that order, it is regarded as alien, incorrect: dirt or noise. Since being human is a state inexorably tied to language—some would say a state *in* or *of* language—then, presumably, linguisticity is the order that obtains. To call the baseline state of human experience impure—dirty or noisy—is simply nonsensical. The impure can only be identified relative to an established norm of purity. That purity, as I see it, could exist only as a metaphysics. The suggestion of an unadulterated, untainted purity of experience prior to linguistic capture seeks a return to a never-present, Romanticized, pre-Enlightenment darkness. Second, if some stimuli actually convey an experiential effect that precedes linguistic processing, what are we to do with such experiences? My sympathies lie along the axis of Peirce's pragmatism and Wittgenstein's dictum. If there is such a strata of experience, we must accept it mutely. It finds no voice in thought or discourse. Since there is nothing we can do with it, it seems wise to put it aside and concern ourselves with that of which we can speak.

As far as the experience of art is concerned, the revelation of phenomena is not enough. Kubisch's walks may introduce us to a normally inaudible by-product of the city's activities. But what can we do with those sounds? What kind of aesthetic value do they deliver? We could start by making a distinction between epistemological and aesthetic values, suggesting that Kubisch's walks are merely epistemological. But this would imply that epistemology is outside the concerns of art, and I do not believe that. The value of conceptual art, again referring to Peter Osborne's definition, is based on the act of questioning existing definitions. Conceptual art is, therefore, essentially epistemological. So I clearly do not want to argue against an epistemological value to art. Instead, a more productive distinction might be that between textual engagements with works of art versus engagements focused on material or perception. Scanning the history of twentieth-century aesthetics, this distinction makes itself manifest

in the authorial dispositions of artists. This contestation is present in Duchamp's legacy, especially as received, interpreted, and retransmitted by Cage. The trick is to avoid misreading Duchamp's claim that his choice of the readymades was based on a "visual indifference with at the same time a total absence of good or bad taste, . . . in fact a complete anaesthesia."[37] This does not mean that the choice of readymades was merely an act of material replacement: urinal for bust. The readymade is a discursive transformation, an intervention into the *textuality* of art and art history. The intention of the readymade is embodied in the act of nominating the object as art, not in the object itself. The aesthetic value is derived, not from the visual or material qualities of the nominated object as it relates to the tradition of art objects, but from the artistic act as it relates to the tradition of artistic acts. Such an intervention requires more than seeing; it also requires reading and thinking the *text* (the situation) of art. As Duchamp wrote of *Fountain*, the urinal he pseudonymously exhibited in 1917, "He [Duchamp's alter ego, R. Mutt] took an ordinary article of life, placed it so that its useful significance disappeared under the new title and point of view—created a new thought for that object."[38]

Cage's loyalties are divided. *Silent Prayer* and *4' 33"* have an undeniable conceptual content. Much of his work is overtly theatrical, foregrounding the activity of music making and the absurdity of performative categories. But Cage still demands that we "let sounds be themselves, rather than vehicles for man-made theories or expressions of human sentiments."[39] Cage's devotion to sound is a faith in phenomena. In *For the Birds*, Cage proposes listening microphonically to the atomic vibrations of objects. "Object would become process;

37. Marcel Duchamp, "Apropos of 'Readymades,'" in *Salt Seller: The Writings of Marcel Duchamp*, ed. Michel Sanouillet and Elmer Peterson (New York: Oxford University Press, 1973), 141.
38. Marcel Duchamp, "The Richard Mutt Case," in *Theories and Documents of Contemporary Art*, ed. Katherine Stiles and Peter Selz (Berkeley: University of California Press, 1996), 817.
39. John Cage, "Experimental Music," in *Silence* (Middletown, CT: Wesleyan University Press, 1973), 10.

we would discover, thanks to a procedure borrowed from science, the meaning of nature through the music of objects."[40] It is not entirely clear what meaning is discovered here unless vibration and sound, where stillness and silence were expected, could be declared a meaning. This attention to sound, rather than to theories or expressions, takes Duchampian an-aesthesia more literally than it was intended and to an extreme that contradicts its most important implications. Product can be downplayed in favor of process, rendering output—the content and form of the artistic object (including objects such as performances, compositions, and texts)—incidental. Yet this doesn't erase the artist from the work.

As aleatory and systems-generated works make apparent, one must always make a decision on how to begin (or whether to begin at all). Steve Reich's famous piece *Pendulum Music*, from his "Music as a Gradual Process" period, runs into the additional problem of the author's role in the ending of a process piece. Though Reich writes that "once the process is set up and loaded it runs by itself," *Pendulum Music* requires a final authorial intervention.[41] "The piece is ended sometime shortly after all mikes have come to rest and are feeding back a continuous tone by performers pulling out the power cords of the amplifiers."[42] The piece's penultimate state is systematically determined: it ends "shortly after the mikes have come to rest and are feeding back a continuous tone." The piece's final conclusion, however, the cessation of the continuous tone, is supplied not by the system, but by performer choice.

No matter how hard one tries to avoid expression, theories, ideas, or intention, there they are. If, on the other hand, one accepts Barthes's declaration of the death of the author, replaced by Foucault's

40. Cage, as quoted in Douglas Kahn, *Noise, Water, Meat: A History of Sound in the Arts* (Cambridge: MIT Press, 1999), 196.
41. Steve Reich, "Music as a Gradual Process," in Cox and Warner, *Audio Culture*, 305.
42. Steve Reich, *Writings on Music* (Halifax: Press of the Nova Scotia College of Art and Design, 1974), 12–13.

notion of the "author-function," then the problem is converted into a nonproblem. If the author/artist/composer is never the actual or sole source of the text, then why must one intervene to absent oneself from the process? Is that not an authorial intrusion in its own right? Kubisch is part of a tendency in the sonic arts that takes Cage at his word. These artists, performers, and composers try to get out of the way, to "let sounds be themselves." The problem with how the *Electrical Walks* are typically received is not that they are overly or merely epistemological. The problem lies in the acceptance of value in the exposition and translation into sound of electromagnetic fields. These sounds, and the way they are presented, decline to engage the rich cultural, technical, social, ontological implications of their origins. It makes no sense to ignore the text of which they are part; to reject their inherent discursivity in favor of their blunt materiality. The typical reception of the *Electrical Walks*—in articles and catalog copy (much of it written by Kubisch or with her cooperation)—does not investigate the work's premises, including the status of the artistic encounter, institutionality, and the social-performative aspects of the spectator's activity. And the work fails to interrogate the power relations instantiated by the various players in the network of its presentation and reception. There is a tendency, especially strong among sound artists, to say: art is the medium of conveyance for that of which we cannot speak. Words are too specific; language, more broadly imagined, is too bound to its symbolic grid. So the wordless aspects of art allow contact with prelinguistic experience. This is especially true of media and the approaches that promise an encounter with the "real." What this neglects is the reality that art, as a cultural activity with a tradition and conventions—an activity that does not perform in a vacuum, but that necessarily interacts with culture, politics, commerce, and sociality—constitutes and is constituted by a vast meaning-making structure functioning in the manner of a text.

Kubisch's *Electrical Walks* are a signal example of a pervasive tendency in contemporary sonic practice. Let's call it the "sound-in-itself" tendency. The inheritance from Cage is obvious—rather too

obvious, one might say, since much of the work that follows this path takes only partial account of Cage's oeuvre. The failure of this reading of Cage is that, instead of seeing Cage as a remedy for much of music's traditional insularity, music's a-xenophonic stance against foreign sounds, it sucks Cage back into the conventional concerns and attitudes of Western music. The most fecund reading of Cage rejects a simple dialectic of noise and silence, but accepts, as Christoph Cox has written, that "Cage's artistic practice involves a set of paradoxes: the intention of non-intention, the choice of indeterminate means, the artist against artists."[43] The sound-in-itself tendency ignores this reading and accepts Cage one-dimensionally and unproblematically.

The sound-in-itself tendency is especially pervasive in Germany, where sound art is an established practice. Helga de la Motte-Haber, a musicologist with an interest in the expanded field of sonic arts, identifies this tendency, grouping it with a broader movement toward "new ideas of esthetics."[44] She identifies a group of sound artists as emblematic of this movement. First on the list is Christina Kubisch, followed by Rolf Julius, Robin Minard (the one non-German in the group), Ulrich Eller, and Hans Peter Kuhn. She identifies perception as a common concern of these artists, writing that "the concept of perception is undergoing a boom. The term [esthetic] thereby relates to the original Greek meaning: sense perception."[45] In the same publication—timed to coincide with a sound art exhibition at the Stadtgalerie Saarbrücken from June to August of 2006—the curator and publication editor, Bernd Schulz, writes:

We may consider the ear to be closer to the world of the dream and the unconscious than the eye. Yet as the most sensitive

43. Christoph Cox, "Steve Roden: Correspondences," in *Some Reconstructions of Wandering and Inner Space*, Exhibition Catalog (Santa Barbara: Santa Barbara Contemporary Arts Forum, 2002), www.inbetweennoise.com/coxessay.html (accessed February 2, 2009).
44. Helga de la Motte-Haber, "Esthetic Perception in New Artistic Contexts," in *Resonanzen/Resonances: Aspects of Sound Art*, ed. Bernd Schulz (Heidelberg: Kehrer, 2002), 29.
45. Ibid.

organ for the exploration of reality, it connects our inner expe-
rience with the world around us. It is precisely this double
perspective which is investigated to its very limits and with con-
stantly new approaches in the Sound Artists' installations.[46]

Schulz's conception of reality, available in dreams and the uncon-
scious, can be traced back to Cage's faith in discovering "the mean-
ing of nature" in amplification or recordings of the atomic sounds of
objects. It's the same impulse that leads to Rilke's coronal suture pho-
nography and finally to Kubisch's *Electrical Walks*. The "real" implicit
in all these imaginings is to be found inside, at the core, hidden from
view and from hearing, at the heart of (the) matter.

The verb "to record" is a curious composition. The prefix *re* means
"again" (as in "to retell") or suggests a backward movement (as in "to
recall"). The root *cor* comes from the Latin for heart, still evident in the
French *le coeur*. To record, then, is to encounter the heart again or to
move back to the heart. The implication is that a recording captures
and replays the heart of its source. The heart of the thing might be its
life-giving component (as in a biological heart), but more commonly it
indicates an essential, fundamental disposition. When we remember
something verbatim, without recourse to clues or aids, we remember
it "by heart," as if it is now inextricably inside us, part of us. In its
own linguistic body, "to record" carries both the sense of essential
physiology and of the nonphysiological essence, something akin to
the soul.

This dual character of recording is to blame for the uncanniness
that marked early encounters with sound recordings. Edison himself
was spooked by the phonograph:

This tongueless, toothless instrument without larynx or phar-
ynx, dumb, voiceless matter, nevertheless utters your words,
and centuries after you have crumbled to dust will repeat

46. Bernd Schulz, "Introduction," in *Resonanzen/Resonances*, 17.

again and again to a generation that will never know you, every idle thought, every fond fancy, every vain word that you choose to whisper against this thin iron diaphragm.[47]

Edison's unsettledness in the face of this mouthless voice seems to be as much about what lies at the heart of being human—idle thoughts, fond fancies, vain words—as about reproductive capacities of the technology. Nevertheless, it is the apparently faithful capture and redistribution of this heart that troubles him.

Douglas Kahn observes how, before the advent of sound recording, a person could only experience his or her own voice "in large degree through bone conduction; it is generated in the throat and carried via the bones in the head to the inner ear." The experience of one's own recorded voice is, however, boneless: "the phonographed voice returns to its parent through air conduction, that is, without the bones. The phonographed selfsame voice is deboned."[48] This deboning underscores the possibility (if not, indeed, the necessity) of a Derridean critique of the centrality, veracity, and authenticity of the relation of sound to the body. As Kahn puts it:

Phonographic deboning is, therefore, a machine-critique of Western metaphysics a century before Derrida's critique of Husserl, for it uproots an experiential centerpiece for sustaining notions of the presence of the voice—hearing oneself speak—and moves the selfsame voice from its sacrosanct location into the contaminating realms of writing, society, and afterlife.[49]

47. Edison, as quoted in Kahn, *Noise, Water, Meat*, 93.
48. Douglas Kahn, "Death in Light of the Phonograph: Raymond Roussel's *Locus Solus*," in *Wireless Imagination: Sound, Radio, and the Avant-Garde*, ed. Douglas Kahn and Gregory Whitehead (Cambridge: MIT Press, 1992), 93.
49. Kahn, *Noise, Water, Meat*, 93–94.

We are not obliged to engage one of Kubisch's *Electrical Walks* as a backstage pass granting sonic access to the "real." The walks send people (bodies) out into the city, highlighting the private/ public nature of urban life. The oversized, industrial headphones that Kubisch employs draw the attention of both the spectator/participant and uninvolved pedestrians. The immersive isolation of headphone culture is made evident. The wearer of the headphones becomes self-conscious, aware that the activity demanded by the *Electrical Walk* does not fulfill any of the typical roles for people moving through the city. Considered along these lines, the *Electrical Walks* engage a slew of concerns having little or nothing to do with the sonic. The "real" in play is sociality, the formation of identity in the metropolis according to predefined actions, functions, and occupations. What is real is the encounter with other people, other bodies, each preoccupied with her or his own set of goals, predispositions, and capacities. In the aberrant context of the *Electrical Walks*, the relation of self to other is determined by the interconnected grids of social, gender, economic, and political positions. This is the *Electrical Walks'* aesthetic value. The crucial encounter is not with sound-in-itself, but with catego-ries of experience and identity; with questions of the naturalness or normality of a class of activities; and with other selves engaged in their own categories, experiences, questions, and activities. Instead of the paradoxical muteness of sound-in-itself, we have the loqua-ciousness of multiple symbolic grids, their overlapping matrices cas-cading into infinity.

5

SOUND-IN-ITSELF

"God is a comedian playing to an audience too afraid to laugh." This quip, attributed to Voltaire, is displayed on the message board outside the Judson Church in New York. Inside, Francisco López presents his *Buildings [New York]*.[1] The performance is constructed of recordings of "machine rooms, elevator shafts, and heating systems of the city's office and residential buildings."[2] Before he begins, López announces that the experience might become quite intense. "Don't worry," López assures the audience; "I know what I'm doing."[3] Born in Madrid in 1964, López is a member of the next generation of sound artists after Christina Kubisch. He is exceedingly prolific, having released hundreds of recordings since 1993. He is also an outspoken proponent of fundamentalist Schaefferianism, going to great lengths to advocate an acousmatic approach to the production and reception of the sonic arts. When he performs live, López is very particular about how the performance space is organized. He refuses to play from a stage. To avoid the inevitable difference between the sound of stage monitors and the main-room PA system, and not wanting to cede control of the final sonic result to a sound engineer in charge of the live mix, he locates himself and his gear in the midst of the audience. He objects to making the performer the visual focal point of an electronic music performance. The audience is arranged around him in concentric circles, their backs turned to him, facing an array of speakers (the Judson Church performance featured eight speakers

1. Program notes for Francisco López, *Buildings [New York]*, Ear to the Earth Festival, Judson Church, New York, October 10, 2008, unpaginated.

2. Program notes for Francisco López, *Buildings [New York]*, unpaginated, www.emfproductions.org/pastevents0809/lopez.html (accessed February 2, 2009).

3. Francisco López, Pre-performance remarks, *Buildings [New York]*, Ear to the Earth Festival, Judson Church, New York, October 10, 2008.

123

on stands) arranged along the perimeter of the space. He darkens the room and, to truly minimize the visual, obscures his panoply of gear under a dark fabric cloak. As extreme as this may seem, it comes off as redundant when López "strongly suggests" that each member of his audience wear a blindfold—supplied by López—for each performance.[4]

In the program notes for the performance, López writes, "Every listener has to face his/her own freedom and thus create."[5] The freedom López wants us to face is curiously compromised by his setup. Though situating himself in the center of the audience may alleviate the two-mix problem, this arrangement also insures that only López is entitled to hear the complete surround-sound mix. Every audience member is forced to occupy a compromised position in the sonic field, closer to one or two speakers than the rest. For the audience, turning their backs on the performer puts them in an implicitly vulnerable position, akin to Jeremy Bentham's panoptic prison design, in which prisoners may be observed by a central warden while the warden himself is invisible to the prisoners. Michel Foucault famously saw the panopticon as a metaphor for the diverse institutions of modern disciplinary society, bent on observation and control.[6] Donning blindfolds only exacerbates the instantiated power relation, creating a kind of *pansonicon*. At a performance just two miles from the site of the World Trade Center, in the midst of the U.S. War on Terror, in the wake of revelations of abuses at Abu Ghraib and at Guantánamo Bay—the whole scenario takes on sinister overtones. This is not to suggest that López intends to lord menacingly over his audience, but that he seems blissfully (if problematically) naive regarding the connotations of his extended text.

He approaches his recordings similarly. Since 1997 nearly all his compositions have been untitled and released in Slimline cases with

4. Ibid.
5. Program notes for López, *Buildings [New York]*, unpaginated.
6. Michel Foucault, *Discipline and Punish: The Birth of the Prison* (New York: Random House, 1975).

minimal text or imagery.[7] López's work is composed from field recordings he makes in locations ranging from Patagonia to the Costa Rican rain forest to the interiors of urban buildings. He also uses found and sampled sounds such as insects (he is a trained entomologist), human voices, and heavy metal bands. Regardless of the sound source, López manipulates the recordings to arrive at sound works intended to be devoid of semiotic attachments to identifiable referents.

I have a completely passional and transcendental conception of music. Of course, I have lots of ideas about the world and politics and whatever, but I think these things shouldn't contaminate, shouldn't pollute, the music. I'm very purist.

López the purist maintains the literally nonsensical fear of the defiling influence of language and signification, what Douglas Kahn calls "the contaminating realms of writing [and] society."[8] He seeks an unsullied, prelinguistic, anodyne relation with sound.

López . . . is critical of what he calls the "dissipative agents" of music, which is anything that distracts attention from the pure matter of sound: language, text, image, referentiality, musical form and structure, technique and process, instrumental virtuosity, etc.[9]

In López's system of sonic order, these "dissipative agents" are the impurities, the noise, the dirt. His work tries to avoid the unavoidable: the linguistic structure of experience. López represents an acute version of the sound-in-itself tendency. He has written critically of

7. Christoph Cox, "Abstract Concrete: Francisco López and the Ontology of Sound," *Cabinet*, 2 (Spring 2001), www.cabinetmagazine.org/issues/2/abstract-concrete.php (accessed February 2, 2009).

8. Douglas Kahn, *Noise, Water, Meat: A History of Sound in the Arts* (Cambridge: MIT Press, 1999), 93–94.

9. Cox, "Abstract Concrete."

Cage's legacy,[10] citing Pierre Schaeffer's reduced, acousmatic listening as the true precedent for his practice.[11] In so doing, he inadvertently highlights the common ground shared by Cage and Schaeffer. Both can be seen to be interested in sound-in-itself, not in sound's source, nor its semiotic capacities, nor the implications of its status as the result of colliding material in the world. López's objection to Cage is "procedural." López believes that the Cagean premise of "letting sounds be themselves," manifest in Cage's aleatory techniques, is an abdication of aesthetic responsibility. What Cage's method lacks, according to López, is intentionality:

> When Cage equates music to sounds, it either destroys the entity of music in an unconscious reductionism to pure physics or denies the possibility of non-musical existence of sound, which, in the end, are equivalent. . . . The essential difference, what converts a sound into music, is a human, subjective, intentional, non-universal, not necessarily permanent, aesthetic, decision.

On the other hand, López sees Schaeffer's method as similar to that of a painter. He starts by creating a palette of sounds. He applies a dab of this, a wash of that. His "hand" is evident. What the listener relates to is not simply the sound, but also the evidence of the artist's intentions as manifest in the sounds and their organization. Again, this ignores the exigencies of authorship. Cage's compositional practice, even at its most aleatory, is not intentionless. The very attempt to erase intention is an intention in itself. Both the naive Cageans on the one hand, and critics like López on the other, are too gullible in taking

10. See Francisco López's "Cagean Philosophy: A Devious Version of the Classical Procedural Paradigm" (December 1996), www.franciscolopez.net/cage.html (accessed February 2, 2009).
11. See Francisco López's "Schizophonia vs l'objet sonore: Soundscapes and Artistic Freedom" (January 1997), www.franciscolopez.net/schizo.html (accessed February 2, 2009).

Cage at his word. Perhaps the fault lies with Cage for not imbuing his word and work with a sly Duchampian wink. But as post–death-of-the-author readers (listeners, spectators), the onus is on us to plant our tongues firmly in the receptive cheeks of our ears.

It is López's insistence on intentionality that allows him to claim:

> It's not "sound for the sake of sound." I do not defend sonic matter as an aesthetic or conceptual category, but as a gate to different worlds of perception, experience and creation. Sound is a fiercely powerful medium, in the original sense. This raw primordial quality is easily lost in the mud of contemplation.[12]

Prioritizing intention does not exclude a practitioner from the sound-in-itself tendency. Intention is an irreducible given of artistic production — maybe the *only* irreducible given. Despite his cursory protestations to the contrary, López is essentialist to the extreme. He imagines sound as a "medium, in the original sense." (I suppose he means something like "a transmitting substance.") Sound, imagined as a transmitting medium, would necessarily include the idea of a message or content being transmitted. Sound, then, is semiotic. It is not primordial in the Husserlian sense. In his critique of Husserl, Derrida points out: "In phenomenology, the idea of primordial presence and in general of 'beginning,' 'absolute beginning' or *principium*, always refers back to this 'source-point.'"[13] The source-point is the now, the blink of an eye, the *Augenblick*. Derrida deconstructs the notion of the *Augenblick*. The now cannot exist devoid of retention (memory) and protention (expectation).[14] Without the necessary instantaneousness of the now,

12. Francisco López, "Against the Stage" (February 2004), www.franciscolo-pez.net/stage.html (accessed February 2, 2009).

13. Jacques Derrida, *Speech and Phenomena and Other Essays on Husserl's Theory of Signs*, trans. David B. Allison (Evanston: Northwestern University Press, 1973), 61–62.

14. See Jacques Derrida, "Signs and the Blink of an Eye," in ibid., 60–69, passim.

Husserlian self-identical presence is inconceivable. No encounter, even that with the self, is self-evident. All experience is the process of differance.

If we are talking about sound, then we have to readjust our anatomy. It is not the eye but the ear that does not blink. The *Ohrenblick* is not provided for anatomically. It's just as impossible philosophically. What López calls "the mud of contemplation" is the necessary process of encounter with sound as it functions in and as a complex of symbolic grids. It may be muddy, but the residue it leaves is meaning. In spite of—but also because of—López's best efforts, interest in his work is largely a product of textuality, narrative, the interaction of sound-in-itself with the symbolic grid. It is the story that López tells with his setup and his justifications that grant the work whatever allure and meaning it might maintain. If we could do the impossible and somehow dispense with these "dissipative agents," we would be left to wallow in a different kind of mud: a stultifying quicksand, engulfing thought, imagination, conversation, and community. Sound, as López imagines it, clogs in the ears, preventing entry to or exit from the brain. Perhaps the term "sound sculpture" is an apt way to describe this practice. If López's sonic ideal could be realized, the blindfolded listener would be reduced to the muteness, blindness, and opacity of clay.

Although López's sound-in-itself tendencies are not an isolated incident in contemporary sound practice, the fundamentalism of his approach and his written justifications render his work uniquely unavailable to non-cochlear recuperation. Still, there are many examples of sound works that avail themselves—sometimes as the result of conditions the artist could not have anticipated—of both sound-in-itself and non-cochlear readings. For example, over the course of six months in 1999, Stephen Vitiello made a series of recordings on the ninety-first floor of the World Trade Center. Vitiello, who had been awarded a residency in an unoccupied office in Tower Number One, fastened contact microphones to the windows. With the vertiginous glass curtain acting as a distended microphonic diaphragm, he

converted one of the world's tallest buildings into the world's largest microphone. The resulting recordings depict a sound world beyond the reach of most human beings, beyond even the reach of most of humanity's edifices. We hear wind and street traffic, the bellow of a ship in New York harbor. We are surprised to be able to pick out an occasional voice from the streets a thousand feet below. Unsettlingly, there are several planes in proximal airspace. On recordings made the day after New York was lashed by Hurricane Floyd, the building can be heard creaking "like an old wooden ship,"[15] straining against the torquing of its frame in the howling gales.

Stephen Vitiello, *World Trade Center Recordings*, 1999. Photo by Johnna MacArthur. Courtesy Stephen Vitiello and the Project, NYC.

15. Stephen Vitiello, interview, *Studio 360*, National Public Radio, www.stephenvitiello.com/mp3/nprpieceonwtc.mp3 (accessed October 14, 2008).

Vitiello's initial interest in these recordings may have been simply for the sound-in-itself, as explorations of a rarified sonic environment. Much of his work involves field recordings and straightforward presentational strategies, with little attempt to engage the overt textuality of sound's sources and situations. But now it would be foolish to suggest that these recordings can be heard in the mode of sound-in-itself. The destruction of the towers gives these recordings a monumental gravitas and demands that attention be paid to the intertextuality latent in all sound. Vitiello's World Trade Center recordings act as aural portraits of the world pre-9/11. They are portraits painted at the very location of transformation, perched on the fulcrum between the then and the now delineated by the date 9/11. From the perspective of now, these portraits fulfill one of the original promises of Edison's invention of audio recording. In *The Phonogram*, published in 1893, Edison described the ten uses he imagined for his new device, such as a "'Family Record,' a registry of sayings, reminiscences, etc., by members of a family, in their own voices: and of the last words of dying persons."[16] Vitiello's recordings are the reminiscences of the fallen towers "in their own voices," the last words, not of the legion dead, but of the buildings themselves, of the architecture that, for the terrorists, symbolized America's capitalist empire, and which now, for the rest of us, symbolizes the multitude lost and the zero from which the new world begins to reaccumulate itself. Vitiello's World Trade Center recordings are symbolic representations of symbolic representations; texts about texts. This is no truer of these recordings than any other. It's just more obvious.

Vitiello's recordings accumulate their most important textual meanings after the act of creation. The recordings were, in a sense, rerecorded when the towers fell. Though sonically identical after 9/11, the recordings became more complex, more emotionally and

16. Thomas Alva Edison, as quoted in Jacques Attali, *Noise: The Political Economy of Music*, trans. Brian Massumi (Minneapolis: University of Minnesota Press, 1985).

intellectually potent—like the text created by Pierre Menard, Jorge Luis Borges's character who rewrites, word for word, "the ninth and thirty-eighth chapters of part one of Don Quixote and a fragment of the twenty-second chapter."[17] Vitiello's World Trade Center recordings now exist as a radically rewritten, yet identical, text. Quoting from Menard's version of the Quixote (which, remember, is the same as Cervantes'), Borges writes of

> "truth, whose mother is history, rival of time, depository of deeds, witness of the past, exemplar and adviser to the present, and the future's counselor."
>
> History, the mother of truth: the idea is astounding. Menard, a contemporary of William James, does not define history as an inquiry into reality but as its origin. Historical truth, for him, is not what has happened; it is what we judge to have happened.[18]

Vitiello's World Trade Center recordings are rewritten by history, while at the same time rewriting history. History is the mother of truth, not the other way around. What is written or spoken or recorded determines what happened. That story is always the product of differential forces at play within the text. It is constantly subject to change, adaptation, co-optation. The extended text of any work of art, sonic or otherwise, is a result of history and of other stories and cultural pressures. No matter what precautions the text takes, no matter what rationalizations it offers, it cannot cordon itself off, inviolate, and pretend to be unto itself.

Vitiello's engagement with the text of history was prospective: the World Trade Center recordings precede the event that eventually inscribes their meaning. In the case of Jacob Kirkegaard's *Four*

17. Jorge Luis Borges, "Pierre Menard, Author of the Quixote," in *Ficciones*, trans. Anthony Bonner (New York: Grove, 1962), 48.

18. Ibid, 53.

Rooms, from 2006, the historical engagement is retrospective. *Four Rooms* moves back in time to engage an already written historical event. The piece consists of four recordings of the room tone (the usually inaudible hum created by interaction of local sounds with the dimensions and materials of a particular room) in four abandoned rooms in the city of Chernobyl, the site of the worst nuclear accident in history. Each of the initial recordings is then played back over a pair of loudspeakers into the same room in which it was recorded, and it is rerecorded. This process is repeated multiple times, the room tone reinforcing itself into amplified audibility. Christoph Cox has written eloquently about *Four Rooms*:

> The depopulated rooms recorded by Kirkegaard are pro-
> foundly overdetermined by the nuclear disaster that, twenty
> years earlier, forced their sudden evacuation. Thus, the drones
> that emerge from these rooms are, presumably, inflected by
> the radioactive particles and electromagnetic waves that still
> invisibly move within them. They are also haunted by the
> human beings that once inhabited them.[19]

The overdetermination that Cox identifies is the product of a multitude of overlapping symbolic grids. As listeners, the inflection we hear is not precisely that of radioactive particles and electromagnetic waves but of the story, the history, of them: the radioactive, electromagnetic *text*. We hear the hum of Kirkegaard's piece through the filter of what we know about Chernobyl. What we hear is haunted not by the actu- ality of the human beings who once inhabited the rooms but by their histories and by history. The actual is constituted by the intertwining texts of the sound, not in and of itself, but of what it takes from and gives to the stories that accompany it. What we are left with is *an* actuality, not *the* actual.

19. Christoph Cox, "Sound Art and the Sonic Unconscious," *Organised Sound* 14(1): 2009, Cambridge University Press, p. 25.

In the sonic arts, you can't swing a cat without hitting sound-in-itself. Though López takes his cues from Schaeffer, many others look to Cage for their wellspring of inspiration. Beginning in the late 1940s, Cage's influence began to have significant reverberations in music. Throughout the fifties Cage's example grew in importance, extending to the worlds of the visual arts and experimental dance via his work at Black Mountain College and his course in composition at the New School for Social Research in New York. La Monte Young first encountered Cage's music and writings at Karlheinz Stockhausen's course at Darmstadt, Germany, in the summer of 1959. The evolution of Young's practice serves as a primer on the multiple ways one might engage, interpret, and apply Cagean ideas. Almost immediately following his return from Darmstadt, Young began a series of numbered pieces entitled *Composition 1960*. These consist of text scores that expand the materials and situations of a musical performance in unexpected ways. *Composition 1960 # 2* instructs the performer to "Build a fire in front of the audience."[20] The score goes on to describe the preferred materials and size of the fire, the positioning of the "builder(s)," and the possible use of a microphone for broadcast. The score for *Composition 1960 # 5* begins: "Turn a butterfly (or any number of butterflies) loose in the performance area."[21] Depending on the available time, the doors and windows of the performance space may be opened, and the piece "may be considered finished when the butterfly flies away."[22]

These compositions show Young feeling suddenly liberated, licensed by Cage's example to dispense with twelve-tone orthodoxy and to move straight past traditional musical materials into a radically expanded field of compositional activity.

20. Michael Nyman, *Experimental Music: Cage and Beyond*, 2nd ed. (Cambridge: Cambridge University Press, 1999), 83.
21. Ibid., 84.
22. Ibid.

Young related his *Compositions 1960* to Cage[,] whose later works "were generally realised as a complex of programmed sounds and activities over a prolonged period of time with events coming and going. I [Young] was perhaps the first to concentrate on and delineate the work to be a single event or object in these less traditionally musical areas."[23]

Cage's influence was disseminated by many artists. As suggested earlier, Robert Morris was one of the first to import Cage's ideas to a gallery art context. Young's receipt of Morris's adaptation of Cage's example points to his interest in the overflow of composition beyond the boundaries of the musical field. *Composition 1960 # 10*, dedicated to Morris, consists solely of one instruction: "Draw a straight line and follow it." The text is so indeterminate that the performer must, in essence, compose the piece, rewriting the score for his or herself first, concretizing the idea of drawing a line and, more critically, of following it. Following this act of recomposition, the performer then executes the rewritten score. When Nam June Paik performed the piece in 1962 (not just rewriting it, but actually retitling it "Zen for Head"), he dipped the top of his head into a bucket of ink and then crawled along a roll of white paper, head to the ground, thereby following the line by drawing it. But just as Young was expanding his definition of "music" and "composition," he was also imposing significant constraints on the development of his own practice, paring down to a claustrophobically reduced set of materials and approaches. Each of his twenty-nine pieces bearing the title *Composition 1961* consists of the same score as *Composition 1960 # 10*: "Draw a straight line and follow it."

Young is frequently counted among the first of the so-called minimalist composers, along with Terry Riley, Steve Reich, and Philip Glass. But that designation is rarely assigned relative to the *Composition 1961* series. Perhaps that is because the materials of *Composition*

23. Dave Smith, "Following a Straight Line: La Monte Young," *Contact* no. 18 (Winter 1977–78): 4–9, www.users.waitrose.com/~chobbs/smithyoung.html (accessed February 2, 2009).

1961 are not conventionally musical. Instead of dramatically extend-
ing the duration of single notes (as Young would later do with his
drone works), or repeating overlapping musical cells (as Riley, Reich,
and Glass would do in their work of the mid- to late 1960s), Young
repeats the score itself, implying that any formal development, any
theme or variation, will take place in the movement from one interpre-
tation, one performance, of the work to the next. At the same time,
Composition 1961 establishes a recursivity dependent on a reading of
the work within an expanded definition of musical practice. In Western
music, the interpretive act of performance comes after the score has
left the composer's control. (Even in cases where the composer per-
forms or conducts her or his own work, this activity, as conventionally
imagined, is no longer part of the composition process.) But Young, in
the wake of Cage's development of aleatory processes, extends the
compositional act into an act of performance. By repeating the score
of *Composition 1960 # 10* twenty-nine times, Young is performing the
score: he is following the straight line drawn by the initial score: he
is initiating the drawing of another straight line each time he repeats
the initial score. Repetition is the straightest line imaginable, another
of the same, another of the same, ad infinitum: no swerves, no diver-
sions, no detours, no tangents. The straightness of each repetition
follows the previous repetition: drawing a straight line and following it.
The reverse is equally true. If we accept that each time Young com-
poses an iteration of *Composition 1961* he is performing *Composition
1960 # 10*, then each performance also circles back as an act of com-
position. Again, as already discussed in chapter 2, this conundrum is
produced by the intrinsically a posteriori ontology of the score, which
must always follow from some material realization of itself, arriving
after the fact to dictate the fact. It is no doubt apparent that all of this
musical activity takes place, as composition often does, out of ear-
shot, in utter silence.

 Another of Young's 1960 compositions can be seen as a turning
point, from a conceptual engagement with Cage's aesthetics, focused
on compositional methodology and a non-cochlear engagement with

sound and music as categories, to a material engagement with Cage's proclamation to let sounds be themselves. *Composition 1960 # 7* consists only of the notes B and F-sharp, "to be held a long time."[24] By 1963, Young had abandoned text scores and their process-based recursivity, devoting himself to long microtonal drones in a project called the Theatre of Eternal Music. Since that shift, Young's ongoing obsession has been tuning. He is interested in the pitch divisions that fall between the half-steps of the Western scale—between the keys of a piano. The intervals possible within such microtonality facilitate effects not available to Western music. The vibrations caused by certain intervals create audible "difference tones," psychoacoustic ghost notes not present in any of the traditional Western instrumental voices. As an alternative to Western music's fixation on harmony—cast in stark relief during the 1920s and '30s by the twelve-tone technique of the Second Viennese School—Young and Tony Conrad, his collaborator in the Theatre of Eternal Music, "focused upon the intersection of intonation . . . and intervallic (rather than harmonic) listening."[25] As Cage had discovered a fascinating variety of sonic detail in what had been considered silence, Young and Conrad discovered a similar abundance in the apparent simplicity of limited musical materials. Young's listening-derived compositional practice is a deep, immersive interaction with sound-in-itself, with the plurality of sounds inherent in any single sound.[26]

In his "Lecture 1960," Young imagines the two approaches, non-cochlearity and sound-in-itself, as interrelated: in essence one justified the other: "It didn't seem to me at all necessary that anyone or anything should have to hear sounds and that it is enough that they exist for themselves."[27] A non-cochlear sound practice, as Young conceived it in 1960, would be validated by the fact that sound has

24. Nyman, *Experimental Music*, 83.
25. Tony Conrad, as quoted in Kahn, *Noise, Water, Meat*, 230.
26. This observation is borrowed from ibid., 232.
27. La Monte Young, as quoted in Branden W. Joseph, *Beyond the Dream Syndicate: Tony Conrad and the Arts after Cage* (New York: Zone Books, 2008), 94.

no need of listeners. Sound exists in and for itself. With his part-
ner, Marian Zazeela, he now operates the Dream House, an ongoing
sound-and-light installation in lower Manhattan. The Dream House's
exceedingly long, ideally never-ending drones continue regard-
less of the presence or absence of listeners. Paradoxically, Young
non-cochlearity is actually a radical adherence to sound-in-itself.
Dispensing with the need for listeners, it posits sound as an organism
with its own reason for being. Young's role is to gestate pitches into
existence and then, essentially, to feed and nurture them, allowing
them to flourish in the incubating environment of the Dream House,
going about their business, growing in complexity. Sound, imagined
this way, is primordial, phenomenal, material. Young couldn't care
less about the symbolic grid. His sounds have no textual, no signify-
ing, status. They are not just non-cochlear, but are also mute in rela-
tion to concerns beyond their intervals.

If an ear is required for Young's music, it is not the receiving ear
but the producing ear; it is Young's ear that is required to establish
the specific desired pitches. Douglas Kahn relates an incident from
Young's performance at *Documenta 5* in Kassel, Germany, in 1972:

> He stopped the performance to berate two people who had
> begun to move with the music and explained later that he
> needed to set an example to instruct people on the discipline
> needed for listening: "Otherwise, there'll be people rolling
> around and doing all sorts of things. You see any movement
> in space moves the air and moves the frequency. And we're
> trying to get the frequencies in tune and they're moving the
> air, so we can't hear."[28]

It is clear that "the discipline needed for listening" refers to Young's
listening. If he is to bring the desired sounds to life—like some obses-
sive Dr. Phonicstein—the apparently incidental audience mustn't

28. Young, as quoted in Kahn, *Noise, Water, Meat*, 233.

interfere. Young's post-text score version of a non-cochlear practice certainly does not expand the situation of music. On the contrary, it prunes it to a core of strictly controlled parameters. Although informed by Cage's example, Young ends up with a reduced listening practice strikingly similar to Schaeffer's—focused on objectified sound entities, areferential and severed from any interaction with extramusical infections, the dissipative agents of sociality, politics, or culture.

Once upon a time, popular music was the music of the populace. As opposed to the official music of the state or the church, the people had their own tunes, their own lyrics, their own instruments and techniques. As such, popular music was an oppositional music, a sometimes explicit and sometimes implicit act of resistance to the message embedded in the music of power. But as imperious power is replaced by commodity power, the mode and manner of popular music is converted into a style, complete with an attendant industry and marketplace. The popular is pruned of its thorns and remade as a sometimes explicit and sometimes implicit musical vehicle for the values and power of the dominant culture. The marketplace becomes the voice of the majority. Since its inception, rock and roll has flip-flopped between partaking of power and resisting it. When Muddy Waters first switched on his amplifier to be heard above the chatter of the patrons of the Macomba Lounge, rock and roll announced its intentions. This was not a music bent on tenderly caressing the ear. Rock and roll was born as a challenge: to the ear, to musical values, to the dominant paradigm. But culture and its commodity impulse constantly chase rock and roll down and reintegrate it into the mainstream. The history of rock and roll's artistic growth could conceivably be charted by identifying the moments when a new challenge to the accepted version of the form rises up from its unlikely nether reaches. The blues provides early rock and roll with models for both its architecture and its stance, rejecting (or simply ignoring) many of the cardinal values of Western music. Rather than emphasizing development and progress, the blues form is endlessly repetitive, cycling through

the same chord progression from start to finish. James Snead attributes these differing formal attitudes to the cultural traditions from which they emerged. The seeds of Western music's fixation on progress are rooted in a Hegelian conception of history. The repetition of the blues, on the other hand, is based in the cycles of ritual:

> In European culture, repetition must be seen to be not just circulation and flow but accumulation and growth. In black culture, the thing (the ritual, the dance, the beat) is "there for you to pick it up when you come back to get it." If there is a goal (*Zweck*) in such a culture it is always deferred; it continually "cuts" back to the start, in the musical meaning of "cut" as an abrupt, seemingly unmotivated break (an accidental *da capo*) with a series already in progress and a willed return to a prior series.[29]

Snead's essay "Repetition as a Figure of Black Culture" creates a series of sweeping cultural oppositions: black versus white, African versus European, repetition versus linear progress. Of course, ideas and influences are not so easily segregated. Each distinction is rife with exceptions. Nevertheless, Snead does provide a set of values by which we might account for the traditions of Western composed music, the blues, and rock and roll. Repetition, less focused on a goal, a telos, bases its values on return, on recovery. Snead's notion of the "cut" becomes central to an aesthetics of repetition. The importance of the work is not in the material itself. In the blues, the chord progression, the number of bars, the melodic content, the slate of likely lyrical concerns—these are all known in advance by both performer and audience. To a large extent, the blues taps into an already-existing iconic form. This is another level of the repetition the blues initiates: repetition of the tenets of the form itself. The importance of the repetitious

29. James A. Snead, "Repetition as a Figure of Black Culture," in *Black Literature and Literary Theory*, ed. Henry Louis Gates Jr. (New York: Methuen, 1984), 67.

work is in how and when the cut occurs, and in how the meaning of the whole is affected with each cycle, each cut, each return.

Western music has long employed the formal conceit of theme and variation, in which an initial musical statement is repeated with modifications, giving the overall structure thematic unity while introducing a sense of forward movement. In repetitious music the theme and variation are achieved not by modifying the initial statement but simply by repeating it. It is the circumstances of listening that have changed. We hear the second iteration in relation to the first, and the third in relation to the second and the first. What's more, we hear the third in relation to what we expect from the fourth. Memory and expectation—neither of which are actually audible—are part of the listening experience. Other factors contribute to this play of repetition and difference. The listener's capacities and circumstances are brought to bear upon the experience of form. To a greater extent than composed music in the Western tradition, repetitious music is produced for reception. The structure of a piece of composed Western music can be identified in the work itself, recognizable to the trained eye in even the unperformed score; but the structure of repetitious music is largely a product of the listener's apperception, grasping the work's formal structure by comparing each iteration to the listener's already-formed body of knowledge and experience, which at each moment includes previous iterations and anticipated future iterations.

It's easy to see how these ideas about music and listening can push in the direction of sound-in-itself and phenomenology. Cage had advocated for relocating the act of composition from the site of production to the site of audition. In a piece like *4' 33"*, the composer has no say over the sonic content of the piece. It is the listener who must identify the sound, the music. But as I will argue in chapter 6, the perceived sound of a performance of *4' 33"* is secondary to the "noise" it creates in the circuits of music as a category. It is possible, then, to read *4' 33"* as profoundly repetitious and, therefore, not primarily an encounter with sound-in-itself but with sound-as-text. Experiencing a performance of *4' 33"* is akin to snapping off sonic portraits of the

environment of the concert venue in rapid succession, constantly refreshing content like a manic Web page. Each snapshot is identical, in a sense the same space heard from the same location within that space. What changes is time and the listener's location, not in space, but in the field of the work-as-text. By 1' 33", the listener has already leafed through the preceding 1' 32", constantly comparing each moment to previous moments, to the gestalt of the accumulation of those moments, and to moments still on the horizon.

The title *4' 33"* reinforces this mode of reception by drawing attention to the second-by-second sequence of the piece. At each juncture, the listener knows precisely how many more seconds to expect. Listening to *4' 33"* as part of the tradition of repetitious music and not as part of the Western tradition allows us to hear the "cut." It is not necessarily the producer, the editor, the mixer, the DJ, who manufactures the cut. As with the act of reading—in which we jump back and forth between our present location in the story and previous events, previous sentences, in which we occasionally drift forward, accessing the titles of upcoming chapters, glancing at a phrase on the next page, assessing the number of remaining pages—the act of listening jumps back and forth in time. Thus *4' 33"* makes us aware that the listener-manufactured cut is unavoidable. It is an essential component of the process of making sense of any sonic text, any experience. Such cutting creates fissures, rips, and ruptures in the time, space, and experience of the text. Different sections and different modes of absorption of the text are folded together in the listening/composing mind of the listener. The result is an unauthored content produced by elision and collision.

> European culture does not allow "a succession of accidents and surprises" but instead maintains the illusions of progression and control at all costs. Black culture, in the "cut," builds "accidents" into its *coverage*, this magic of the "cut" attempts to confront accident and rupture not by covering them over but by making room for them inside the system itself.[30]

30. Ibid., 67.

Again, it is reductive to so conclusively equate a given tendency with a given culture. Western thinkers, including Viktor Shklovsky, Roland Barthes, and Gilles Deleuze, have each theorized and championed the cut within the context of their own fields of concern and discourse. African-American composers from Will Marion Cook to Duke Ellington to Julius Eastman have contributed to the development of Western composition.[31] Still, recognizing the values inherent to repetitious form and the notion of the "cut" helps us parse the ways in which rock and roll separates itself from the instantiated presumptions of Western music.

When rock and roll boiled up from underneath the sedate strata of postwar, Tin Pan Alley songcraft, popular music reclaimed its status as tweaker of official mores, a wrench in the cultural works. African-Americans, only eighty years removed from slavery and still excluded from the institutions of power, wealth, and education, suddenly found themselves at the center of an interracial upheaval. Not only were white kids clamoring to hear their songs on the radio and occasionally venturing into traditionally black venues to see the artists perform, but the artists themselves—in some cases—were also making money, earning respect, gaining economic and social mobility. The lure of the music, combined with the lure of a buck, forged alliances like those between the Chess brothers and Muddy Waters. The great upheaval of Elvis Presley was not about his shaking hips on national television; it was about the realization of the fears underwriting the legend of Sam Phillips's discovery of Elvis. The story—that Phillips vigorously denied—is that Phillips claimed he could make a million dollars if he could find a white man who sang black rhythms with a black feel. In a 1978 interview with the *New York Times*, Phillips said, "That quote is an injustice both to the whites and the blacks. I was trying to establish

31. In the introduction to a performance at Northwestern University, included on the CD *Unjust Malaise* (New World Records, 2005), Eastman explains his idea of "organic music": "The third part has to contain all of the information of the first two parts and then go on from there." This is what Snead calls "progress within cycle, 'differentiation' within repetition." See Snead, "Repetition as a Figure of Black Culture," 65.

an identity in music, and black and white had nothing to do with it."[32] Perhaps the story is untrue. Phillips's denial is a denial of the suggestion that he was exploiting black culture for financial gain, that, rather than hitching his wagon to a black artist, he cynically discovered an acceptable white vehicle for "the unlimited possibilities, and untapped potential, in the popular appetite for African-American culture."[33] Regardless of Phillips's personal motivations, it is undeniably true that many white producers, managers, label executives, and venue proprietors profited unfairly from the blatant manipulation of the work and personas of African-American songwriters and performers.

Another byproduct of the introduction of African-American cultural products into the mainstream was the challenging of the dominant cultural structures, to slowly but surely change white people's perceptions of black people, and perhaps to a lesser extent to change black people's perception of white people. Rock and roll was born as an agent of change: popular music in the original sense of the term. This is the prophetic status claimed for music by Jacques Attali in *Noise: The Political Economy of Music.* Blues, then rhythm and blues, then rock and roll, were faster to change—and faster to change their listeners—than the economic models of their attendant industries or the political system of the society itself.

After backing Sonny Boy Williamson on a 1964 tour, the then-Yardbirds' guitarist Eric Clapton remarked, "It was a frightening experience, because this man was real and we weren't."[34] This is the flip side of Phillips's apocryphal prognostication. The reason a "white man who sang black rhythms with a black feel" could make a million dollars was because the black men already singing those songs were too real

32. Phillips, as quoted in Douglas Martin, "Sam Phillips, Who Discovered Elvis Presley, Dies at 80," *New York Times*, August 1, 2003, query.nytimes.com/gst/fullpage.html?res=9E06E4D6153EF932A3575BC0A9659C8B63&sec=&spon=&page wanted=all (accessed February 9, 2009).

33. Peter Guralnick, from his *Last Train to Memphis: The Rise of Elvis Presley* (Boston: Little, Brown, 1994), as quoted in Douglas Martin, "Sam Phillips."

34. Clapton, as quoted in Robert Palmer, *Rock & Roll: An Unruly History* (New York: Harmony Books, 1995), 116.

for white audiences: they were too black. Clapton's fear, as a white British musician with a ravenous appetite for African-American music, was that he was not real enough, not black enough. The implication that haunts the entire history of rock and roll is that there is something elusive about the music, something unfakeable. There is something beyond the music, something other than the music, something extra-musical. This may be the most important distinction between Western composed music and popular music since rock and roll. While the former goes to great lengths to exclude the extramusical from its field of concern, the latter courts it and elevates it to the point of all but excluding the "properly musical."

The repetitious nature of rock and roll means that it ultimately must appeal, not to the ear, but to a broader sense (in both meanings of the word) of experience. Rock and roll is about the confrontation of an audience with a performer. It is understood that both parties may or may not be playing a role, and yet the interaction is no more and no less "real" than the social interactions of everyday life. Separated from day-to-day existence and shorn of the consequence of actions taken there, rock and roll allows a playing out of desires, fears, and provocations. The confrontation of audience and performer involves more than simple spectatorship. Bodies interact in space. Responses on both sides are tested. The British punk-era practice of gobbing, in which the audience showers the performer with spit, represents an explicit intermingling of the visceral products of bodies usually sepa-rated by fourth-wall protocol.

Rock-and-roll recordings are steeped in the innovations of Pierre Schaeffer's *concrète* studies. But in rock and roll the technological isolation of sound from sound and of sound from source does not yield the *objet sonore* detached from connotation. Instead, rock and roll has invented a vocabulary of production choices, of how mate-rials are produced, captured, treated, combined, and broadcast. Presentation and production choices constitute a complex semiotic in which extramusical ingredients of the musical experience are crucial.

This semiotic includes sonic elements and effects such as reverb, doubled vocals, distortion, close-mic'd or large-room drum recordings, and choices of sampled material. It also includes unhearable features. The band's choice of instrument brands and styles (Fender vs. Gibson, small-drum kit vs. double kick drum), its gender and ethnic constitution, and its fashion choices all signify its relation to the traditions and conventions of which it partakes. Plaid flannel is not incidental to the meaning of Nirvana's "Smells Like Teen Spirit."

Like any semiotic system, rock and roll is subject to misreadings, misunderstandings, and abuses. The semiotic fool's gold standard of rock and roll is authenticity. Both the black feel of the Phillips quote and Clapton's "real" refer to it. Like Schaeffer's phenomenological primordiality, Michelson's notion of Peircean firstness, Cagean sound-in-itself, and Kittler's "real," authenticity is installed as a universal truth to which the entire system must refer and defer. Where does one locate the original to which the authentic has recourse? Against which "genuine article" can we gauge the accuracy or reliability of the authentic instance of it? Meaning does not emanate from a single source point but is constructed and reconstructed on the fly as nodes of various symbolic grids come in and out of play. Even the founding documents of rock and roll are not originary, but are the product of uncountable intersections of tunes and lyrics and styles and instruments and stories and, not least of all, people. Muddy Waters's "I Feel Like Going Home," like Cage's *Silent Prayer* and *4' 33"*, like Schaeffer's *Étude aux chemins de fer*, is less an invention than a discovery; a discovery of similarities and differences in what had come before. When "I Feel Like Going Home" was released in 1948, it may have been the first work of rock and roll, but it was not new. It had already been "Country Blues" in 1941, "Walkin' Blues" in 1936, and "My Black Mama" in 1930. When the first instance of something cannot be called authentic, then authenticity as a value is rendered highly problematic, if not meaningless. The problem of authenticity is the core problem of all signification. *It* is never simply it. As Jean-François Lyotard makes

clear, this is not simply a musical problem: "There is no 'in accordance with,' because there is nothing that is a primary or originary principle, a *Grund*. . . . Every discourse, including that of science or philosophy, is only a perspective."[35]

Authenticity posits a source of truth or value outside the realm of human meaning: outside of politics, sociality, economics. As a transcendental origin and/or telos, authenticity is both indefinable and unachievable. The examples of Phillips's disputed statement and Clapton's expressed inferiority imply that authenticity is a natural, immanent feature of race, that at least as far as the authentic experience and expression of the blues is concerned, blacks have it and whites do not. This ignores an absolutely crucial understanding: race is a semiotic too. The attributes assigned to one race or another are cultural constructions. There is nothing "natural" about the blues, nothing "real," nothing "authentic." The blues and rock and roll—like all other forms of cultural production—are what you make of them.

It is additionally perplexing that the rock-and-roll artists most fixated on such essentialism have repeatedly pursued their ephemeral quarry through mechanistic means: technical virtuosity, mimesis, and high fidelity. If you put your faith in the transcendentalism of authenticity, you ought to believe that you've either got it or you don't. The idea of creating authenticity should be oxymoronic. This explains the necessity of the supernatural legend of the Delta bluesman Robert Johnson, who is said to have gone down to the crossroads to trade the devil his soul in return for the power of the blues. The best rock and roll—whether by choice or by necessity—dispenses with this essentialist discourse of authenticity and instead engages with the traditions and conventions of the form. Rather than a degree of mechanical competence, manifest in virtuosity and fidelity to models and sounds, this approach requires a conceptual competence, an understanding

35. Jean-François Lyotard, *The Inhuman: Reflections on Time*, trans. Geoffrey Bennington and Rachel Bowlby (Stanford: Stanford University Press, 1991), 28–29.

of the expanded situation of rock and roll as text. Those who try to produce technically accurate copies of the original model fall prey to a variant of the essentialism that feeds the sound-in-itself tendency. (In addition to Clapton, this might include the 1960s American folk revivalists; the English Canterbury scene; the early, R&B Rolling Stones; and, more recently, the White Stripes's miming of the Yardbirds and early Led Zeppelin (a blatant copy of a copy) and the spate of late-1990s New York City bands who recreate the styles and sounds of early 1980s English post punk (Radio 4's channeling of Gang of Four and the Clash comes to mind).

Rock and roll's adaptation to amplification, recording, and electronically facilitated distribution on radio and vinyl altered the basic ontology of the listening experience. In the music of Western notation, the emphasis is on the form, as coaxed into existence by the composer. The listener's role is that of a detective, assembling clues to piece together the story. The abiding assumption is that the music is imbued with an intentional form and that it is incumbent upon the listener to discover that form and in it recognize the composer's invention and inspiration. In blues-based rock and roll, the form comes not from the composer but from the tradition. The performer-as-composer inflects the form with individual differences or contravenes the conventions outright. In either case, the listener starts with an understanding of the form that is roughly equal to that of the performer. The listener's responsibility, in the first case, is to remain sensitive to the performer's inflections, weighing them against the demands and allowances of the form, as well as against the inflections of other performers. In the second case, the listener must understand the status of the formal expectations being disrupted, while also comparing the contravention against a slate of other potential disruptions, and thus to piece together the differential meaning of the gesture. The assumption is not one of invention and inspiration but of an engagement with a tradition and of negotiation with the possibilities, forms, and meanings of that tradition.

Rock and roll has always been a music of collective composition. Although many bands have one or two de facto songwriters, the authoring of the rock-and-roll semiotic is almost always a group activity. Unlike what happens in the Western compositional tradition, rock bands rarely work from scores. Although a songwriter may create the basic architecture for a song, that composer rarely writes parts for each instrument. As a result, the bassist and the drummer, for instance, often work out their own parts within the framework of chord changes and melody provided by the songwriter. These players are seldom credited as authors. From the start, rock and roll has been an unschooled medium. Writers and performers usually come to the process of creation without formal musical educations. Many cannot read music. Fewer write it. Fluency in Western notational music theory is all but nonexistent. As a result, bands compose songs democratically, anarchically, performing them, rehearsing and refining the performance until a stable, repeatable form is secured. It is not uncommon for individual members to work at cross-purposes, in the process inventing a musical amalgam that would probably not have resulted from a singular, informed compositional perspective. Additionally, the extended text of the rock song is always the product of decisions made by individual members of the band, yet also by producers, engineers, graphic designers, publicity agents, and others external to the unit of the performing artist. The text of the rock song— its musical content, its extramusical sonic elements and effects, its nonsonic supplements—is up for grabs. The entity of the group-as-author is often divided against itself, leaving the listener to negotiate the sonic artifact and to determine what it is, how it functions, what it means. Allegiance to authenticity, fidelity to a model or score, and the faithful presentation of flawless technical execution—such standards ignore the give-and-take of rock and roll as text, rock and roll as conversation, in favor of a wild goose chase after a fictional essence.

6

UNHEARING CAGE

Krauss's Expanded Field of Sculpture

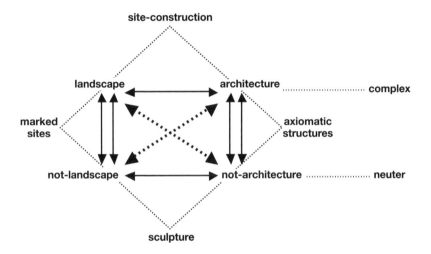

The logic of the space of postmodernist practice is no longer organized around the definition of a given medium on the grounds of material, or, for that matter, the perception of material. It is organized instead though the universe of terms that are felt to be in opposition within a cultural situation.

—Rosalind Krauss[1]

It, **it turns out, is never simply it.** This is true no matter what it is. Pointing at it only obscures it. If it is sound art, it must be distinguished from music on one side and from the gallery arts on the other. The

1. Rosalind Krauss, "Sculpture in the Expanded Field," *October* 8 (Spring 1979): 30–44, http://hseveri.com/docs/Sculpture/krauss.pdf (accessed February 2, 2009), 38 (diagram), 43 (text).

151

borders are blurry, which means that it is blurry. Nevertheless, it might prove illuminating to try to find it, to identify it, to say—even provisionally—where it begins and ends. Rosalind Krauss felt the same responsibility when she tried to point at sculpture in the late 1970s. She came to this conclusion: an avenue of artistic practice does not depend on the exigencies of material. If the sculptor turns to materials never before employed in the production of sculpture, the right to call the work sculpture is not forfeited. Nor does the definition depend on a given mode of perception, a certain way of perceiving, or a set of accepted perceptual responses, conditioned by a given material. It is not *it*—or not all of it, anyway.

Instead, Krauss identifies a "universe of terms." The definition of sculpture is a product of how we talk about it and think about it. Sculpture is a discursive construct. This shouldn't have come as a surprise. All categories are products of discourse. To be persuaded of it, one needs only to return to Foucault's reaction to reading a story by Borges:

> It shattered, as I read the passage, all the familiar landmarks of thought—our thought, the thought that bears the stamp of our age and our geography—breaking up all the ordered surfaces and all the planes with which we are accustomed to tame the wild profusion of existing things and continuing long afterwards to disturb and threaten with collapse our age-old definitions between the Same and the Other. This passage quotes a "certain Chinese encyclopaedia" in which it is written that "animals are divided into: (a) belonging to the emperor, (b) embalmed, (c) tame, (d) sucking pigs, (e) sirens, (f) fabulous, (g) stray dogs, (h) included in the present classification, (i) frenzied, (j) innumerable, (k) drawn with a very fine camelhair brush, (l) *et cetera*, (m) having just broken the water pitcher, (n) that from long way off look like flies." In the wonderment of this taxonomy, the thing we apprehend in one great leap, the thing that, by means of the fable, is demonstrated as the

exotic charm of another system of thought, is the limitation of our own, the stark impossibility of thinking *that*.[2]

When Foucault writes "that," he of course means "it," that being nothing more than another example of the *it*-that-is-not-simply-it. Krauss goes further, incorporating the implications of Foucault's constructive collapse of the categories of self and other. Which is to say, Krauss starts from a Derridean understanding of meaning as a product of differance and the trace of alterity in the selfsameness of the it. Sculpture as a category of artistic practice is not merely a universe of terms. It is also a product of those terms in opposition, contesting the groundwork that they simultaneously lay and lie upon. What constitutes the *it* in question is not the terms themselves, but the friction between them and the entangled skein of confirmation and denial created by the interactions of these terms. Sculpture, then, is not so much a stable and static site of contestation but a dynamic, inconclusive situation. This situation is not merely lexical, not discursive in any limited sense; it is, Krauss says, "a cultural situation." The terms in play are animated by their role as elements constitutive of, and constituted by, culture, granted conditional meaning according to their usage in culture. In turn, they organize the logic of a practice such as sculpture.

Krauss's schema designates two classes of forms that are not sculpture: landscape, or the natural environment, and architecture, or the built environment. Conversely, sculpture is that which is notlandscape and not-architecture. Relative to the built environment, sculpture is "what is in the room that is not really the room."[3] Relative to the landscape, sculpture is "forms which are distinct from the setting only because, though visually continuous with grass and trees, they are not in fact part of the landscape."[4] Yet this schema is

2. Michel Foucault, *The Order of Things: An Archaeology of the Human Sciences* (New York: Vintage, 1973), xv.
3. Krauss, "Sculpture in the Expanded Field," 30–44, esp. 36.
4. Ibid.

applicable only in a limited sense and sphere. It functions a bit like Borges's taxonomy. My shoes are not landscape. And even if Frank Gehry or Richard Serra had designed them, they would not be architecture or sculpture either. Human bodies and animals too should be excluded from these categories. Nevertheless, the schema does make certain things clear about how a practice like sculpture marks out its territory.

> In this sense sculpture had entered the full condition of its inverse logic and had become pure negativity: the combination of exclusions. Sculpture, it could be said, had ceased being a positivity, and was now the category that resulted from the addition of the *not-landscape* to the *not-architecture*.[5]

In Krauss's schema the four terms collide—"architecture," "not-architecture," "landscape," "not-landscape"—each impact yielding an output, an offspring, a remainder. In addition to the formula of *not-landscape* and *not-architecture* = sculpture, we see that *landscape* and *not-landscape* mark out the boundaries of what Krauss calls "marked sites," of which Robert Smithson's *Spiral Jetty* is emblematic. *Architecture* and *not-architecture* yield "axiomatic structures": Sol LeWitt's geometric forms and Richard Serra's room-scale, sculptural spaces. The combination of the positive categories of *landscape* and *architecture* result in "site construction," including work such as the *Partially Buried Woodshed*, also by Smithson.[6] These categories constitute the expanded field of sculpture. The implication is that the practice has changed ahead of the definition of the category, which must now play catch-up.

> The expanded field is thus generated by problematizing the set of oppositions between which the modernist category sculpture is suspended. And once this has happened, once one

5. Ibid.
6. Ibid., 30–44, esp. 41, with added emphasis.

is able to think one's way into this expansion, there are—logically—three other categories that one can envision, all of them a condition of the field itself, and none of them assimilable to sculpture. Because as we can see, sculpture is no longer the privileged middle term between two things that it isn't. Sculpture is rather only one term on the periphery of a field in which there are other, differently structured possibilities. And one has thereby gained the "permission" to think these other forms.[7]

This schema and its component terms are far from perfect. They function allegorically or synecdochically. The following act of mimicry is thus undertaken advisedly. Yet Krauss's model, translated into the sonic field, with its terms and oppositions replaced by those applicable to a thinking of auditory experience, do serve to highlight certain presumptions. At the same time, such an exercise will allow us to think through the implications and categorizations of existing works of sonic art and to imagine future directions for the still-nascent practice of sound art.

The Expanded Sonic Field

non-cochlear sonic art

```
           non-cochlear sonic art

              noise  ←————→  speech      ............ complex

  sound-                                    sound
  in-itself                                 poetry

              not-noise ←————→ not-speech   ............ neuter

                      music
```

7. Ibid., 30–44, esp. 38.

In the proposed schema of the expanded sonic field, we start with the opposition of "speech" and "noise," and with the negative opposition "not-speech" and "not-noise." Speech—"built" sound, if you will— functions like architecture in Krauss's model, while noise parallels landscape as the nonintentional ambience of the environment (natural or otherwise). Music is the privileged term, the position occupied by sculpture in Krauss's schema. Music is the output of the collision of "not-speech" and "not-noise": sound that is neither speech nor noise. While imperfect, this definition actually maintains more traction than does Krauss's initial opposition. "Noise" and "not-noise" mark out the boundaries of the sound-in-itself tendency. Cage and Schaeffer both sought to hear noise as not-noise. The collision of "speech" and "not-speech" yields the practice of sound poetry, ranging from Kurt Schwitters's *Ursonate* (1922–32) to Michael McClure's 1960s "beast language" to the more recent work of Henri Chopin and Bob Cobbing. Sound poetry is an oral form, presented in performance or in recordings, that eschews semantic and syntactic convention in favor of phonetic composition. The combination of the positive categories of "noise" and "speech" result in what I am calling non-cochlear sonic art: noise that functions linguistically and is therefore read as much as it is heard.

Just as each work of art engages certain conceptual concerns, every sound work cannot help but signify. But certain artworks foreground their conceptual aspects, and certain instances of sonic art engage the materiality of sound as a means to a semiotic end. The term semiotic is intended here in a broad sense to include a range of concerns organized across a diverse matrix of symbolic grids. So non-cochlear art, as we will see, might engage philosophical texts, musical discourse, social roles enacted by the production and reception of sound and/or music, conventions of performance, or the inherent presumptions underlying the experience of audio recordings. In Krauss's schema, the expanded sculptural field is defined "in relation to the logical operations on a set of cultural terms, for which any medium—photography, books, lines on walls, mirrors, or sculpture

itself—might be used."[8] This is no less true for the expanded sonic field. Yes, sound might be used. But so too can a non-cochlear sonic art present itself in any medium: photography, books, lines on walls, mirrors, sculpture, as well as performance, speech, choreography, social practice, and so on. Distinguishing sound art from music and the gallery arts depends upon distinguishing its universe of terms and understanding how these terms establish fields of opposition within their cultural lifeworld.

I will not be dealing with sound poetry in this book. The opposition that produces it—speech versus nonspeech—is arguably more relevant to literature than to the gallery or sonic arts. So I will leave that discussion to my colleagues in literary history and theory. My concern here is to identify a space of praxis for a non-cochlear sonic art. Such a practice is neither music nor gallery art. Nor does it approach its project from the direction of sound-in-itself. Again, these distinctions are drawn not on the basis of the material or medium engaged, but strictly according to the "universe of terms that are felt to be in opposition within a cultural situation."

Music has long enjoyed its reputation as the abstract art form par excellence, constitutionally exempted from any obligation to mimesis, iconicity, or indexicality. Romantic painting and literature viewed music as privileged, unbeholden to any external referent. As mentioned in chapter 2, Walter Pater, the instigator of the Aesthetic movement in Britain, famously declared that "all art constantly aspires to the condition of music."[9] Musical meaning has traditionally been construed or constructed in the mode of abstraction: form is understood as self-referential and self-justifying, gestures and decisions making sense only relative to a logic established internally.

In the gallery arts, Duchamp's readymades dodge the traditional obligations of mimesis and semiotic attachment to a referent. The readymades reset the poles of representation such that the artwork

8. Ibid.
9. Walter Pater, "The School of Giorgione," in *The Renaissance: Studies in Art and Poetry* (London: MacMillan, 1912), 135.

no longer points at what it indicates. Instead, "indication" is replaced by "concern," the former being linear—from indicator to indicated—and the latter being constellative—a complex of interconnections from which something akin to representation (albeit significantly less mimetic) might be extracted. Duchamp was famously skeptical of what he called "retinal art," which caters too specifically and too willingly to the eye and thus risks falling prey to fetishism, commodification, or exploitation by commercial mechanisms of image making. By the same token, the conceptual work does not point at another text in order to read one through the other. Instead, conceptualism points at itself and its situation, its metatextuality, its intertextuality, its extratextuality. The conceptual work indicates the channel through which any reading passes, the conventions it depends upon, the rules by which it must play in order to reach its goal.

Peter Osborne defines conceptual art as "art *about* the cultural act of definition paradigmatically, but by no means exclusively, the definition of 'art.'"[10] This definition doesn't completely excise formal concerns or allegorical interpretations. Conceptualism doesn't even completely suspend mimesis in the iconic or indexical sense. The urinal still looks like a urinal, LeWitt's cubes resemble cubes, I'm convinced of the bulletlike qualities of the bullet as it passes through Chris Burden's arm and of the indexical aspects of his wound. Conceptualism redirects the signification of the artwork away from explicit correspondences of the composition to its internally elaborated laws (as in abstraction), of the text to another text (as in allegory), of the image to its referent (as in mimesis). This redirection supplants a reading based on outward perception with one based more fully on self-reflexive apperception, thus based on a process that constructs or construes meaning relative to context, conventions, and circuits of transmission and reception.

The question upon which this study pivots is whether there is anything to be gained from the development of a non-cochlear

10. Peter Osborne, *Conceptual Art* (London: Phaidon, 2002), 14.

musical, or, more broadly, sonic practice—and, pursuing the inquiry further, whether such a practice constructs or construes its meanings in the mode of conceptualism as I've described it above. If so, how would this practice constitute itself? How would we distinguish it from abstract or allegorical sound or music? I will explore these questions by returning to the founding figures with whom this book began: Pierre Schaeffer, John Cage, and Muddy Waters. All three are typically understood from within the context of Western music: Schaeffer and Cage within the history of Western composition, and Waters in terms of Western popular music, rhythm and blues, and rock and roll. The *détournement, the revision*, I want to initiate identifies specific lines of precedent for a non-cochlear sonic practice in the examples of Schaeffer, Cage, and Waters. It would be foolish to claim that each instance of each of their practices overtly or intentionally engages non-cochlearity. Instead, I suggest that the concerns emerging as critical to a non-cochlear practice are already present, perhaps in a latent state, in Schaeffer, Cage, and Waters. I will offer alternative readings of certain key works, extracting the elements and attitudes that point the way toward the non-cochlear. In the present chapter I will focus on Cage as the most apparent precursor of a conceptual sonics. In chapter 7 I will discuss how other practitioners received and adapted Schaeffer's *musique concrète* and Waters's sometimes ignored, sometimes esteemed legacy in rock and roll. In an effort to trace these lines of development to the present day, chapter 8 will examine the work of contemporary practitioners, which suggests the receipt of a non-cochlear message embedded in the examples of Schaeffer, Cage, and Waters.

David Tudor opened and closed the lid of the piano's keyboard. This is the first and most familiar answer to the questions above. It was delivered in 1952 in Woodstock, New York, indicating the endings and beginnings of the three movements of John Cage's *4' 33"*. Although the piece is familiar by now, allow me to point out what are generally considered to be its most salient features. The piece *4' 33"*

is scored for any number of instrumentalists on any instruments. A performance consists of three movements, during which the players do not play. Those movements are divided by tacet sections: sections of silence. The durations of the movements and how the beginnings and endings of the movements are indicated are left to the performers' discretion. Thus *4' 33"* is known, colloquially, as "the silent piece," but as the *tacet* sections dividing the movements suggest, the more agreed-upon interpretation focuses on the extraneous, environmental, and ambient sounds that are always present in any performance of *4' 33"*, relocating the site of production—indeed the site of music— from the space and figure of the composer to that of the listener.

The myth of John Cage is as fully realized as that of any artistic figure of the twentieth century. Cage himself was largely responsible for the cultivation and propagation of this myth. Given the status of *4' 33"* in the mythology, it's surprising to discover how difficult it is to nail down a definitive reading of the piece. If we are trying to locate first or fundamental moments of non-cochlear conceptualism, then this inconsistency undermines any claims that might be made on behalf of *4' 33"*. The confusion arises from three tellings of the tale of how *4' 33"* came to be. Each telling emphasizes different meanings and modes within the space (and within the time) that the piece nominates and frames as its territory.

The most mythic of these tales concerns Cage's visit to an anechoic chamber at Harvard University in 1951. An anechoic chamber is a room designed to absorb any and all sound waves, to diffuse any echoes or reverberation, making it as close to silent (or "dead," in the parlance of audio engineers) as possible. After spending some time in the chamber, Cage became aware of two sounds: one high-pitched and one low-pitched. He asked the on-duty engineer to explain what he was hearing and was told that the sounds were emanating from him, from his body. The low sound, according to the engineer, was caused by the circulation of his blood; the high sound was the product of his nervous system at work. For the record, most knowledgeable audio people doubt this and assume that the

engineer was mistaken. Apparently it is unlikely that the high sound was Cage's nervous system and far more likely that it was caused either by low-level tinnitus—a ringing in the ears commonly occurring in people around the age of forty—(Cage was thirty-nine at the time of his visit to Harvard)—or by the sounds of air molecules bumping into the eardrums: a sound often perceptible after a period in very quiet surroundings. In any case, Cage left the anechoic chamber a changed composer. His revelation: there is no such thing as silence; as long as one is alive, there is sound.

Version two of the tale of *4' 33"* takes its cues not from bio-ontological or phenomenological stimuli but from visual art. In 1982 Cage said of *4' 33"*, "Actually what pushed me into it was not guts but the example of Robert Rauschenberg. His white paintings . . . When I saw those, I said, 'Oh yes, I must; otherwise I'm lagging, otherwise music is lagging.'"[11] In 1952 Cage organized a multimedia event at Black Mountain College, near Asheville, North Carolina, which included, among other components, Charles Olson reading from his poems, music by David Tudor, Cage himself perched on a ladder and delivering his *45 Minutes for a Speaker*, and an exhibition of some of Rauschenberg's white paintings.

Historical accounts differ about when and where Cage might first have seen these multipanel canvases. Branden Joseph reports that, although Rauschenberg made a desperate plea to Betty Parsons to show the white paintings in 1951, she declined, and they were not publicly exhibited until 1953 at the Stable Gallery.[12] Irwin Kremen, to whom Cage dedicated a version of *4' 33"*, remembers seeing the white paintings in Cage's apartment in December of 1951.[13] Whatever the actual circumstances of encounter, version two of the story of *4' 33"*

11. John Cage, Roger Shattuck, and Alan Gillmor, "Erik Satie: A Conversation," *Contact: A Journal of Contemporary Music* no. 25 (Autumn 1982): 22.

12. Branden W. Joseph, "White on White," *Critical Inquiry* 27, no. 1 (Autumn 2000): 92.

13. Douglas Kahn, *Noise, Water, Meat: A History of Sound in the Arts* (Cambridge: MIT Press, 1999), 168.

locates its eureka moment in Cage's experience of the emptiness of Rauschenberg's canvases.

The third version of the story connects *4' 33"* to Cage's interest in South Asian and East Asian philosophy and his burgeoning association with Zen Buddhism. This telling of the tale has been called into question, most notably in Douglas Kahn's *Noise, Water, Meat*. Still, despite semantic, historical, geographical, and theological inconsistencies in this version of the story, the Eastern mystic reading of *4' 33"* has maintained a definitive hold on the reception and interpretation of the piece since its premiere. As Cage himself said in 1985, he was "just then in the flush of my early contact with oriental philosophy. It was out of that that my interest in silence naturally developed: I mean it's almost transparent."[14] I rehearse these now-familiar apocryphal accounts not to further disseminate the creation myths they establish, but quite the contrary, to interrogate the myths and the meanings they transport. What do these stories say about how *4' 33"* functions? How it means? About its relationship to abstraction, allegory, and conceptualism?

Of these stories, the second most easily accommodates a non-cochlear, conceptual reading. "I must," Cage says upon seeing Rauschenberg's canvases, "otherwise I'm lagging, otherwise music is lagging." If Cage locates the innovation of the white paintings in their disruption of the conventions of art, in short circuits in concepts and categories, then yes, one could argue that *4' 33"* emerges from conceptual impulses. But there is nothing to support the idea that this is how Cage saw them. In his essay "On Robert Rauschenberg, Artist, and His Work," Cage describes the white paintings as "airports for the lights, shadows, and particles."[15] He saw them as correlates of the anechoic chamber: empty, neutral spaces in which the unintended materials of the environment could come to our attention. So, taking into account the expanded context of Cage's reception of the white

14. Stephen Montague, "John Cage at Seventy: An Interview," *American Music* (Summer 1985): 213.
15. John Cage, *Silence* (Middletown, CT: Wesleyan University Press, 1961), 102.

paintings, it becomes evident that story number two has much in common with story number one. The potentially conceptual inspiration for the piece turns out to be a materialist, listening activity, still very much about the ear—an engagement with sound-in-itself, and thus subject to the same shortcomings we would ascribe to retinal art.

Douglas Kahn suggests that the historical effect of *4' 33"* has been an extension of the category of music, but only from within its established presumptions. It is, after all, scored. It designates three movements. It is intended for the concert hall. Its title is its duration, prescribing a certain period of attentive listening—a prescription that doesn't happen in everyday life, occurring almost exclusively in music. To paraphrase the poet Frank O'Hara, *4' 33"* is no more outside music than Bear Mountain is outside New York State. The piece *4' 33"* never strays from the condition of music most admired by the Romantic poets: musical areferentiality. Cage's inability or unwillingness to challenge music's traditional avoidance of questions of time, place, context, gender, politics, ethnicity, and economics has become, in the past decade or so, the linchpin in an emerging critique of Cage's legacy. Cage's notion of letting sounds be themselves, of not distinguishing between good sounds and bad sounds, seems to make an egalitarian, democratic proposal; yet Douglas Kahn, Philip Brophy, and others critique Cage's approach for deriving from a vague mysticism, lacking an account of the real-world situations and connotations of sound. Brophy accuses Cage of operating in his own "anechoic chamber which excluded the world and its cultural noise."[16]

A precedent for a more conceptual reading of *4' 33"* is readily available, residing just one year later in Rauschenberg's career and just one page earlier in Cage's essay on Rauschenberg: "It's a joy in fact to begin over again. In preparation he erases the De Kooning."[17] Rauschenberg's *Erased de Kooning Drawing* of 1953 appears, on the surface, to resemble the white paintings. But it achieves its results

16. Philip Brophy, "Epiphanies: John Cage (Not)," *The Wire*, no. 273 (November 2006)
17. Cage, *Silence*, 101.

by different means. The process explicit in its title gives the emptiness of *Erased de Kooning Drawing* a different semantic weight. Rauschenberg himself called it a "monochrome no-image,"[18] emphasizing its negative presence rather than its status as an object, a product, a result. Although *Erased de Kooning Drawing*, like the white paintings, is void of intentional mark-making, the eye alone cannot be trusted to make sense of this picture.

Robert Rauschenberg, *Erased de Kooning Drawing*, 1953, traces of ink and crayon on paper, mat, label, and gilded frame. 25¼ in. x 21¾ in. x ½ in. (64.14 cm x 55.25 cm x 1.27 cm). San Francisco Museum of Modern Art. Purchased through a gift of Phyllis Wattis © Robert Rauschenberg Estate / Licensed by VAGA, New York.

I was trying to figure out a way to bring drawing into the all-whites. I kept making drawings myself and erasing them. And that just looked like an erased, uh...Rauschenberg. I mean, it was nothing. So I figured out that it had to begin as art. So I thought "It's going to be a de Kooning then, if it's going to be an important piece." You see how ridiculously you have to think in order to make this work? And he [de Kooning] said, "Ok, I want it to be something I'll miss." I said, "Please, it

18. Joseph, "White on White," 114–15.

doesn't have to be that good." "I wanna give you something really difficult to erase." And I thought, "Thank God." And he gave me something that had charcoal, oil paint, pencil, crayon . . . I spent a month erasing that little drawing that's this big and on the other side is another one that isn't erased. The documentation is built in. [19]

The value of the *Erased de Kooning Drawing* is not the same as the white canvases. Instead of acting as a landing strip for light and particles, *Erased de Kooning Drawing* is simultaneously an exercise in discourse, narrative, and performance. To engage these exercises, one must think about or around the canvas, circumventing the face of it in order to engage what lies, both figuratively and literally, behind it. There is another drawing on the other side, unerased but obscured on the verso. This other drawing "documents" the erased recto side; it tells us what was there. But it tells us silently: invisible information about invisibility. The thinking required is "ridiculous." One must think about or around the frame. The invisible documentation tells the story of how Rauschenberg couldn't simply erase his own drawing. For the work to have some meaning, it had to be an act of erasure of something of importance. How is this silent story made audible? Not by anything inside the frame. The story, the meaning of the work, is conveyed by the title and by Rauschenberg himself, not as avisual artist, but as a storyteller. The work is animated, authorized—in a very real way, it is brought into being—by the narrative of its making and by the discursive universe of terms and oppositions in the culture surrounding the work. If its title named its dimensions, *25.25 x 21.75 Inches* (in parallel with Cage's *4' 33"*), it would not be the same work. The title *Erased Drawing* (without reference to de Kooning) would make it something different again. If you don't know who de Kooning is, the piece is significantly reduced. Likewise if you don't know who Rauschenberg is. Knowing about the invisible verso drawing enriches the work. To see

19. Robert Rauschenberg, interview, video, artforum.com/video/id=19778& mode large (accessed February 2, 2009).

the work, we don't need our eyes. The work appeals to our reading faculties, employing eyes and ears as mere conveyance. The "work" of the work is non-retinal and conceptual, appealing to considerations outside the territory usually designated as the work.

Reading *Erased de Kooning Drawing* as an act of addition, supplementing the raw fact of the drawing's materiality with a constitutive discursiveness, allows us to erase the traditional reading of the piece as an act of pure destruction, of Freudian patricide. Branden Joseph generously extends this reading to all the white canvases:

> Following the implications of the critique of negation, Rauschenberg's elimination of artistic elements from his painting was now understood as allowing incorporation of the temporally changing, nonart realm. Indeed, by incorporating duration, the *White Paintings* no longer represent a return to the monochrome as degree zero of painting, but rather assert—as his hermetic statements from the "Art of Assemblage" symposium would have it—that "there is no zero which returning implies." In this, Rauschenberg's *White Paintings* differ from their historical avant-garde counterparts as well as from their formalist or minimalist understandings.[20]

Considering Rauschenberg's post–white canvas output, this reading is certainly justified. But *Erased de Kooning Drawing* is more overt than the white paintings in its "incorporation of the . . . nonart realm," positively engaging the broad spectrum of the expanded situation. Through its discursive operations, *Erased de Kooning Drawing* not only avoids the suggestion of a degree zero of painting; it also denies the mute neutrality of Cage's reading of the white canvases. *Erased de Kooning Drawing* cannot be the passive recipient of incidental phenomena. It is already an active participant in the process of differential meaning-making. It is hard to imagine a more explicit illustration of Derrida's idea of identity as a product of the trace of alterity. By dint of

20. Joseph, "White on White," 113.

what it is not, *Erased de Kooning Drawing* is what it is. As Joseph suggests, it does escape its formalist, minimalist understandings. Like Robert Morris's 1960s sculpture, it engages Peircean thirdness and an expanded situation that is both theatrical and aphenomenological.

If we align *4' 33"* with *Erased de Kooning Drawing* rather than with the white canvases, we can reread its apparent acts of abrogation as expansions of the territory and the concerns of music. As with de Kooning's drawing, in *4' 33"* all the music is erased: the musicians, their instruments, their expert music-making capabilities, the conventions of the concert hall, the traditions of Western music production and reception—these have all been deleted from the picture. Music itself is absent. But the space it once occupied is far from empty. It is densely populated—overabundant and overdetermined—by its traces, conceptual marks of indication-by-differance. The stage, the piano, the musician(s), the score in three movements—in each case the usual ontology is radically expanded, pushing out from the perceived center of musical practice to include the cascading processes of signification and the constant redefinition that accompanies it. The listener must fill the emptied space. Normally stable ideas about the roles of the performer, the composer, and the relationship of one to the other are unmoored from their anchorage, allowed to drift freely in the tides of conceptualization. This is the same independence realized by Robert Morris in the 1960s: reducing a practice to its minimal means and materials diminishes the intransigence of its categorical boundaries, allowing the work and the world to freely intermingle. Yet *4' 33"* predates minimalist sculpture by more than a decade. If it took only a few years to arrive at this understanding of minimalism, why is *4' 33"* still accepted as an act of listening to the noise inherent in silence? By insisting on *4' 33"* as an engagement with materiality; with sound-in-itself, with concerns that, while not central to the Western music theory of its time, are still thoroughly focused on the ear—by so insisting, Cage and his adherents fail to realize the fundamental thought of a non-cochlear sonic practice: sound is bigger than hearing. The gallery arts have put the eye in its place. Why this recalcitrance of the ear?

"The audience is instructed to leave the theater."[21] This is the word score for George Brecht's *Word Event, Fluxversion 1*, of 1961. In tracing the trajectory toward a non-cochlear sound art, it is easy to identify two distinct forces. From one direction, experimental music, from the 1950s onward, pursued an agenda that increasingly recast not just the organizational logic of music but also the very values and assumptions by which that logic was justified. From another direction, in the 1960s and '70s, practitioners in the gallery arts invested themselves in strategies related to, and in many cases derived from, sonic and musical methodologies. The dematerialization of the art object sought a status already achieved by the ephemerality of sound. The emphasis on performance shifted the gallery experience from one of exhibition to one of encounter.

In the 1960s John Cage was an enormously influential figure in both these fields of practice. To find evidence of Cage's stature in the world of music, one need only check the biographies of any of dozens of composers who came of age after World War II:

EARLE BROWN: A meeting with John Cage in 1951, in Denver, was of considerable importance to me.[22]

PAULINE OLIVEROS: Cage really liberated the notion of what could serve as musical material.[23]

LUC FERRARI: The meeting which was the most enlightening for me, in terms of philosophy and aesthetics, was with John Cage.[24]

21. Ken Friedman, Owen Smith, and Lauren Sachyn, eds., *Fluxus Performance Workbook* (Performance Research e-Publication, 2002), 23, www.thing.net/~grist/ld/fluxusworkbook.pdf (accessed February 2, 2009).

22. Christoph Cox and Warner Daniel, eds., *Audio Culture: Readings in Modern Music* (New York: Continuum, 2004), 191.

23. Interview with Alan Baker, musicmavericks.publicradio.org/features/interview_oliveros.html (accessed February 2, 2009).

24. Luc Ferrari, as quoted in Dan Warburton, "Interview with Luc Ferrari," *ParisTransatlantic Magazine,* July 22, 1998, www.paristransatlantic.com/magazine/interviews/ferrari.html (accessed February 2, 2009).

In the gallery arts, Cage's influence emerged from the class he offered on experimental composition at the New School in New York from 1957 to 1959. His students—including Brecht, Allan Kaprow, Al Hansen, Dick Higgins, and Alison Knowles—exported Cage's expanded notion of composition into the visual art world through happenings and Fluxus events, adopting the use of verbal instructions to initiate and guide the activities of one or more performers. Such events utilize the mechanics of the performing arts, not only of music but also of choreography and the theater. However, in Fluxus we find a special preoccupation with the terminology, practices, and conventions of musical communication and performance, evident, for instance, in the frequent use of the word "score" to indicate a set of instructions or in the common appearance of the word "music" and the names of musical instruments in titles. Examples include Alison Knowles's *Color Music 1* and *2*, Nam June Paik's *One for Violin Solo*, Takehisa Kosugi's *Theatre Music*, and Dick Higgins's "Danger Music" series.

Brecht's event scores of 1960–61 are some of the earliest, sustained responses to Cage's influence. These pieces exist in the form of short instruction texts that suggest frameworks within which performers may execute certain activities. Many of the event scores do not address themselves specifically to the activities or materials of music. *Three Lamp Events*, from 1961, reads: "on. off. / lamp. / off. on."[25] But many of Brecht's event scores directly address music— more than half of those given in the *Fluxus Performance Workbook* make explicit reference to music or musical instruments. The score for *Saxophone Solo*, 1962, reads simply: "Trumpet." *Solo for Violin, Viola, or Contrabass*, 1961, also consists of a one-word score: "polishing."[26] While it's easy to imagine that a given performance of either of these pieces might involve the production of sound, neither score expressly directs the performer in this regard. More important, the emphasis in each piece seems to be a subversion of the normal employment of

25. Friedman, Smith, and Sachyn, *Fluxus Performance Workbook*, 23.
26. Ibid., 25.

the musical instruments in question. Brecht's *Solo for Violin, Viola, or Contrabass* refers to the instrument not as a sound maker but, by referring to the act of polishing, appeals instead to its status within the realm of the visual. His *Saxophone Solo*, by contrast, refers neither to hearing nor seeing, but presents itself as a category error. Recalling Peter Osborne's definition of conceptual art as "art *about* the cultural act of definition," we begin to see one way in which a conceptual sound practice might constitute itself.

To further refine how such a conceptualism might function, let's look at another Brecht score, *Incidental Music*, from 1961:

> Five piano pieces, any number of which may be played in succession, simultaneously, in any order and combination, with one another or with other pieces.
> 1. The piano seat is tilted on its base and brought to rest against a part of the piano.
> 2. Wooden blocks. A single block is placed inside the piano. A block is placed upon this block, then a third upon the second, and so forth, one by one, until at least one block falls from the column.
> 3. Photographing the piano situation.
> 4. Three dried peas or beans are dropped, one after another, onto the keyboard. Each such seed remaining on the keyboard is attached to the key or keys nearest it with a single piece of pressure-sensitive tape.
> 5. The piano seat is suitably arranged and the performer seats himself.[27]

Immediately, we can detect that this score is different from the previous two. With the two *Solo* pieces, the score seems to demand no definite action, hovering in an indeterminate state between instructions and riddle. However, here the instructions are explicit enough to demand

27. Ibid., 23.

performance. Events one, two, four, and five are explicit in terms of the performer's actions. There is still, however, a degree of performer choice regarding where within the piano the blocks are stacked, how the seat is tilted, how the beans are dropped, the arrangement of the seat, and the sitting. Gravity plays a part in each of these four events. There is no strict prescription of their final material form.

Event number three is different in kind, closer in spirit, perhaps, to the two *Solo* pieces. The form of the verb "photographing" is ambiguous. Is it the gerund, the participle, the continuous present? Is it meant to direct or to describe action? It suggests a neutrality, a passivity, while the other four scores—despite their apparently passive forms—are understood as directions, if not commands. But why a piano? Brecht could have chosen any object. The seat could have been brought to rest against a desk, for instance. Of *Incidental Music*, Brandon LaBelle writes:

> That sound figures dominantly within the construction of events underscores the move away from visual objects and their inherent stability and toward the vibratory, the performative, the humorous, the playful, the propositional, for sound undermines form, as stable referent, by always moving away from its source, while slipping past the guide of representational meaning by exceeding the symbolic.[28]

Implicitly, LaBelle acknowledges the fact that Brecht engages more than sound. The humorous is a product of textuality; often intertextuality as one text inappropriately interrupts another. The propositional is, by definition, discursive. *Incidental Music* engages representational meaning and sets roots firmly within the symbolic. By explicitly engaging music, it initiates symbolic action: the questioning of conventions, of roles, of the "proper" use of materials. That it does so within a

28. Brandon Labelle, *Background Noise: Perspectives on Sound Art* (New York: Continuum, 2006), 62.

space normally designated as nonrepresentational only makes that incursion more pointed. The signifying maneuvers of *Incidental Music* leap out of their context in stark relief. The inherent contravention, then, is a contravention of musical practice, musical tradition, musical understanding. The piece is about terms in opposition in a cultural situation. The title points the way. *Incidental Music* doesn't vaguely undermine form as a stable referent; it subverts musicality itself, and with it the areferentiality that music takes for granted as its birthright. This is a music not of sound but of incidents. What is instigated is not institutional critique in the conventional sense but something more like a critique of "institutedness": of the institutions of music, of the assumptions that underscore its permissions, sanctify its validity. By implication, *Incidental Music* questions the source of such institutedness: the culture that constitutes and is constituted by its institutions and by its institutionality. Conceptual works inhabit their circuits of operation, but do so in a discomfiting way. The position of the conceptual work within its circuit is such that it redirects the customary flow and function of the apparatus. The conceptual work doesn't blow up the pipeline; it doesn't shut it down; it reroutes it so that its contents arrive at an altered destination, drawing attention to the contingency of its normal functioning. Our customary acceptance of the naturalness of the system, of how and what it provides, of our own modes of reception—are all called into question. And this *calling-into-question* is constitutive of the state-of-being of the conceptual work. The responsibility of forming *specific* questions is left to the spectator.

Approached from this perspective, Brecht's *Incidental Music* opens a space of questioning, a space in which some of the basic presumptions of music might be reconsidered. For example, the first event suggests that "the piano seat is tilted on its base and brought to rest against a part of the piano." The materiality of the piano and its seat are brought to our attention. This construct—the "seat-piano," as Deleuze might have said—offers itself for reconfiguration. The precise form of this reconfiguration is not dictated, nor is it clear that any given configuration would differ meaningfully from any other. It is the

reconfiguring gesture itself, or even just its suggestion, that intervenes in the circuits of the piano and of music.

George Brecht performing *Incidental Music* (piece number 2), ca. 1961. Photographer unknown.

The mechanics of the piano are quite simple. A key is depressed, activating a hammer, which strikes a string or group of strings. The second and fourth pieces of *Incidental Music* directly intervene in both the mechanics and the circuit of the piano. In the second, the hammer is supplanted by the blocks, while the mechanism and intentionality manifest in the keys are replaced by the instability of the stacking procedure, by gravity, by the unintentional and unpredictable nature of the moment of collapse. In the fourth, the keys *are* engaged, but by objects too light to depress them, too insubstantial to activate the hammers. Nevertheless, one can imagine that the dried peas or beans dropping onto the keyboard *would* produce a sound, a faint ticking. This sound surely is always present in piano performance, as the player's fingertips contact the keys, yet—like the ambient noise of Cage's *4' 33"*—it is almost always overlooked. Additionally, the sound produced by the beans takes no advantage of the great cavernous internal space of the piano, the sound board, or the resonance of the wooden body, designed to amplify the inputs of the pianist. The piano, as designed, as employed at the heart of Western music for

three centuries, is ignored. The approach to the piano is that of a child or an alien, of one encountering this contraption for the first time, without preconception. *Incidental Music* is, thus, a *re*conception of the piano; a questioning of the concepts embedded in this object, this machine, this totem.

As I've already mentioned, the third event of *Incidental Music* is the most passive, the most neutral in its presentation as score or instruction; yet its conceptual implications are possibly the most active and intrusive of the set. The overt reference to "the piano situation" immediately draws our attention to the fact that the piano does actually initiate a situation. The presence of a piano—especially on a stage—dictates behaviors, creates expectations, conjures a history, solicits a technique—all of which are products of cultural habits, not natural givens. Everything engaged by *Incidental Music*, most explicitly in the third event, constitutes the expanded situation of the piano and, by association, of music. If we accept Cage's *4' 33"*, conceptually, as a subversion of the circumstances of musicians and instruments at-the-ready, then we can see Brecht's reference to "the piano situation" as intervening at an earlier and more basic stage of musical conceptualization. The instrument itself establishes norms. The third event even suggests that this situation is so real, so palpable, that it can be photographed.

Like the most successful examples of conceptual art, *Incidental Music* doesn't ask explicit questions. Instead, it creates the conditions of possibility within which certain questions *can* be asked. The questions we are bound to ask are questions of the constitution of the musical text, the musical performance—of the constitution, the *concept*, in its most basic sense, of music itself. We find ourselves wondering, along with the musicologist Jean-Jacques Nattiez, about the minimal condition of something we might reasonably call music.

Sound is an irreducible given of music. Even in the marginal cases in which it is absent, it is nonetheless present by allusion.[29]

29. Jean-Jacques Nattiez, *Music and Discourse* (Princeton: Princeton University Press, 1990), 67.

7

SOUND-OUT-OF-ITSELF

It is never it, but *almost nothing* is something else. In 1967 Luc Ferrari placed a pair of microphones on the windowsill of his bedroom on the Dalmatian coast. Every day, for the same three hours in the very early morning, he recorded the first signs of daily life in the tiny fishing village. He then selected certain sounds and sequences and edited them into a twenty-one-minute composition entitled *Presque Rien, ou, Le lever du jour au bord de la mer* (*Almost Nothing, or, Daybreak at the Seashore*). Nine years earlier, Pierre Schaeffer had invited Ferrari to join the Groupe de Recherches Musicales (GRM), a new research facility dedicated to the study of musique concrète. Schaeffer's methodology was well established: "Use sounds as instruments, as sounds on tape, without the causality. It was no longer a clarinet or a spring or a piano, but a sound with a form, a development, a life of its own."[1]

Ferrari, meanwhile, pursued his own compositional ideas. Although he and Schaeffer shared an interest in recorded sounds and the freedom they offered from compositional orthodoxy, Ferrari was never as ideological as Schaeffer, viewing rules and systems as strictures to be resisted. Ferrari rejected Schaeffer's central tenet, the acousmatic reduction. Rather than detaching a sound from its source to arrive at the primordial *objet sonore*, Ferrari prized sounds for their connection to the world and to senses other than hearing:

From 1963 on I listened to all the sounds which I had recorded, I found that they were like images. Not only for me who could remember them, but also for innocent listeners. Provide

1. Luc Ferrari, as quoted in Dan Warburton, "Interview with Luc Ferrari," *Paris Transatlantic Magazine,* July 22, 1998, www.paristransatlantic.com/magazine/interviews/ferrari.html (accessed February 2, 2009).

images, I told myself, contradictory images which catapult in the head with even more freedom than if one really saw them. Play with images like one plays with words in poetry.[2]

Presque Rien, No. 1 (as it has been known since 1977, when Ferrari began a subsequent series of numbered *Presque Riens*) is a marvel of its kind. Although now there are entire subgenres of its kind, at the time of its release, on Deutsche Grammophon in 1970, there really was nothing like it. It is a portrait, not just of sounds, but also of a community and the repetitive cycles of its daily life. By recording every day at the same time, over an extended period, Ferrari came to recognize the town's significant aural features:

I recorded those sounds which repeated every day: the first fisherman passing by same time every day with his bicycle, the first hen, the first donkey, and then the lorry which left at 6 am to the port to pick up people arriving on the boat. Events determined by society.[3]

Presque Rien, No. 1 bears some resemblance to Walter Ruttmann's *Wochende* from 1930. Ruttmann had also created his work of "blind cinema" by recording the sounds of everyday life: transportation, meals, music, and conversation. But the "world" he depicted was fictional, an impressionistic montage, created to represent an idealized vision of a working-class German weekend. Ferrari's world is not created by the composer. It is a work of documentary or reportage. But Ferrari is not so naive as to suggest that what he has captured is the "real." Contrary to Schaeffer's adherence to Husserlian essentialism, Ferrari's relationship to his material has far more in common with the cultural phenomenology of Merleau-Ponty, accepting phenomena as "the permanent data of the problem which culture attempts

2. Luc Ferrari, "I Was Running in So Many Different Directions," trans. Alexandra Boyle, *Contemporary Music Review* 15, part 1 (1996): 100.
3. Ferrari, as quoted in Warburton, "Interview with Luc Ferrari."

to resolve."[4] Ferrari recognizes that his sonic portrayal of human rit-
ual is prone to the same problems that plague any anthropological
endeavor. The act of recording alters what it records. "The work is a
series of sequences that represents a natural, given situation captured
by a given manner of recording. This was the most radical composi-
tion I had ever composed."[5] The composition is radical for both what
it does and what it does not do. As quickly as Ferrari posits a "natural,
given situation," he denaturalizes it via a "given manner of recording."
His conception of what constitutes the work agrees with Merleau-
Ponty's proposal that raw, phenomenological data is importantly, yet
merely, the foundation from which thinking and doing proceed. Unlike
with the Schaefferrian acousmatic, sound is not stripped of its mean-
ing, neutralized as sound-in-itself, to be reconstructed as a compo-
sition. Instead, its connection to a social reality is left intact. More
than that, the social meaning of the sounds play a part in determining
their placement and treatment in the composition. To do this, Ferrari
must approach his sounds not just as a listener—separated from the
sound source by the acousmatic curtain—he must approach sound
as a reader: he must understand what these sounds represent, how
they relate to one another, how and to whom they communicate.

Ferrari's interest in cycles of societal interaction predates his
involvement with Schaeffer. Throughout his career, in addition to his
tape pieces, he has composed for conventional instruments, fre-
quently employing repeating cells of musical material, overlapping
cycles of different durations, to create newly evolving interactions.
His interest in repetition is extramusical.

Repetition presented for me not so much a process as the
observation of the social organisation of time. Thus observed,

4. Maurice Merleau-Ponty, "The Primacy of Perception and Its Philosophical
Consequences," in *The Phenomenology Reader*, ed. Dermot Moran and Timothy
Mooney (London: Routledge, 2002), 446.

5. Luc Ferrari, as quoted in Brigitte Robindoré, "Luc Ferrari: Interview with an
Intimate Iconoclast," *Computer Music Journal* 22, no. 3 (Fall 1998): 13.

time organises itself in layers and according to a certain num-
ber of points of view—social, political and sentimental. . . . It
is in this sense that repetition fascinated me. For example, I
remember having said, "Monday is a day like any other but
the butchers are closed."[6]

Unlike his researcher colleagues at the GRM, Ferrari has never
approached his work clinically. Both his compositions and his commen-
taries are leavened with a mischievous sense of humor. Distinguishing
his practice from orthodox musique concrète, he wrote, "I called that
musique anecdotique without really believing it."[7] His sense of humor
belies an incisive understanding of the issues at play in his practice,
including an acute awareness of the listener-as-reader. His work is
anecdotal rather than concrete because it maintains a connection to
the situations in which it is recorded and to the narrative from which
it is excised. He has also referred to his tape compositions as *son
mémorisé* (stored, recorded, or memorized sound). It is not concret-
ized but rather stored for future use in the technological memory of
the recording medium. His recordings act as seed banks from which
future plantings and harvestings might be derived. To push the meta-
phor further—but also closer to Ferrari's own conception—his record-
ings are beings-in-the-world of his compositional microsocieties.
Their interactions carry some of the complexity of the situations in
which they were recorded, combining in unpredictable ways. They
are anecdotal both because they are formed of anecdotes from the
flow of the cultures in which the original recordings are made, yet
also because they combine to form new anecdotes. The sounds of
a piece of Ferrari's *musique anecdotique* are open conduits in which
meaning flows between the worlds from which they were taken and
the world they create. This meaning is pointedly Derridean, a product
of differential friction and the trace of alterity, a meaning constituted
by what it is not.

6. Ferrari, "I Was Running," 97.
7. Ibid., 101.

Beginning at least as early as *Hétérozygote* (1963–64) Ferrari included recorded snippets of spoken language. "I believe that one cannot speak seriously without the persiflage which gives to serious-ness its complicity, and to rightness the counterpoint of error to which it is irremediably attached."[8] This complicit seriousness, this error-laden rightness, is an inevitable product of narrative structure and linguistic content. In 1977 Ferrari created *Presque Rien, No. 2: Ainsi continue la nuit dans ma tête multiple* (*Almost Nothing, No. 2: Thus Continues the Night in My Multiple Head*). Ferrari goes beyond the inclusion of captured conversations, intervening in the most uncon-crete way: "*Presque Rien, No. 2* was a derailment of *Presque Rien, No. 1.*"[9] He recorded the traffic, birds, bells, crickets, and dogs of the tiny village of Tuchan, in Corbières, Switzerland, much as he had done in Dalmatia in *Presque Rien, No. 1.* But rather than recording from a fixed perspective, he strolls around the town, recording in multiple locations. More important, as he strolls and records, he speaks into the microphone, inserting an overt narrative perspective, where previ-ous environmental recordings had posited an untenable objectivity.

There was also the idea of the walker/observer, who realises what he's recording and adds his ideas. In fact there's true and false involved—there are some things which were added for dramaturgical reasons, some commentaries which are completely bogus! In any case, playing with truth and lies is what makes up the concept, . . . putting the walker inside the recording process and recognising him as a person, led me to think: "There are these natural sounds, and I'm going to make sounds too, incorporate a symbolic transcription of what comes into my head and then intervene as composer."

Ferrari's concern goes well beyond sound-in-itself. Sound is merely the track upon which his train of thought runs, traveling from

8. Ibid., 96.
9. Ferrari, as quoted in Warburton, "Interview with Luc Ferrari."

Point A—the rhythms, cycles, interactions, and accidents of human life—to Point B—an aesthetic engagement with what Ferrari has called "a concrete attachment to social, political and sentimental life."[10] The subtitle *Thus Continues the Night in My Multiple Head* captures the metaphorically reverberant nature of the piece. The night as phenomenon exists "out there," but it also exists "in here" for anyone who experiences it. The interior night echoes the exterior night, introducing the inevitable "counterpoint of error." The exterior night also echoes the interior night, adapting to the experience of the witness. To further complicate matters, the "in here" of the head is multiple. The walker/observer is never of one mind. He realizes he's recording. He mixes fact with fiction. As Jean-Luc Nancy has theorized it, sound is innately referential. Meaning and sound constitute each other and, in the process, identify both an origin and objective of reference:

> One can say, then, at least, that meaning and sound share the space of referral, in which at the same time they refer to each other, and that, in a very general way, this space can be defined as the space of a *self*, a subject. A *self* is nothing other than a form or function of referral: a *self* is made of a relationship *to* self.[11]

Ferrari's "symbolic transcription" of his thoughts is the space of referral of the self, the symbolic grid that *is* the self, comparable to Peirce's conception of the "man-sign." This grid interacts with the symbolic grids of the recorded sounds, of his awareness of himself and his activities, of facts, of fiction. But it does not stop there. These symbolic grids, located roughly on the side of production, interact with the matrix of symbolic grids on the side of reception: the recorded sounds as received, the awareness of the process of recording, the

10. Ferrari, "I Was Running," 99.
11. Jean-Luc Nancy, *Listening*, trans. Charlotte Mandell (New York: Fordham University Press, 2007), 8.

recorder's interventionist presence in the recording, the listener's awareness of the walker/observer's awareness of himself, the listener's awareness of one's listening self engaged in the listening activity, and so on, ad infinitum.

Luc Ferrari, making a recording for *Far West News, Episodes 2 and 3*, Colorado, 1998. Photo: Brunhild Meyer-Ferrari. Courtesy Brunhild Meyer-Ferrari.

Far-West News, Episodes 2 and 3 (2006) is comprised of recordings made during a trip to the American Southwest in 1998; in many ways it is Ferrari's fullest exploration of *musique anecdotique*. Instead of the snippets of captured conversation of *Hétérozygote*, or the hushed, interior monologue of *Presque Rien, No. 2*, the interaction of voices in *Far-West News* constitutes a record of interaction. Ferrari isn't simply an objective recordist or a detached observer/narrator; he and his wife, Brunhild Meyer-Ferrari, are active participants in their environment. Ferrari's long-standing concern with the social, political, and sentimental are foregrounded, along with the resulting problematic relation of his work to the category of music. The piece starts in familiar Ferrarian territory, with the sounds of birds and crickets.

Forty-five seconds into "Episode 2," a passing car is manipulated, post-recording, to resonate like the otherworldly harmonies of Ligeti's *Atmosphères* (used to great cinematic [i.e., narrative] effect by Stanley Kubrick in *2001: A Space Odyssey*). Throughout the piece, Ferrari overdubs musical passages, ranging from cartoonishly manic interventions to faux-symphonic soundtrack accompaniments, using these passages as both connective tissue between episodes and as a kind of aural punctuation.

Later in "Episode 2," Meyer-Ferrari's pitched-down voice announces, "At Springdale, there was an appointment with the American composer Phillip Bimstein." The encounter that follows condenses all of Ferrari's concerns into a single interaction. After a knock on the door, we hear the squeak of the door hinges as Bimstein welcomes the couple to Springdale, Utah. Bimstein checks his pronunciation of Ferrari's first name, Luc, which is then spoken more than ten times by the three new acquaintances, stretching the single syllable to confirm the vowel sound. It is unclear if they actually spoke the name so many times or if Ferrari looped "Luc." But in either case, he takes a palpable, sonic glee in the absurd repetition of his name. The piece expresses its self-awareness when Ferrari explains why he is recording their conversation: "I make sound-land-art." Again the three voices repeat the one-syllable words, this time reshuffling them to create new constructions, each equally applicable to Ferrari's enterprise: "sound-land-art," "land-sound-art," "art-land-sound," "art-sound-land." Ferrari's practice couldn't be more distant from phenomenological essentialism, from sound-in-itself. *Far-West News* engages sense, not sound. Sense can never be *in-itself*. Sense cannot partake of the absolute proximity of self-presence. As Nancy points out, sense is an awareness of being aware; a conception that finds its most comfortable expression in the reverberant, expanded situation of sound:

> Indeed, as we have known since Aristotle, sensing (*aesthe-sis*) is always a perception, that is, a feeling-oneself-feel: or, if

you prefer, sensing is a subject, or it does not sense. But it is perhaps in the sonorous register that this reflected structure is most obviously manifest.[12]

In *Far-West News* the subsequent conversation turns to Bimstein's dual role as composer of experimental music and mayor of Springdale. He explains how his musical training qualifies him for his political responsibilities:

> We know how different sounds can be combined, different voices; . . . those can be blended together in a way that works. Same thing in politics. You've got all these people in town with different voices, different feelings, different opinions. So I know, as someone who has orchestrated pieces, that they can all work together. And there can be counterpoint.[13]

When Meyer-Ferrari suggests that all politicians should be musicians, Bimstein responds, "Except that we know that some musicians are too, too, you know . . ."[14]

"I am sitting in a room different from the one you are in now." Alvin Lucier's voice first announces its situation. Then it announce its intentions:

> I am sitting in a room different from the one you are in now. I am recording the sound of my speaking voice and I am going to play it back into the room again and again until the resonant frequencies of the room reinforce themselves so that any semblance of my speech, with perhaps the exception of rhythm, is destroyed.

12. Ibid.
13. Luc Ferrari, *Far-West News, Episodes 2 and 3* (Blue Chopsticks, 2006).
14. Ibid.

What you will hear, then, is the natural resonant frequencies of the room articulated by speech.

I regard this activity not so much as a demonstration of a physical fact, but more as a way to smooth out any irregularities my speech might have.[15]

In 1969, at his apartment in Middletown, Connecticut, Lucier threaded a reel of magnetic tape onto a reel-to-reel tape recorder, connected a microphone, and sat down to read the text above. *I am sitting in a room* plays out a simple procedure. The text is recorded onto one tape recorder and then played back into the room and recorded onto a second tape recorder. The second recording is then played back into the room and recorded on the first machine, and so on. Each recording captures sound played over loudspeakers in the room. In other words, this is not a tape-to-tape dub occurring in the hermetic electronic environment of the machines. Sound is always effected by the physical space in which it is heard. The size and shape of the room; the materials of the walls, floor, and ceiling; the presence or absence of curtains and carpeting—all exert an influence. Some frequencies fit naturally in a given room and are therefore maintained with minimal degradation. Other frequencies, however, clash with the room and are canceled out in a process that closely resembles the one used in noise-canceling headphones. As the text describes, the effect is that of an accretion of these effects, each iteration subject to additional reinforcement of certain frequencies and additional cancellation of others. After a short while, the sound of the recording changes dramatically, eventually transformed into a shimmering electrical pulse. *I am sitting in a room* has ascended to a position slightly below *4' 33"* in the pantheon of postwar American sonic arts practice. To confirm this, one need look no further than *The American Century*, a survey of twentieth-century American art presented at the Whitney

15. Alvin Lucier, *Reflections: Interviews, Scores, Writings, 1965–1994* (Cologne: MusikTexte, 1995), 312.

Museum of American Art in 2000. The sound and music components of the exhibition were gathered under the title *I am sitting in a room*.

Alvin Lucier was an undergrad at Yale in the mid-1950s. Later, in Rome on a Fulbright Scholarship, he first encountered the music of John Cage, and for him, as for so many others, the encounter was decisive. One need not recount the history of twentieth-century Western composition to recognize that composers coming of age artistically in the fifties and sixties were doing so under the inescapable influence of Serialism, the prevailing musical aesthetic, method, and ethos of the day. American composers—particularly, but not exclusively—responded to Serialism as an edict imposed from another place and time. It felt, as many of the composers of this generation have said, like a foreign tongue. Nevertheless, it was the lingua franca of mid-century music. This explains, in part, the liberating impact of Cage on composers five, ten, and twenty years younger than himself.

By the time Lucier returned to the United States in the mid-1960s, he was already composing experimental works, employing Cagean ideas like indeterminacy, suspension of composer or performer intention, and the employment of electronics. In *Music for Solo Performer, for enormously amplified brain waves and percussion* (1965), EEG electrodes are attached to the performer's scalp. The performer assumes a state of minimal visual stimulation—either by closing his or her eyes or by concentrating on nonvisual stimuli. This mental state produces low-frequency alpha brainwaves in the range of eight to twelve hertz—well below the range of human hearing. The waves are amplified and routed to speakers. The resulting energy—despite the fact that we can't hear the frequencies it produces—nevertheless causes the speakers to pulsate. The speaker diaphragms are used to vibrate various percussion instruments. (The score suggests gongs, tympani, and snare drums, as well as other sound sources such as cardboard boxes and metal ash cans.)[16] In order for the performer to

16. Ibid., 294.

maintain this nonvisual state, and thus produce the required alpha waves, he or she must remain calm and restful, nearly meditative—a distinctly nonperformative version of performance.

In *I am sitting in a room*, elements traditionally conceived as operating in different registers and at different phases of the work's existence leech into one another's space and time. The text is both the content of the work and the instructions for the work. The process, dictated and described by the text, doesn't simply manufacture the form of the work; it is also subject to it. That process, that form, takes the text as its content. The composer's score, normally thought to precede the work's materialization, is imbricated in the act of materialization. To perform the work requires no interpretation, no translation, no manipulation on the part of the performer. The elaboration of the work is achieved by the process, which in this case is also the instructions, also the content, also the description (the catalog copy or the program notes). Even the title is nothing more than synecdoche: a part-for-whole invocation of everything else.

I am sitting in a room is a particularly conspicuous example of what I referred to, in chapter 2, as "retrospective composition." What I wrote of Robert Morris's *Box with the Sound of Its Own Making* is equally true of *I am sitting in a room*: The "score" for the sound material of the work is only available (constructable) after the performance/ production. In the case of *I am sitting in a room*, this is literally true: the score included in Lucier's book *Reflections* is dated 1970, the year *after* the first performance/recording of the piece. This apparent paradox is always present in the contradictory nature of the score, which must always follow from some material realization of itself. More than any other piece of sonic art, *I am sitting in a room* reveals the dirty secret of the score: the score is the founding document of *re*-creation; it does not precede the work, but follows from it; it is the descendent of a realization that claims it retrospectively as a precedent. As I wrote in chapter 2, the score always arrives after the fact to dictate the fact.

In the middle of the twentieth century, philosophy underwent its so-called "linguistic turn." In the 1960s and 1970s, the gallery arts adopted language as an implicit and explicit material. We can conceive of both Brecht's event scores and *I am sitting in a room* as emblematic of a related—if less prevalent—development in the sonic arts. The conveyance of musical instructions in text scores was not a new idea by 1969. As we have seen, visual artists had adopted this practice from composers like John Cage, Earle Brown, and La Monte Young. Nor was the use of recordings of spoken language as a musical material unprecedented. Ferrari's *Hétérozygote* (1963–64) includes recorded speech, and Steve Reich's famous tape pieces *It's Gonna Rain* (1965) and *Come Out* (1966) are constructed of nothing but recorded speech. But Lucier's *I am sitting in a room* treats language not just as a medium of communication, nor simply as material to be subjected to nonlinguistic procedures. Instead, like the conceptualists Lawrence Weiner and Mel Bochner, Lucier leverages the representational contradictions built into the fabric of language. In Lucier's case, working with the "irregularities" (as he calls them) of spoken language, these contradictions take on additional meanings. The most obvious of these is the regulating effect that the space and the process of repetition have on Lucier's stutter. A stutter is a corruption of both the sonic and the semantic aspects of language. It upsets the rhythms of language and the distribution of the sounds of specific consonants and vowels. A stutter turns the so-called music of speech into a mechanical grind, drawing our attention to the usually ignored flow from syllable to syllable, word to word, phrase to phrase. A stutter also upsets sense-making: the process of retention and protention, of toggling between what has just been said and what is likely to be said next, with constant adjustment as new information is introduced. When we listen to a speaker who stutters, we can hear, and sometimes even say, words before the speaker speaks them. We are newly aware of the decision-making process at work in acts of speech.

Brandon LaBelle goes so far as to claim that "the stutter *drives the work*, . . . is the very heart of the work."[17] This raises questions: Would a subsequent version of *I am sitting in a room*, in which Lucier does not stutter, be an unsuccessful interpretation of the piece? Would it be a different piece altogether? Can someone other than Lucier—someone without a stutter—perform *I am sitting in a room*? If so, is that nonstutterer obliged to stutter? In September of 2005, Lucier performed live on my radio program, *Unst: Bespoke Sound*, a weekly broadcast of radio art on Resonance FM in London. It was the first time he had ever presented *I am sitting in a room* on the radio. For the occasion, Lucier reworked the text:

> I am sitting in a radio studio. The sound of my voice is being picked up by a microphone and fed into a delay system which recycles my speech into the room again and again. As the process continues, those frequencies of my voice which match the physical dimensions of the room are reinforced. By the end of the process only the resonant frequencies of the room remain. I made this work in 1969 in a small apartment in Middletown, Connecticut. The apartment had a green shag rug on the floor and large green drapes on the windows. I unplugged the refrigerator and turned off the heat. I waited until the traffic outside subsided. It was snowing, making everything quiet.[18]

The text makes no reference to speech irregularities, and Lucier's performance is delivered without a stutter. Still, the process unfolds. As with the most familiar versions of *I am sitting in a room*, recorded in 1969 and 1980, Lucier's speaking voice melts into a metallic shimmer. As with the earlier versions, the process, dictated and described by

17. Brandon LaBelle, *Background Noise: Perspectives on Sound Art* (New York: Continuum, 2006), 126.

18. Alvin Lucier, *I am sitting in a radio studio. Unst: Bespoke Sound*, Resonance FM (104.4), London, September 17, 2005.

the text, doesn't simply manufacture the form of the work; it is also subject to it. It would be misguided to map the term "irregularities" to Lucier's stutter in a one-to-one correspondence. All speech is irregular. This is insured by the materiality of individual voices, accents, and cadences. But it is also insured by the infidelity of speech to both its written counterpart and to any notion of a preceding referent. In the radio broadcast, Lucier's voice is still irregular: the cadences are uniquely his (possibly informed by his efforts to control his stutter). His strong New England accent is clearly evident at the start, but by the end, that regional distinction is rubbed out by the process. He might as well be speaking Spanish with a Catalonian accent. The work also makes evident the always encroaching semantic decay of speech. The voice is always fading away. In *I am sitting in a room*, it plays a cruel game with the listener, repeating itself for semantic confirmation, while at the same time eroding the sonic clarity that makes meaning possible. None of this is affected by the absence of the stutter.

Additionally, *I am sitting in a radio studio* throws open the window of the room, so to speak, welcoming history and biography. The revised text references the original version, time-stamping it and accentuating the distance between "original" and "copy," between inspiration and iteration, between composition and interpretation. Likewise, each iteration of the piece's process echoes the previous iteration(s): the 1980 version echoes the 1969 version, the 2005 version echoes both, producing an echo of echoes. The radio text includes verbal descriptions of physical and visual specificities with sonic ramifications. A green shag rug and drapes set the scene in a way no one previously familiar with the piece would have imagined. New England snow turns the scene positively bucolic. With the 2005 version, *I am sitting in a radio studio*, the acoustic artifact, the sound-in-itselfness of *I am sitting in a room*, is finally reattached to the time and place of its production, replete with the interior design touches of its era and the meteorological exigencies of winter in New England. But this history, too, and all these specific details, are constantly being

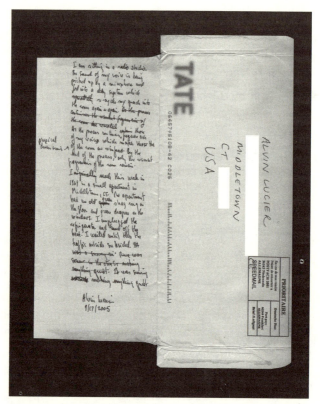

Alvin Lucier's text score for *I am sitting in a radio studio*, scrawled on the back of a Tate Modern envelope, September 17, 2005.

swallowed by the process, by time and language and the blurring of memory. *I am sitting in a room* is about much more than the stutter. It cannot be reduced to an "obsession with physical phenomena,"[19] nor to an "audio recording and amplified playback, compounded by architecture, and made object."[20] Brandon LaBelle rightly points out that Lucier's work, including *I am sitting in a room*, "engages . . . the contexts of its experience."[21] But at the same time, he describes

19. LaBelle, *Background Noise*, 127.
20. Ibid., 131.
21. Ibid.

Lucier's work as an "explorative pursuit of how sound works as physical phenomena."[22] This is the predominant, yet reductive, reading of Lucier's oeuvre that has found purchase in the history of the sonic arts. The Museum of Modern Art describes Lucier this way: "In his experimental compositions, Lucier explores auditory perception from a scientific point of view. Much of his work is influenced by the physical properties of sound itself."[23]

While *I am sitting in a room* undoubtedly explores auditory phenomena, the text itself announces that it is "not so much . . . a demonstration of a physical fact." Its richest existence takes place away from the ear, either before it or after it, in another kind of space. The most fascinating questions the piece might compel us to ask are not questions of the final audible material of the recording. The most critical implications of the piece—as it inserts itself variously into the circuits of music, literature, the gallery arts, plain speech, psychology, speech pathology, ontology, and epistemology—are accessible to the spectator without recourse to the material fact of the recording. It might even be that close attention to the sonic results of *I am sitting in a room* occludes the more pressing conceptual concerns raised by the piece. Thus I might suggest that, in order to best engage it, one need not—perhaps even *should* not—listen to *I am sitting in a room*.

"Simple ain't easy." This utterly unsimple truth is attributed to Thelonious Monk. Similarly, Bob Dylan's "Like a Rolling Stone," despite the simplicity of its form, is anything but simple. That crack of the snare drum, followed by a kick drum thud, trips the band as they pass through the doorway into the song. Greil Marcus, in his book-length meditation on the song, calls it a "rifle going off not in the third act but as the curtain goes up."[24] Marcus astutely directs attention

22. Ibid., 124.
23. From the Museum of Modern Art's film exhibition program, November 2008, www.moma.org/exhibitions/film_exhibitions.php?id=9222&ref=calendar (accessed February 2, 2009).
24. Greil Marcus, *Like a Rolling Stone: Bob Dylan at the Crossroads* (New York: Public Affairs, 2005), 94.

away from the sound-in-itself, from its self-presence, and toward the absence it opens up, a newly minted negative space: "For an expanding instant there is nothing."[25] To Marcus's ear, the moment between the snare drum and the kick drum (longer, somehow, than the space between the kick and the band's entrance—though it shouldn't be, they are equal divisions of musical time) is an opening onto the past and into the future. Irreducible to the *Ohrenblick*, this space and this time are where the past and the future collide: a moment of indefinite presence. It is the advent of the idea of song, as if, despite the centuries of songs that preceded it, songs simply hadn't realized what they were capable of. The space between the snare and the kick drum at the opening of "Like a Rolling Stone" is a signal that the new way has arrived; the old way of thinking and being and living is no longer useful because it is no longer good enough and, in truth—the space between snare and kick seem to say—it never was. "No one had ever tried to make as much of a song, to altogether open the territory it might claim, to make a song a story, and a sound, but also the Oklahoma Land Rush."[26] When Marcus calls it an "expanding instant," he means it in the sense of the westward expansion, an invention, not just of a new sound, but also of a new nation and a new people; not just *a* new world, but also *the* New World.

In the opening seconds the piano falls behind. The playing is tentative, as if Paul Griffin, the piano player, hasn't heard the song before. In fact, it was only the sixth time Griffin had ever heard the song and the first time he'd heard it all the way through from beginning to end. The day it was recorded—June 16, 1965—was the second day that Dylan had led his band through the song. But on the first day, June 15, Griffin had not been present. So on the sixteenth, the band played the song twice in rehearsal and tried, three times, to record it, never making it all the way to the end. The version we know, the single and the track as it appeared on Dylan's album *Highway 61 Revisited*, was the fourth take of the day. The song is the sonic evidence of the band

25. Ibid.
26. Ibid., 95.

finding their feet on a song they barely know. Griffin is already a little late on the second chord of the song and very perceptibly late on the fourth. The threads holding "Like a Rolling Stone" together have already started to come undone; the seams are loosening. At various points throughout the song, the piano falls out of time. It hits bum notes. It explores new approaches to sections, only to abandon them in the middle of a bar and return to an already-used approach. But the piano player isn't the only one who gets lost. The tambourine goes absolutely AWOL. During the verse there appears to be a pattern: hits on the second beat and on the "ands" after the third and fourth beats of the measure. Even this simple scheme drifts, separating at times from the rhythm. The listener is forced to negotiate the feel created by the drums and the bass guitar with the tambourine's detours. It's difficult. The tambourine is so high in the mix that it challenges the entire drum kit for rhythmic dominance. In the choruses, everything goes to the dogs; the tambourine gropes for new patterns, occasionally falling back into the verse pattern. At times it is so distracted, so inconsistent, that it sounds like it's responding to an entirely different song.

But sloppy execution is just one variety of infidelity evident in "Like a Rolling Stone." The manifest sonic aberrance is a symptom of more significant dysfunctions. The song itself, as we imagine it—separated from this or any subsequent performance; separated from the ideal or model of the song—is unwaveringly repetitive. The structure is basic: four verses, each followed by a chorus. The verses are comprised of two parts: vocally, the first is a breathless effluence:

Once upon a time you dressed so fine,
 You threw the bums a dime in your prime, didn't you?
People'd call, say, "Beware doll, you're bound to fall."
 You thought they were all kiddin' you.[27]

27. Bob Dylan, "Like a Rolling Stone," *Highway 61 Revisited* (New York: Columbia Records, 1965. All subsequent citations of "Like a Rolling Stone" lyrics refer to this recording.

The vocal in the second part of the verse is more measured, spacing out phrases for emphatic effect:

> You used to . . .
> laugh about
> everybody that was . . .
> hangin' out.
> Now you don't . . .
> talk so loud
> Now you don't . . .
> seem so proud
> about having to be scrounging . . .
> for your next meal

Lyrically, by and large, the first part of the verses describes the past, laying out the history of the second-person subject of the song. The second part paints a picture of her current state ("Now you don't seem so proud"), asks her if she's learned her lessons ("Ain't it hard when you discover that he really wasn't where it's at?"), offers advice ("Go to him now, he calls you, you can't refuse").

The chorus follows like a pointed stick:

> How does it feel,
> How does it feel
> to be on your own, to be without a home
> like a complete unknown,
> like a rolling stone?

In the role of cold-blooded prosecutor, the singer presents his evidence in the verses and then asks the devastating questions in the chorus. Vocally, Dylan hangs on the "f" in "feel," torturing the single consonant that, not incidentally, arms the English language's most virulent curse. The subject of the song (Miss Lonely, as she is called in the second verse), is not given an opportunity to respond.

The singer-inquisitor trusts that we, the listener-jury, will draw the proper conclusions.

As with much of Dylan's mid- to late-1960s output, the reality of the performance of "Like a Rolling Stone" constantly evades the ideal of its form. That it still manages to communicate a form—while never, in good faith, delivering it—is a tripartite sleight of hand: (1) it is dependent on listeners' familiarity with traditional song form—a familiarity Dylan himself, as much as anyone, created; (2) it relies on Dylan's compositional finesse at navigating established paths, rutted by the wheels of previous songs, while managing to create distinct, new impressions; (3) most of all, it derives from Dylan's sly performative strategies, which allow every single particle of the performance to map to its correlate component in the model, without ever supplying the model itself—a version of the old carnival knife thrower's act that traces the assistant's outline after she has stepped away from the board. In the perceptual imaginations of latecomers, the knives supply all the information needed to generate both the form of the assistant and the constitutive act. With Dylan, we are all latecomers. The assistant is never there against the board; the knives alone testify. The melody, although we can detect it from the outline of knives, is never sung straight. Each knife, each inflection, is off axis. Upon inspection, the outline is ragged and distracted. We begin to wonder if it actually suggests the assistant at all or if we have supplied that meaning by dint of some subliminal or desirous suggestion from within or without the song, from within or without ourselves. So it dawns on us: this could have been otherwise. A slightly different skew in this or that inflection would instigate no crisis. We would not lose the suggestion of the song in its ideal. A different arrangement would make different meanings *within* the song, *against* the backdrop of our hearing of it, but it would not—indeed, could not—chase the song out of itself.

"High fidelity" is a technological term, meant to suggest that the recording is faithful to the sonic features and parameters of the original. High fidelity is technological verisimilitude. Both the term and the ideal it implies ignore the unavoidable facts of modern recording.

The performance is never a feral organism to be captured but rather a Frankenstein monster animated for the occasion of the recording. Tracks are overdubbed hours, weeks, sometimes years after the initial performance—if there ever was one. Any recording displays fidelity to its ontological model because it is its own original. This isn't to propose recordings as an instance of phenomenological primordiality. Recordings are still differential texts, products of the layer-upon-layer overlap of semantic fabric. But there is no point in evaluating a recording's fidelity to an "authentic" original performance. The poorly named lo-fi movement—discussed briefly in chapter 4—exerted considerable influence on independent rock in the early to mid-1990s (I'm thinking here, again, of bands like Sebadoh, Pavement, and Guided by Voices). The representational problem these bands faced was actually the opposite of what is normally discussed. The scratchy, hissy releases by these bands exemplify this point. The issue was not the faithfulness of the recordings. The recordings are not low-fidelity representations of high-fidelity performances. The sound quality—noisy, distorted, muffled—is a primary component of these recordings-as-texts—not just style, but content. In live performance these bands struggled to convey the degraded sonic signifiers of their recordings: they tended to sound *too good*. The sonic degradation of their recordings always indicated something more than inferior equipment and small recording budgets. It reflects a disregard for the technical, aesthetic, and commercial values of the rock-and-roll recording industry. Lo-fi recordings are acts of resistance to the conventions of the medium. They are portraits of iconoclastic fuckups in their self-imposed bedroom exiles, dedicated not to money or fame or virtuosity but to a do-it-yourself ethos and to an intimacy that bridges the divide between artist and audience. Of these bands, Sebadoh was, perhaps inadvertently, the most successful at transposing the meaning of its recordings to live performance. Sonic degradation became social degradation as the band became associated with their publicly expressed hostility toward one another. Concert goers came face-to-face with the dysfunctional freaks they thought they heard

on record: performances often devolved into arguments, physical fights, and occasionally full-blown melees, with the performers taking down their instruments and amplifiers and scuttling whatever remained of the gig.

Exporting the term "high fidelity" to the formal and ontological realms is equally problematic. Although the concept of the score as originary is highly suspect, the Western compositional tradition still finds solace in the score as interpretive backstop. Performances (interpretations, as they are known) of a given score must hew to the score-as-blueprint or justify their deviance. Without the verification of a score, the form of a rock-and-roll performance is up for grabs. As practiced by Bob Dylan, rock and roll is about deviance, and not only in the social sense. Dylan's take on the folk music with which he came to prominence was never predicated on authenticity. His music, his persona, his obscurantist liner notes and interviews—all are intended to sabotage the veracity of the history and conventions of his medium, of his own identity and myth, of the cultural imperatives at play in the social politics of the 1960s. The inclusion of irreconcilable components and mistakes, the act of straying off course, is constitutive of the aesthetic ontology of "Like a Rolling Stone." Differance is central to its form and content. Rather than keeping all four wheels firmly on the road, the song veers off onto the shoulder or into the roadside shrubs, allowing the listener to look back and see what features of the landscape implied the road's most natural path. "Like a Rolling Stone" disavows formal, ontological high fidelity. Nor does it depend on the kind of lo-fi signification of Sebadoh and others. Possibly the most salient feature of "Like a Rolling Stone" is its abdication of any responsibility to mimesis, verisimilitude, or fidelity to a preceding model of form or content. It is always leaking out of its own seams, never quite what it seems. Rather than hi-fi or lo-fi, it opts for something closer to no-fi. If there is no "original," "authentic" referent, then the very idea of fidelity is absurd.

Dylan's vocal infidelity raises possibilities, contingencies. His performance on "Like a Rolling Stone" is the explicit embodiment of the

implicit phenomena named by Derridean differance. Each enunciation, each component of the whole, carries other possibilities like latent genes. Its eyes might have been blue; its hair could have been blonde; but for the grace of something or other, it would be diabetic, obese, a genius. The song actively taunts these other potentialities, defining itself in its aversion to them. Yet it is still a version of them. Each skew falls into an assemblage of other skews that could just as easily occupy this particular position, situation, or condition. Such an assemblage, like a stellar constellation, is constituted by its member components. At the same time, the significance of the components is determined by the assemblage *as* constellation. The Big Dipper is nothing but a pattern imposed upon an assemblage of stars. Each star is significant only as a component of the dipper. If we cease (willingly or not) to distinguish the constellation as an entity, the component stars themselves become indistinguishable from one another and from the rest of the night sky. If we cease to see the stars, the constellation disappears.

A band is also a collective. Their form, palpable in song, is constituted by and constitutive of the music they make. Dylan, perhaps aware of the potential in contingency, put little care into assembling his early bands. The responsibility was often left to his producers or to chance, as Dylan crossed paths with random players and casually invited them to join. The band on "Like a Rolling Stone" were mostly New York session players. Before the recording sessions, they hadn't worked with Dylan on the songs that were to become *Highway 61 Revisited*. The band assembled in Columbia Records's Studio A and learned the songs with the tape rolling. There is audible uncertainty in the playing of "Like a Rolling Stone" that sounds shocking today. Such ramshackleness rarely passes unfiltered to released recordings anymore; if and when it does (as with the lo-fi bands), it is granted little commercial truck. In the sophisticated marketplace of the twenty-first century, ramshackle equals marginal. Not so in 1965, as rock and roll moved from its childhood into its adolescence. Audiences and record moguls alike had better things to worry about than commodity

sheen. Everyone—on both sides of the ball—was making it up as they went along.

The uncertainty is most audibly apparent in two ways. First, the band is, to put it kindly, rhythmically elastic. As I pointed out previously, the drums and the tambourine are at odds, unable to agree on the basic beat. Normally, this would be a negligible difference of opinion if the tambourine were mixed where it usually is, as a kind of sonic seasoning. But the producer, Tom Wilson, leaves the tambourine remarkably, unaccountably, high in the mix, enabling it to engage the drums in this debate. The conflict is exacerbated by the song's intrinsically delicate, elusive rhythmic feel, which probably owes to the fact that Dylan originally wrote the song in waltz time and adapted it to a 2/4, 4/4 feel only shortly before the recording. As a result the phrasing of the vocals—originally set to a 3/4 rhythm—sits awkwardly against the changes. The first part of the verses implies a slow, insistent, and exaggerated two-beat phrase, the beats falling on the words accented in Dylan's phrasing:

> *Once* upon a *time*,
> You *dressed* so *fine*,
> *Threw* the bums a *dime*

The second part of the verse shifts to more of a four-beat feel, stretching out and opening up with Dylan's more laconic delivery.

The second way in which the band's uncertainty is apparent is in their efforts to spontaneously arrange the song while performing it; while recording what was to become one of the most popular singles in rock history. Again, focusing on Paul Griffin's piano is instructive. In the first part of the first verse, the piano plays little flourishes, residing in the shallows of the downbeats between the insistent pronouncements of the vocal. Here the piano acts as a counterbalance to the deliberateness of the two heavy beats. The piano responds as congregation to Dylan's preacher, staying out of the way of the

words. Then, in the first part of the second verse ("You've gone to the finest school . . ."), the piano starts out playing similar flourishes but this time is more faithful to the chord progression. It lands more on the beat, with the vocal. Now it is more of an accomplice to the vocal. Halfway through the first part of the second verse ("Nobody's ever taught you how . . ."), Griffin abandons the flourishes in favor of blocky, percussive, syncopated chords, which work against the grain of the rhythm and the vocal, creating a sense of undertow.

As the third verse begins ("You never turned around . . ."), the piano returns to the syncopation of the second verse, but this time in a higher register. Now the pattern is more defined. The piano inhabits the interstices between the two beats dictated by the vocal, defining a four-beat counterpart and interjecting on the two, on the *and* between three and four, on the *and* between four and one. Griffin is apparently more focused on working out his rhythmic approach than on his note choice, because at the end of the first part of the third verse, after Dylan sings "kicks for you," he drops a couple of clams, chords that are badly fingered, discordant, decidedly off.

The beginning of the fourth verse ("Princess on the steeple") starts with what sounds like a tape splice. Greil Marcus makes no mention of it in his book, and when I pointed it out to him via e-mail, he said he did not hear it. To me it is most apparent when one is concentrating on the left side of the stereo field—the one featuring the piano. If it is actually a tape splice, it might indicate that this take wasn't selected for release as a single and an album track simply because it was the most acceptable take of all the flawed takes the band attempted. A tape splice might tell us that Dylan and Tom Wilson heard something in the first three verses that they liked, that they wanted to salvage. But perhaps something went wrong in the fourth verse or the final chorus, forcing them to splice the final ninety seconds from another take. If what I hear *is* a tape splice, it would mean that Dylan and Wilson felt they'd tapped something valuable in the first three verses, something that in spite of its very apparent flaws—or perhaps because

of them—was able to communicate the abstract, complex business of the song and the moment. Tape splice or not, in the fourth verse the piano pursues a different approach, very subtle and reconciled to the background. It has none of the buoyancy of the first verse's flourishes, nor does it cantilever the rhythm as in the second and third. It doesn't seem too far-fetched to imagine that, in this take, Griffin— who had been through a number of earlier attempts at the song, failing each time to reach the end—assumed that this take would also be scrubbed. It sounds as if he's stopped actively trying to engage the song or the vocal and has decided to ride out this take and wait for the next one.

Dylan's lyrics indict a fallen, unnamed coconspirator. His delivery is venomous. He draws out the delivery of the verses, reveling in the you's abjection. Yet the band seems oblivious to the intent of the lyrics and the vocals. Probably they are too focused on simply learning the changes and trying to capture the feel. The piano, again, seems deaf to the vocal inflections: the spit, the sadistic hesitations. The piano rollicks along like a player piano in a second-rate ragtime theme park. This is due, in part, to how it is recorded. Wilson's microphone placement accentuates the plinky percussion of the piano's hammers and mechanisms. Any depth, any low-end warmth, is lost. The vocal seems weary of, or oblivious to, the vaudevillian jauntiness of the accompaniment. As distinct from the song's sloppy execution, this is a misregistration of the song's meaning on the parts of the players, producer, and engineers. And Dylan too deserves blame or credit.

One feels sorry for the musicians. It seems an unfair assignment to play with a man like Bob Dylan. One is likely to be victimized; Dylan may opt for a version of the song that fails to display your talents. Perfectly good players are immortalized playing indecisively and sloppily on a recording that sells in the millions and is played on the radio five, six, or seven times that often in the forty years since its release. Even within the song, Dylan throws curveballs and pulls out rugs. In the recorded version, the first chorus has five lines:

> How does it feel,
> How does it feel
> To be without a home
> Like a complete unknown,
> Like a rolling stone?

But each of the following choruses has six lines:

> How does it feel,
> How does it feel
> To be on your own,
> With no direction home,
> Like a complete unknown,
> Like a rolling stone?

One has the impression that this is not an intentional compositional variation. It sounds and feels more like a product of the moment, a singular difference in this performance. This impression is borne out by subsequent versions of the song. For example, the infamous live version from the 1966 Manchester Free Trade Hall includes all six lines in each of the four choruses.[28]

On *Highway 61 Revisited*, Dylan leads the band into each of the first three choruses with the line "How does it feel?" landing the word "feel" on the first beat of the chorus. For the band just learning the song, this would be an important bit of guidance. You can be off the map, exploring territory that does not belong to the song proper, scrounging around in the shrubs on the periphery of the road, getting the lay of the land, searching for a useful artifact to retrieve and utilize for the song's benefit. But when Dylan sings "How does it feel?" you are instantly transported back to home base, to the center of the song, its capital. However, at 5:20, leading into the final chorus,

28. Bob Dylan, "Like a Rolling Stone," in *The Bootleg Series*, vol. 4, *Bob Dylan Live 1966: The "Royal Albert Hall" Concert* (New York: Columbia Records, 1998).

Dylan rushes the phrase, landing the word "feel" on the last beat of the verse, rather than on the first beat of the chorus. The band dissolves, hedging the beat, unsure if they should leave the emphasis in the usual place or bring it forward to match Dylan's phrasing. Some of them come flying home, some of them linger in the bushes. And for an instant the territory claimed (according to Marcus) by the song is swallowed by its own expansion: like a black hole, it implodes and loses itself in itself. For just a second or two, the song disappears within the song. By changing his phrasing, Dylan undermines his own creation. I'm not suggesting that he foresaw the outcome of his subversion—he may not even have been aware of where the "feel" was falling—but in releasing this version of the song, the value is placed on this unfaithful reading of the song reading itself.

Nietzsche, contemplating the modern impulse to dispense with history, wrote that the modern man "forgets everything in order to be able to *do* something; he is unfair toward what lies behind and knows only one right, the right of what is now coming into being as the result of his own action."[29] At the time of "Like a Rolling Stone," Bob Dylan was the name of a point in space and time—what Foucault referred to as an "author function," a nexus of cultural, political, and aesthetic forces. Dylan was the ambassador from what Greil Marcus has called the "old, weird America," an America before the corruptions of modernity: commerce, mass media, political cynicism, ubiquitous cultural homogenization. He was the modern man who had traveled back in time, capturing not just the material of decades past, but, more importantly, the sensibility. Only Dylan could have made "Like a Rolling Stone." Only Dylan could have made the song as a sonic, material artifact; only Dylan could have shepherded the song into its expanded textual situation, because only Dylan had done the research, had absorbed the lessons of his past, of his country's past, of his art's past, and then forgotten them.

29. Nietzsche, as quoted in Paul de Man, *Blindness and Insight* (Minneapolis: University of Minnesota Press, 1983), 147.

Dylan, uniquely, was in the position to be "unfair toward what lies behind." He turned his back on the values of virtuosity, fidelity, and authenticity. He turned his back on the type of historicism that Nietzsche is deriding in "Of the Use and Misuse of History for Life," a historicism that accepts history as valuable simply because it is history. Such a history would rely only on the facts: the chord changes, the mythical sources of the lyrics, the locations, the characters, and the players. Don't get me wrong: Dylan was intimately acquainted with the facts. But Dylan's conceptual reading of the facts transcends and voids their claims to authenticity. Depending on how you read Dylan's reading, "Like a Rolling Stone" either turns its treasonous back on those facts (this is the reading of those who, at the time, booed his concerts and of Pete Seeger, who wanted to ax the cables supplying power to Dylan's performance of the song at the 1965 Newport Folk Festival), or assimilates the facts in the sense of Nietzsche's "forgetting," a forgetting that takes the full force of the facts into account and indeed feeds vampirically off their blood without any use for their corporeality. Dylan's forgetting is the forgetting that grants him the right to focus solely on "what is now coming into being as the result of his own action."

Only Dylan could have made "Like a Rolling Stone." Only Dylan could have made the ripple in the fabric of cultural space-time. Only Dylan stood at the maw of the future that is the nexus of overlapping layer-upon-layer of semantic fabric; of lines intersecting horizontally, vertically, diagonally, up, down, and across; of individual intersections rubbing with or against other intersections, creating additional lines of vibration, like colliding ripples in a lake, like phasing sound waves, coming in and out of synch. Dylan occupied a temporary position, forged by history and culture; he was somehow *of* the past and *for* the future. Instead of stepping out of time to inhabit the instantaneousness of the now, he was immersed in time, trapped in the now that never arrives: the messianic past, as well as the always-imminent future (in other words, the "not-now"). Jean-Luc Nancy points out that

even Husserl's conception of the now—at one point described in the context of listening to a melody—cannot retain its self-presence:

The present of this perception is a present formed by the overlapping, in it or on it, of the present impression and the retention of the past impression, opening forward onto the impression to come. It is a present, consequently, that is not instantaneous, but differential in itself.[30]

The serious dissent that Dylan engendered in the culture of 1965–66 came down to this always-differential, always-deferred now; to the difference between two visions of this inevitable messianism. In one camp, Dylan represented an impossible return to some imagined, authentic, essentialist American past that sang of equality and liberty and somehow rid itself of slavery and civil bloodshed and the annihilation of the native population. In the other camp—made up of converts from the first camp and new acolytes—he represented an equally impossible exclusion from convention and parentage, from history itself (inclusive of slavery and civil bloodshed and the annihilation of the native population). The first camp saw in Dylan the possibility of a kind of epochal husbandry: mating the past and the future; producing progeny free of the impurities of the past yet imbued with the best of its traits. The second camp wanted Dylan to drop the past, to drive it off the continent and into the sea, erasing it from collective memory. They imagined a spontaneous generation, the delivery of the centuries-old promise implicit in the idea of the New World.

That only Dylan could have made "Like a Rolling Stone" as material artifact corresponds to the first of Roland Barthes's threefold schema of interpretation, that of the "informational".[31] The materiality

30. Jean-Luc Nancy, *Listening*, trans. Charlotte Mandell (New York: Fordham University Press, 2007), 18.

31. Roland Barthes, "The Third Meaning: Research Notes on Some Eisenstein Stills," in *Image Music Text*, trans. Stephen Heath (London: Fontana Press, 1977), 52.

of "Like a Rolling Stone" is a matter of fact, of apparent historical inevitability. That only Dylan could make the song the source of a disturbance in culture is a result of what Barthes calls the "symbolic." This symbolism is a matter of conjecture, of the pure, contingent desires of the culture made up of the camps of the past and the future. It is in a third sense—Barthes's "obtuse" meaning—that "Like a Rolling Stone" truly exhibits its conceptualism. According to Craig Owens, it is at this "obtuse" level that a work exposes itself as fiction.[32] And fiction, according to Paul de Man, is "the disruption of the narrative's referential illusion."[33] We might think of the "obtuse" level of meaning as the point of balance, or friction, between the "literal" and the "symbolic," between the "real" and the signifying grids, between the primordiality of perceptual experience and the "problem which culture attempts to resolve, . . . the relation of man to man in language, in knowledge, in society and religion."[34] The obtuse fulcrum of "Like a Rolling Stone" constructs not just the song-as-text, not just Dylan-as-text, not just the cultural-moment-as-text; it also constructs the very act of reading. This is the claim of "Like a Rolling Stone": reading (perceiving plus thinking) is a (de)constructive and (de)constructed act. The song initiates this infinite (de)construction while carrying on with super-Beckettian insistence (it is *because* it cannot go on that it *must* go on), verse-to-chorus-to-verse-to-chorus.

In the end, "Like a Rolling Stone" is the subject of its own damnation:

You're invisible now,
you have no secrets to conceal.

32. Craig Owens, "The Allegorical Impulse: Towards a Theory of Postmodernism," *Beyond Recognition: Representation, Power, and Culture* (Berkeley: University of California Press, 1992), 82.
33. Paul de Man, *Allegories of Reading* (New Haven: Yale University Press, 1979), 292.
34. Merleau-Ponty, "Primacy of Perception," 446.

What passes as eminently logical, even tautological, is neither. Being invisible is the state of ultimate concealment. But being invisible (or inaudible) has nothing to do with whether or not one has secrets to conceal. This state of being is futility: What's the good of being invisible if you have no secrets to conceal? This is a state of total inconsequence: nothing to say, no way to say it. The state of invisibility, inaudibility (non-cochlearity), is only valuable if one does, indeed, have secrets to conceal (or reveal). Enter the obtuse meaning, which "exposes the literal level . . . to be a fiction, implicating it in the web of substitutions and reversals properly characteristic of the symbolic."[35] The literal is just as constructed, just as much a product of textuality, as the symbolic. The apparent authenticity and fidelity of "Like a Rolling Stone" are exposed as duplicitous, unworthy of trust. The song is incapable of one-to-one correspondence, even to itself. It exposes, in turn, all of Dylan's songs as products of the chaotic bricolage of signifying grids. It exposes Dylan himself. It exposes the desperation and desires of the culture. In retrospect, it is completely understandable—bordering on inevitable—that just moments before Dylan performed "Like a Rolling Stone" at the Manchester Free Trade Hall on May 17, 1966, a member of the audience cried out "Judas!" Only within the thrall of the expansion of the territory of the song-as-text—a sophisticated understanding of the fictions, frictions, and contradictions at play—does Dylan's response that night make any sense: "I don't believe you," he shouts back into the hall, indicting not just the heckler but everyone present, including, maybe, most of all, himself: "You're a liar!"

35. Owens, "Allegorical Impulse," 82.

8

A DOT
ON A LINE

You can't have a window without a wall. To conceive of passage from one space to another, it is first necessary to imagine what stands between them. From time immemorial, what stood between music and the visual arts was blank space, a pure divide. In recent decades sound art has flooded into that space, reinforcing the inviolability of each island of practice while also providing a medium across which material, ideas, and practitioners may pass. Inspirations from Robert Rauschenberg were shipped to John Cage. A message in a bottle from Yves Klein was discovered on the seashore (at daybreak) by Luc Ferrari. By the same token, artists in the gallery were catching waves produced on the sonic side of the gulf. As early as 1967, Bruce Nauman was making video works of himself playing the violin, not only producing the sound of a musical instrument, but also exploring ideas about composition and performance borrowed from the currents of late-1960s experimental sonic practice. With the filmmaker Michael Snow, the composer James Tenney, and the sculptor Richard Serra, Nauman was one of Steve Reich's handpicked performers for the presentation of Reich's *Pendulum Music* at the Whitney Museum of American Art in 1969. Nauman's *Violin Film # 1 (Playing the Violin as Fast as I Can)* (1967–68) and *Playing a Note on the Violin While I Walk around the Studio* (1967–68) feature the artist engaged in repetitive, banal activities. Both works evoke the monotony of rudimentary instrumental practice and, at the same time, contemporary minimalist compositional tendencies. *Violin Tuned D.E.A.D.* (1969) enacts a jumbled cross-reference of the code of Western notation with the code of the English alphabet. Instead of tuning the violin according to harmonic logic, Nauman tunes it according to linguistic logic, facetiously declaring the instrument and, by association, the tradition of

Western music embedded in the violin, to be dead. Three decades later Nauman was still self-consciously indebted to the revolutions of Cagean aesthetics. His 2001 video installation, *Mapping the Studio II with color shift, flip, flop, & flip/flop (Fat Chance John Cage)*, acknowledges his long-standing engagement with Cage's ideas of chance procedures and openness to environmental events.

Examples of the exchange from the visual to the sonic and back again are everywhere apparent since the 1960s. From Cage's New School class emerges Fluxus and Allan Kaprow's "Happenings." Following these innovations, a relational-performative conceptualism becomes evident in works such as Nauman's violin pieces, Vito Acconci's *Following Piece* (1969), Adrian Piper's *Catalysis* performances (1970), and Dan Graham's *Performer/Audience/ Mirror* (1975). An argument could be made that the performance and relational branch of conceptual art is a direct descendent of Cage's influence on visual arts practitioners. But this two-way ferment was not restricted to Cage's influence, or to North American arts. In Tokyo in 1960, the future Fluxus members Takehisa Kosugi and Chieko "Mieko" Shiomi, along with the media-art pioneer Yasunao Tone, formed Group Ongaku (Music Group), made up of art students and musicology students at Tokyo National University. Group Ongaku stumbled upon what Tone described as "an absolutely new music. It was an improvisational work of *musique concrète* done collectively."[1] In 1963 the South Korean Nam June Paik presented his "prepared television" works in his *Exposition of Music—Electronic Television* at the Galerie Parnass in Wuppertal, Germany. Starting in 1962, the Vienna Actionists (Günter Brus, Otto Mühl, Hermann Nitsch, and Rudolf Schwarzkogler)—members of the first generation of Austrians born during or after the war—engaged in an aggressive, often violent confrontation with the conventions of art, performance, music, and society.

1. Yanunao Tone, as quoted in William A. Marotti, "Sounding the Everyday: The Music Group and Yasunao Tone's Early Work," in *Yasunao Tone: Noise Media Language* (Los Angeles: Errant Bodies Press, 2006), 23.

In 1967, taking her cues in part from the Actionists, Waltraud Lehner changed her name to VALIE EXPORT (in capital letters). Her earliest work, which she describes as "expanded cinema," includes the never-realized *Tonfilm* (Soundfilm; 1969). The typewritten instructions for *Tonfilm* read as follows:

> a photoelectric resistor is built/surgically into the glottis and connected with a light sensitive resistor, which is attached to the outer skin below the ear. the photoelectric amplifier controls the volume. when there is a lot of light, lots of electricity is directed toward the amplifier, the volume is high. with low light it is the reverse.
>
> the live soundfilm works like this, people scream horrifically at midday—as a side effect of the glottis irritation enormous salivation and intestinal cramps etc. occur—with increasing twilight the register of the nation is subdued.
>
> soundfilm offers a lively panorama of early morning chirping, midday slobbering and screaming and absolute night's rest. communication is made possible over thousand meters, the secret disappears (evenings without speaking, midday only screaming) . . . also this is a new way of communication![2]

EXPORT's intervention inserts itself into multiple linguistic circuits: the physical passages and apparatus from which the voice emanates, the intentionality ascribed to meaningful language, and the sonic control that allows for the conveyance of a verbal message. This network of processes is replaced by chirping, slobbering, and screaming. The latter-day sound practice of using photoelectric cells to convert light into sound is anticipated and turned on its ear. The implication of the "natural" conversion of light energy into sound energy is pushed to absurd extremes, in which communication is held hostage to

2. EXPORT, VALIE. *Tonfilm: Voice and Void*, ed. Thomas Trummer (Ridgefield, CT: The Aldrich Contemporary Art Museum, 2007), 105.

solar cycles. *Tonfilm* is a redirection of systems of control over the body and the voice. According to EXPORT, the voice of the people has already been ventriloquistically hijacked by the institutions of the state and the church and subjected to various "impairments, . . . rules, specifications, and norms of society."[3] *Tonfilm* simply redirects control from constructed societal concentrations of power to the irrefutable cyclicality of nature. It therefore does not commit any additional acts of symbolic violence. Instead, it converts the figurative violence of cultural control into the literal violence of the surgical incision into the body of the performer/performed subject. Impairments—whether institutional, surgical, physiological, or cultural (think of Lucier's stutter)—are always components of speech. EXPORT's gesture is to make this manifest by altering the type and source of impairment.

VALIE EXPORT, *Tonfilm*, 1969. Expanded movie, communication action. India ink and collage on paper. 11 ¾ x 8 ¼ in. © 2009 Artists Rights Society (ARS), New York/VBK, Vienna. Collection of Museum Moderner Kunst Stiftung Ludwig, Vienna.

3. Ibid., 106.

Tonfilm tries to intervene at what EXPORT refers to as "the beginning of speech, the voice," which she identifies as the glottis.[4] The work knowingly exposes the faulty notion of a biological origin, highlighting the inadequacy of purely medical, mechanical, or physiological identifications of speech. Speech is understood, instead, as a vehicle of identity and power. *Tonfilm* flips the notion of a non-cochlear sonic art, arriving at a non-glottal vocal art. As Derrida indicates in *Of Grammatology*, his extended critique of the logocentric privileging of speech over writing, the voice is not a conduit to the nature or the essence that underwrites the self. And EXPORT has explicitly stated, "I don't want to get back to the origin in the sense of voice's ontology, because that does not exist."[5] This deconstructive engagement with the voice is further removed from the circuitry of language-power due to its status as a thought experiment. Because *Tonfilm* has never been realized (and probably was never meant to be), its reappropriation of the voice is incomplete. The materiality of the voice is not controlled nor silenced, it never comes into being. The voice, as imagined by *Tonfilm*, is pure latency, infinite possibility, irreducible to in-itselfness.

In the introduction, I recounted a scene from the film *Down by Law* in which a prisoner instructs his cellmate about which preposition to use to indicate a window drawn on their jail-cell wall: "In this case, Bob, I'm afraid you've got to say, 'I look *at* the window.'" The episode of prepositional confusion functions as a metaphor for the way in which sound has been conventionally construed. Both in practice and in theory, the sonic arts have more often listened *at* sound, like a window drawn on a wall, than listened *out* or *through* sound to the broader worldly implications of sound's expanded situation. This book has been an effort to replace, or at least to supplement, the available options with a listening *about* sound. A non-cochlear sonic art seeks to replace the solidity of the *objet sonore*, of sound-in-itself, with the discursiveness of a conceptual sonic practice. Such a replacement

4. Ibid., 109.
5. Ibid.

adjusts the focus of producing and receiving sound from the window itself to its expanded situation. When such an adjustment took place in the gallery arts, after the reception of Duchamp, it was described as a turn from "'appearance' to 'conception'" (Joseph Kosuth),[6] from "the era of taste [to] the era of meaning" (Arthur Danto),[7] from the "specific" to the "generic" (Thierry de Duve),[8] and from "material, or, for that matter, the perception of material [to] the universe of terms that are felt to be in opposition within a cultural situation" (Rosalind Krauss).[9]

Jean-François Lyotard has made similar claims, arguing that postmodernism is a particular tendency within the cultural and artistic epoch of modernism. Central to Lyotard's aesthetics is the notion of the sublime, borrowed from Kant and updated to agree with contemporary experience. Responding in part to Theodor Adorno's dictum that "to write a poem after Auschwitz is barbaric,"[10] Lyotard takes up the problem of representation. The beautiful, he suggests, relies on representation, on something corresponding to something else (even in the reduced isomorphism implied by Kant). The sublime, on the other hand, is a product of unrepresentability, of something exceeding the means of absorption or incorporation. Tellingly, Edmund Burke argued that beauty is accentuated by light (vision), but that the sublime is a product of not enough or too much light (blindness). Kant elaborated upon Burke's distinction, detailing a mathematical sublime (when confronted with the immensity

6. Joseph Kosuth, "Art After Philosophy" (1969), www.ubv.com/papers/kosuth_philosophy.html (accessed December 8, 2008).

7. Arthur C. Danto, "Marcel Duchamp and the End of Taste: A Defense of Contemporary Art," *Tout-Fait: The Marcel Duchamp Studies Online Journal* 1, issue 3 (2000), www.toutfait.com/issues/issue_3/News/Danto/danto.html (accessed February 9, 2009).

8. Thierry de Duve, *Kant after Duchamp*, October Books (Cambridge: MIT Press, 1996), passim; esp. see chap. 3, "The Readymade and the Tube of Paint."

9. Rosalind Krauss, "Sculpture in the Expanded Field," in *The Originality of the Avant-Garde and Other Modernist Myths* (Cambridge: MIT Press, 1985; repr., 2002), 289.

10. Theodor Adorno, "Cultural Criticism and Society," in *Prisms* (Cambridge: MIT Press, 1967), 34.

of natural objects) and a dynamic sublime (when confronted with overwhelming forces). Arthur Schopenhauer imagined a spectrum with beauty at one end and the strongest sense of the sublime at the other. His scale culminates with the fully sublime experience of confronting the immense size and duration of the universe. In each case the sublime is an experience of negotiating a referent beyond representation: either too big or too small, too powerful or too incomprehensible. Kant believed that the sublime is an aesthetic feeling, created as the subject overcomes such unrepresentability by *coming to terms* with one's inability to contain or control the sublime object. This compresses the object; allowing the subject to subdue it by means of concepts such as *infinity* or *forever* or *impossible*. The subject then experiences the pleasure of capturing the uncapturable, albeit in abstracted form.

Lyotard's equation of the sublime with postmodern aesthetics signals a different approach to the question of representation. The sublime object is no longer conceived strictly as the product of nature, as in mountains, oceans, and earthquakes, nor strictly as a product of the boundlessness of time and space. The sublime object, as it is now understood, is just as likely to be the product of human intervention. How can one conceive of the horror of Auschwitz, of Hiroshima, of the Rwandan genocide? How can these horrors be represented? Lyotard suggests that the sublime, as a Kantian category of modern aesthetic experience, is predicated on the notion that there is some content in the object that cannot be adequately conveyed in a given artistic medium. This locates the problem of representation in the adequacy, or inadequacy, of form to content. Which rhyme scheme can convey the content of Auschwitz? Which syntax, which metric pattern? The implication is that there is an *it* in the sublime object that cannot or will not be accommodated by the forms, materials, and conventions of an artistic practice. For Lyotard, this modern sublime is nostalgic because it yearns for something missing: something lost or something not yet attained. The fundamental misunderstanding of modern

aesthetics lies in its efforts to reclaim the real, the pure, the essential, the authentic; or to discover the secret, the answer, the truth, or God.

> Modern aesthetics is an aesthetics of the sublime, though a nostalgic one. It allows the unpresentable to be put forward only as the missing contents; but the form, because of its recognizable consistency, continues to offer the reader or viewer matter for solace and pleasure.[11]

Herein lies the barbarity identified by Adorno. A poem that seeks to address the calamity of Auschwitz runs the risk of beautifying or fetishizing the content, offering solace and/or pleasure. In a modernist aesthetic, an irreconcilable friction exists between the domesticating tendencies of form and taste on one hand, and the feral disposition of nature, history, and human behavior on the other. After Auschwitz, form and content cannot be brought into correspondence. Postmodern aesthetics recognizes the fiction of correspondence, which underwrites the concept of representation. It is only a slight simplification to insist that the postmodern sublime is a reduction of the unrepresentable to an engagement with that very unrepresentability. Artistic progress and innovation are not driven by the need for a more adequate correlation of signifier to signified, but by the effort to more fully come to terms with the impossibility of representation. The sublime is not a matter of form, but of formlessness.

> The postmodern would be that which, in the modern, puts forward the unpresentable in presentation itself; that which denies itself the solace of good forms, the consensus of taste which would make it possible to share collectively the

11. Jean-François Lyotard, "Answering the Question: What Is Postmodernism?" trans. Régis Durand, *The Postmodern Condition: A Report on Knowledge*, trans. Geoff Bennington and Brian Massumi (Minneapolis: University of Minnesota Press, 1984), 81.

nostalgia for the unattainable; that which searches for new presentations, not in order to enjoy them but in order to impart a stronger sense of the unpresentable.[12]

For Lyotard, the sublime is also concerned with the question of time. In place of Husserl's conception of the now, Lyotard proposes the question *Is it happening?* replete with question mark. Rather than an impossibly frozen, impossibly indivisible moment, the *Is it happening?* is a cascading, infinitely divisible process of coming to terms. It asserts becoming as opposed to being, question as opposed to answer. It is not simply a statement: *It is happening.* This sublime sense of time, in the form of a question, is an acknowledgment of recursivity, of reflexivity, of self-awareness. Yet it is absolutely crucial to distinguish such self-awareness from the self-confidence, the self-sameness, the self-presence of essentialism. Lyotard's *Is it happening?* is supremely uncertain of its own constitution. The postmodern sublime, as described by Lyotard, does not reside in the instantaneous blink of an eye. The sublime inhabits the constant deferral, or—it amounts to the same thing—the constantly in-process duration of the blink of an ear.

Replacing the satisfaction of sound-in-itself with Lyotard's *Is it happening?* demands a rethinking of certain familiar works and episodes. In Cage's experience in the anechoic chamber at Harvard, he identifies two sounds: the high-pitches of his nervous system and the low tones of his blood circulating. In Cage's telling and retelling of the tale ("Anyone who knows me knows this story. I am constantly telling it."[13]), this episode carries the weight of sublime epiphany; a realization of the always and everywhere nature of sound that would forever alter Cage's aesthetics. Still, Lyotard's *Is it happening?* is critical

12. Ibid.
13. John Cage, as quoted in Douglas Kahn, *Noise, Water, Meat: A History of Sound in the Arts* (Cambridge: MIT Press, 2001), 190.

to Cage's experience. Douglas Kahn has identified a decisive "third internal sound" in Cage's anechoic episode,

> the one saying, "Hmmm, wonder what the low pitched sound is? What's that high-pitched sound?" Such quasi-sounds were, of course, antithetical to Cagean listening by being in competition with *sounds in themselves*, yet here he was able to listen and at the same time allow discursiveness to intrude in the experience.[14]

The discursiveness of the *Is it happening?* of the "Hmmm," occurs without recourse to beauty or form. It is oblivious to the specifics of material and media. It is, most important, immune to the lure of nostalgia for the lost origin or the promise of an imminent telos. The revision (reaudition, rereading) I am suggesting is a transformation from the *it*-centrality of the Kantian, modern sublime, to the discursive and dispersive Lyotardian, postmodern sublime. The conceptual turn is a turn to the inconclusiveness of Lyotard's postmodern sublime, and away from the "solace of good forms." In what has been widely accepted as the founding moment of the sound-in-itself tendency— Cage's anechoic chamber revelation—it is crucial to recognize the anti-essentialist, nonphenomenological move that Cage must make in order to issue his proclamation "Let sounds be themselves."[15] The essentialism of sound-in-itself is an illusory side effect of the discursiveness of the *Is it happening?*

Janet Cardiff's sound work since the early-1990s has persistently asked, "Is it happening?" Sometimes working alone, sometimes in tandem with George Bures Miller, Cardiff has pursued a singularly discursive implementation of recorded audio. Broadly speaking, her work takes three forms. She is most well known for her "walk" works, which

14. Ibid.
15. John Cage, "Experimental Music," in *Silence* (Middletown, CT: Wesleyan University Press, 1973), 10.

employ portable audio players to trace a narrative thread through museum or city spaces. She has made walks in cities and museums around the world, including Münster (1997), the Villa Medici in Rome (1998), London's East End (1999), Central Park in New York (2004), the Bienal de São Paulo (1998), and the Museums of Modern Art in New York (1999) and San Francisco (2001). Second, she makes theatrical sets that the spectator either views from the perspective of an audience or moves through with the license of an actor. These works include *An Inability to Make a Sound* (1992), *The Dark Pool* (1995), *Playhouse* (1997), *The Muriel Lake Incident* (1999), and *Opera for a Small Room* (2005). Third, she makes audio installations in which an array of speakers create a spatially dispersed sound environment centered around a single narrative or musical core. For instance, in *Forty-Part Motet* (2001), Cardiff reinterprets Thomas Tallis's *Spen in alium nunquam habui* (1575), a piece of early English church music for forty voices. In the gallery, forty speakers are arrayed in a circle, each playing back the voice of one individually recorded singer. The spectator moves among the speakers, selectively, mixing the choir based on proximity.

Cardiff's particular enunciation of the *Is it happening?* works in the two directions suggested by Lyotard. Her work suggests that the *it* is not a stable product but a shifting process. Second, this process refuses the consolation of a static moment of judgment. Judgment always requires process time, yet some object forms propose themselves as suspended temporal points, willing to sit still for contemplative convenience. (It was Robert Morris's dissatisfaction with this conception of time and experience that necessitated his situational expansion of the minimalist, sculptural object.) Sound-in-itself similarly tries to objectify the auditory, ignoring its inexorable entanglement with time. But there is no such thing as a sonic freeze-frame. With audio recordings, if the playback is paused, the sound occurring at the moment of interruption does not hang, object-like, in the air, but evaporates, recuperable only in memory. Even the *objet sonore* does not hold still, compliant and constant. It shuttles in time, constituted

by a cascade of *befores* and *afters*, but lacking any positively identifiable *now*. (The concretization of sound is all the more confounding, given that Pierre Schaeffer must have been intimately acquainted with this reality.[16]) Cardiff's work exhibits a sophisticated relationship to the time in which it inescapably lives. Within the disjointed narratives of her walk works, the spectator/listener/participant is often confronted with media-within-media. In *The Missing Voice: Case Study B*, against a background of sound effects, Cardiff speaks directly to the listener, directing the route of the walk through London's East End and narrating the fragmented details of the *noir*-ish framing story. The walk begins in Whitechapel Library.

Sound of phone ringing, receptionist answering.

> JANET: I'm standing in the library with you, you can hear the turning of newspaper pages, people talking softly. There's a man standing beside me, he's looking in the crime section now. He reaches to pick up a book, opens it, leafs through a few pages and puts it back on the shelf. He's wandering off to the right. Pick up the book he looked at . . . it's on the third shelf down. It's called *Dreams of Darkness*, by Reginald Hill. I'm opening it to page 88. "She set off back at a brisk pace in a rutted and muddy lane, about a furlong from the house she thought she heard a sound ahead of her. She paused. She could hear nothing but her straining eyes caught a movement in the gloom. Someone was approaching. A foot splashed in a puddle."

16. The act of editing magnetic audio tape depends on running the tape back and forth—into the before, into the after—across the machine's playback head. Recorded sound makes its non-object-like status apparent at every turn.

Scary movie music rises during excerpt from book, girl screams, music fades out.

JANET: Sometimes when you read things it seems like you're remembering them. Close the book. Put it back to where you found it. Go to the right. Walk past the main desk. Through the turnstile.

Sound of voices, conversations.

DETECTIVE: (Man's Voice, British accent.) One of the librarians recognized her from the photograph. . . .

Siren passes.

JANET: Turn to the right, Gunthorpe Street. A man just went into the side door of the pub.[17]

Occasionally the narrator plays a cassette recording, clicking the buttons of what sounds like a small, portable player. On the cassette we hear Cardiff's voice again. The cassette voice is compressed and hissy, another instance of the signifying capacity of low fidelity. The status of the second voice is unclear. At times it is simply the narrator's voice replayed. But at other times, it comes across either as a second person—a doppelgänger of sorts—or as Cardiff as narrator of a different story, recorded at a different time, extracted from a different set of narrative concerns. Sometimes the second voice lacks the confidence and authority of the first. While the intentions of the first voice are comprehensible—she is directing the route of the walk and

17. Janet Cardiff, *The Missing Voice: Case Study B* (London: Commissioned and produced by Artangel, 1999), www.cardiffmiller.com/artworks/walks/missing_voice.html (accessed February 2, 2009), slightly reformatted for publication.

supplying its narrative context—the meaning and circumstance of the recorded voice are more difficult to appraise.

Sound of tape recorder being stopped, rewound, replayed.

JANET: (Recorded voice.) A man just went into the side door of the pub.

Sfx [sound effects] of recorder being stopped.

JANET: I've a long red-haired wig on now. I look like the woman in the picture. If he sees me now he'll recognize me.

DETECTIVE: Found in her bag, two cassette tapes with a receipt and a tape recorder. . . . As far as I can tell she's mapping different paths through the city. I can't seem to find a reason for the things she notices and records.

JANET: (Recorded voice.) A naked man is walking up the street towards me. He's walking as if he is sleeping, staring straight ahead. He walks past me without seeing me.

Sound of recording being stopped.[18]

It is typical of Cardiff's work to fold time and persona into itself in this fashion. Not only the recording-within-the-recording, but also the reference to "the woman in the picture"—apparently Cardiff herself—complicates the understanding of identity and temporality. As Cardiff has pointed out, this complication extends to the role of the listener:

18. Ibid.

If you're listening to a tape recording and you hear a different tape recorder playing inside "your" recording, it puts you as the listener into a unique space. You can tell that it's more in the past than the main voice is, but then where does that position you as listener? The first voice is more real somehow, closer in time and space to your reality.[19]

The doubling of identity is a product of time. The past, in the form of memory, constantly infiltrates the present. Discussing the complexity of subjectivity and temporality in Cardiff's work, Eric Méchoulan describes experience as always, at the very least, double:

In fact, we must conceive of each instant as always offering two faces, where present perception is virtualized in the memory of the present, just as a fleeting immediacy is duplicated in an immediacy that remains and grows. Thus every present is bordered here by perception (a first immediacy), and there by memory (a second immediacy), so that the past is never cut off from the present, but on the contrary is contained in it, folded within it like a protein. However, we must add a third mode of immediacy to these two, one where each present is overwhelmed by the very contemporaneousness of these two heterogeneous registers.[20]

Reading this passage is likely to invoke the very sense of déjà vu it describes. We have encountered this overlay of past and present elsewhere. It is implicit in Kierkegaard's conception of consciousness as a collision between ideality and reality and in Douglas Kahn's identification of Cage's "Hmmm," both instances of Peircean thirdness.

19. Janet Cardiff, "Conversation with Carolyn Christov-Bakargiev," in *Janet Cardiff: A Survey of Works Including Collaborations with George Bures Miller* (Long Island City, NY: P.S. 1 Contemporary Art Center, 2001), 22.

20. Eric Méchoulan, "Immediacy and Forgetting," trans. Roxanne Lapidus, *SubStance*, issue 106, vol. 34, no. 1 (2005): 148.

The self-certainty of self-presence finds no purchase in this multipli-
cation of time and identity because it relies on the impossibility of a
return of the already impossible now.

In the mediated reality of Cardiff's walks, this destabilization of
experience is achieved in more than one way. The environment in
which the walks take place is much more than a narrative setting. The
gallery spaces of the museum or the streets of London's Shoreditch
neighborhood activate the experience of the work. They are not pas-
sive sets, but constantly transforming social-architectural-commercial
organisms. As the listener navigates the fictionalized version of the
environment as presented in the audio, one is simultaneously navigat-
ing the factual physicality of the actual locale. Some critics have taken
issue with the exercise of control in these works, questioning the lati-
tude of the listener's participation and freedom as Cardiff explicitly
directs the pace and progress along a designated route. Such con-
cerns are certainly worth considering. But this criticism overlooks the
crucial role the listener plays in negotiating the facticity and the sig-
nificance of these two overlapping environments. Cardiff has asserted
that this negotiation reveals fact by contrast with fiction, making the
listener acutely aware of the reality of his or her self and situation:

> The way we use audio makes you much more aware of your
> own body, and makes you much more aware of your place
> within the world, of your body as a "real" construction. What
> is reality and authenticity if not that? If you give someone
> hyper-reality, then they have more of a perspective on what's
> really real. You are hearing the sound behind you, and you
> know it's not real, but you want to turn around and look for it.[21]

But the experience, for instance, of *The Missing Voice: Case
Study B*, is nearly the opposite. As one navigates London's East End,

21. Cardiff, "Conversation with Christov-Bakargiev," 16.

the fiction of the audio and the fact of the streets become confused. Just as a not-real sound can cause the listener to turn toward it, the sound of a very real oncoming car can be ignored as part of the audio. The result is not a greater awareness of what is real, but of the absolute contextual constitution of perceived reality. Even reality is made manifest, not by its self-evident content, but by its peripheral framing particulars.

In the anechoic chamber, Cage heard sounds he considered "really real." At the same time, perhaps without realizing it, Cage's "Hmmm" negates the bluntness of the *in-itself* and instead opens onto the expanded situation of sonic experience. Ultimately, the mythic value of the anechoic chamber episode does not depend upon sound-in-itself. The discursiveness of what Kahn describes as the "third internal sound" has the effect of a referral. The sound-in-itself refers to additional, supplemental facts: blood, nerves, life, and so forth. Cage's epiphany is not a direct effect of sound-in-itself. That epiphany, and the legacy it has inspired, refers instead to a text revolving around the semantic unit of "sound-in-itself." The sound at the heart of this story is not anchored to inviolate phenomena but to terms in opposition. Even this, the *ur*-moment of essentialist listening, must construct its significance from its *parerga*, the connotations and indications that surround, inform, and, according to Derrida, constitute the *ergon* (work): the *thing-itself*. It is from this *parergonal* material that a non-cochlear sonic art constructs itself. The phenomenal is reduced in favor of the expansiveness of the textual and the discursive. Objects are replaced by processes, including the process of questioning the urge toward objects (first and foremost, the sonic object). The normally supplemental *parerga* become central to the act of encounter.

Much contemporary artistic practice is marked by an absence at its center. The maturation and increasing sophistication of appropriative strategies build complex structures on the foundation, not of something signified, but of apparently descendent signifiers. There is

no stable *it* to which this work refers. The referent has been replaced by the ever-receding, ever-expanding process of signification. The film manipulations of Douglas Gordon, the cinematic installations of Angela Bulloch, the plunderphonics of John Oswald—these are all constructed from a chain of signification, shimmying in relation to time, space, identity, intention, and meaning. This is accomplished partly as a result of time-based media. Where an appropriative work by Barbara Kruger, Richard Prince, or Sherrie Levine stood still as the spectator tried to parse its relation to its precedents, the newer work continually slips back into the past and forward into the future as material from a known source is both remembered and anticipated. At the same time, this simple backward and forward in time is problematized by the fact that remembered material from the source is anticipated in the appropriation (the past in the future), and by the fact that, once it arrives, this anticipated remembrance slips into the second-generation memory of the appropriation (the past-in-the-future: first in the present, then in the past).

It is easy to forget a basic fact of appropriation: it is a relational practice. The appropriating work enters into a relationship with the appropriated material. This relationship may be collaborative, confrontational, even downright violent, but it is always dialectical: signifier versus signifier. For Jarrod Fowler, this dialectic is rhythmic. Or when thought in reverse, percussion is a dialectical process: one thing engaging, striking, or bouncing off another. Fowler, a drummer by training, is fundamentally interested in the two-way, dialectical, appropriative relationship between two materials. The interaction of drum skin and stick, for instance, shares important attributes with the interaction of text and voice. Fowler's artistic practice since 2003 has organized itself around this idea. Fowler engages the most basic unit of sound production: the beat. At the same time, he conceptualizes rhythm: the musical concern that, more than any other, has defined the revolutions of twentieth-century music, from Stravinsky's rhythmic provocations, to the percussive audacity of Varese and Ligeti and Reich, to Cage's

rejection of harmony in favor of rhythm, to the centrality of the beat in both minimalist composition and popular music of the recording age. Fowler's operations are, by turns, literally, figuratively, metaphorically, and metonymically rhythmic and/or percussive.

Since his emergence from the Boston free-improvisation scene of the early 2000s, Fowler has translated the dialectics of rhythm from a *physical* process of interaction into a *conceptual* process of interaction. Over the course of half a decade, Fowler has released a torrent of conceptual CDs under titles such as *Distribution as Rhythm*; *Translation as Rhythm*; *Argument as Percussion/Agreement as Percussion*; *On Pulse, Repetition, Percussion, and Layers*; *On Botanic and Rhythmic Structures*. In Fowler, the sensibilities of European modernism and those of ritual cyclicality, as described by James Snead (discussed in chapter 5), are brought together in a percussive dialectic. Fowler's long-standing interest in plants—he is a horticulturist by trade—puts him into meaningful contact "with the seasons, a broader measurement of time, and an other (the plant kingdom)."[22] At the same time, Fowler is deeply invested in postwar musical and artistic practice, citing as influences Cage, Fluxus, minimalism, Joseph Kosuth, Lawrence Weiner, and experimental hip-hop. The two apparently discontiguous areas of experience initially come together for Fowler's practice in the "systems of field guides, morphology, taxonomy and their translation."[23] For Fowler's early work, field guides to trees, birds, insects, and so forth provided

a way to get outside of my musical context but to bring something else in. At that point in time I really liked those early Sol LeWitt cubes, and I liked the early Kosuth work, and I was really inspired by Douglas Huebler's stuff—the map stuff—all

22. Jarrod Fowler, as quoted in Susanna Bolle, "An Interview with Jarrod Fowler," *Rare Frequency* Web page, WZBC radio (Boston, 2007), www.rarefrequency.com/2007/07/jarrod_fowler.html (accessed February 2, 2009).

23. Ibid.

of that first-wave conceptualism. I was really, really inspired by that; how those guys are dealing with authorship, how they're dealing with time, how they're dealing with space, how they're dealing with the object, how they're dealing with legitimation, and how this is given any meaning or value by anybody. All of those late-modern to postmodern considerations.[24]

LeWitt, Kosuth, and Huebler certainly turned to systems and processes to generate the form and content of their work. But each of them seems to have chosen his specific system for a reason beyond system-for-system's-sake. Each looked to systems rooted in fundamental inquiries regarding the conditions of existence—for Lewitt it was geometry; for Kosuth, epistemology; for Huebler, sociology. Their systems are both generative, purely as systems, and neutral in a sense. But they also lead back to fundamental philosophical questions and profound aesthetic problems. Fowler may have turned at first to field guides and the systems of morphology and taxonomy they represent. But his work quickly moved from the application of these systems in a somewhat arbitrary fashion, to a much more incisive questioning of the very notions of morphology and taxonomy and the portability of their application.

Fowler's CD *Translation as Rhythm* (Errant Bodies, 2006), is an extended rumination on, and experiment with, this problem. The first track, "Wittgenstein to Fowler," takes the chapter structure of Ludwig Wittgenstein's *Tractatus Logico-Philosophicus*, one of the most notoriously elusive texts in Western philosophy, and translates it into a rhythmic structure. Wittgenstein's text is organized in seven numbered sections with numbered subsections, taking the form: 1, 1.1, 1.11, 1.12, 1.13, 1.2, and so on. Each section is intended as a comment or elaboration on the previous section, so 1.1 comments

24. Jarrod Fowler, conversation with the author, Norwich, CT, August 16, 2008.

on 1, and 1.12 comments on 1.1. Fowler transports, or (his word) "translates," this structure into a series of electronic clicks. Each section is represented by a silent duration equal in seconds to its number (e.g., section 1.12 is 1.12 seconds long). The start of each section is denoted by a click. The result is a sequence of clicks, moving farther and farther apart in time. "So you literally think of those numbers [of the *Tractatus*] stacked up against each other. So you have click, click . . . click click click."[25]

The morphology of Wittgenstein's text, its form, is dictated by its taxonomy, the classification and subsequent ordering of its contents. The organization of the book, significant to its mode and meaning, becomes the model for Fowler's rhythmic organization:

> Wittgenstein begins the *Tractatus* with very logical, matter-of-fact, and concise philosophical statements about the world as such. And the work ends with him pretty much saying "I've just talked a whole bunch of nonsense." The way my piece replicates this is that initially one can understand his pulse and then, over forty-plus minutes, it becomes mostly silence with one click every seven seconds.[26]

Following the book's movement from lucidity to obscurity, Fowler's structure becomes more diffuse, frustrating the desire to make rhythmic sense of it. The work functions as a demonstration of sound-as-sense.

Fowler has engaged with other source material in similar ways. On *Translation as Rhythm*, he also tackles Joseph Kosuth's *Text/Context* (1979), in which two adjacent outdoor public billboards display related texts referring to each other and to their respective methods of linguistic and visual communication.

25. Ibid.
26. Ibid.

What do you see here? The text/sign to the right presents itself as part of something else, something we could normally take for granted. What you expect to see has been removed, to be replaced by a kind of absence, which attempts to make visible what is unseen. This text/sign would like to explain itself, but even as it does, you continue to look beyond it to something else, that meaning that seems provided in advance by a location of which it is already a part. This text/sign wants to see itself as part of the "real world," but it is blinded by those same conventions which connect you to it, and blinds you to that which, when read, is no longer seen.

Can you read this? This text/sign to the left expects you to read more than it provides, but it provides more than is needed to mean what it does. What it says, how it says it, and where it says it either connects or separates you from what it is. This text/sign (like other things seen here before it) is trapped by conventions which constitute its conception of the possible in terms which deny what they would want to suggest. Is the relationship of this text/sign to itself any different than this text/sign is to this context? To read this text/sign is to erase that erasure which this must become in order to say more than that which is said here.

Joseph Kosuth, *Art after Philosophy and After: Collected Writings, 1966–1990*, ed. Gabrielle Guercio (Cambridge: MIT Press, 1991), plate 24.

Fowler alters the texts, changing "see" to "hear," "text/sign" to "speech/recording," "read" to "interpret," "make visible what is unseen" to "make audible what is unheard," and so on. The texts are then read simultaneously by a speech synthesizer, with the left text on the left side of the stereo field, the right text on the right. Fowler often employs standard computer speech synthesis software as a kind of voiceless voice for the asubjective presentation of text.

This piece, "Kosuth to Fowler," lasts all of one minute. Yet it manages to confirm, contradict, and conflate many of the confirmations, contradictions, and conflations of Kosuth's original work. It is as literal a translation as one can imagine from the visual text of Kosuth's original billboard presentation, to the realm of audio. The audio text is nearly identical to the visual text. Yet the simultaneous transmission of the two texts accomplishes something that would be impossible with Kosuth's original. The space between the two texts, literal and essential in Kosuth, is erased in Fowler. Their simultaneity, made

possible by sonic presentation, problematizes the cross-referen-
tiality of the two texts. The stereo separation is not complete: one
channel bleeds into the other, making it impossible to say that one
text is completely the "left" text and the other is the "right." They
impinge on each other's virtual, stereophonic space, giving the lie to
the spatial illusionism of stereo. Nor is Fowler's choice of Kosuth's
texts incidental. "Kosuth to Fowler" revisits key questions of Kosuth's
Text/Context: the conventional nature of seeing and reading, the
absence that sits where the signified is assumed, and the unbridge-
able separation between signifier and signified. But in Fowler's trans-
lation a term such as "conventions" becomes a "shifter," in Roman
Jakobson's sense of the term: a word whose specific content is pro-
vided by its context. Just as the word "I" is filled differently by each
speaker—referring to me when I use it, and to you when you use
it—the word "conventions" has one set of meanings when Kosuth
uses it to refer to public billboards, advertising, and the experience
of finding text in a space usually reserved for images. It has another
set of meanings when Fowler uses it to refer not only to the "speech/
recording" at hand, but also to Kosuth's original work and to the
typical modes of intervention of conceptual works of art; not only
to the transposition of the visual to the aural, but also to the act of
subverting a subversion.

Fowler's percussive dialectics extend beyond localized events in
which one identifiable material impacts another. Each entity is already
the product of differential processes. The dialectical process is never
as simple as $1 + 1 = 2$. Every 1 is also implicitly and unavoidably many.
So the sum of $1 + 1$ is closer to infinity. Fowler's dialectic functions
at a higher level of abstraction, colliding broad categories of prac-
tice to produce significant reverberations. Fowler's practice tests the
tolerance of a discipline the way a structural engineer might test
the tolerance of a steel foundation, investigating the discipline's abil-
ity to withstand challenges to its integrity. His *Distribution as Rhythm*
series (2006) is an interruption of the commercial circuits of music.

Joseph Kosuth, *Text/Context*, 1979. © 2009 Joseph Kosuth/Artists Rights Society (ARS), New York. Courtesy Joseph Kosuth.

Fowler commissioned a number of people, including the conceptual poet Kenny Goldsmith; the sound artist Brandon LaBelle; the noise/drone artist SCUTOPUS; the hip-hop beat-maker Durlin Lurt; and (full disclosure) me, to produce a CD that Fowler then distributed both commercially to stores and reviewers, and personally to friends and acquaintances. For Fowler, this is merely another form of percussion: bodies and ideas coming into contact and producing noise:

> The concept of rhythm is this big, overlooked joker card that runs throughout lots of theoretical practice. I started creating works based on ideas hitting each other: the *Distribution as Rhythm* series published other artists' works with very little or no intervention on my part other than asking, "Would you be interested in being involved?" and then performing the Fordist, assembly-line aspect of production.[27]

27. Ibid.

Rhythm is nothing but perceptible periodicity. By releasing a series of other people's CDs over the course of 2006, Fowler created a diffuse rhythmic pattern of diverse material, testing the boundaries between categories: artistic practice as it abuts commercial distribution, production versus curation, the thin line between authoring and authorizing. He condensed this metaphor with *Dissemination as Rhythm* (2007), in which he solicited a package of already-released CDs from the sound artist JLIAT. Fowler then handed out JLIAT's CDs to people he met in various contexts: performances, conferences, parties, and so forth.

Like Kosuth, Fowler uses materials (CDs, texts) and disciplines (philosophy, music) both as a generative apparatus and as content. He makes no hierarchical distinction between theoretical work and practical work, allowing one to fold into the other until they are distinguishable only according to context or the expectations of a given spectator. This is certainly a performative act, practicing what it preaches.

> If you think of Deleuze, if you think of something like *A Thousand Plateaus*—and that's supposed to be read like you listen to a record—how do you differentiate that from sound art? Or Cage's books, how is that not sound art?[28]

Depredation as Rhythm (2007) engages the work of John Oswald, who since the early 1980s has been manipulating, mangling, and transforming recorded music into new amalgams of sound and sense. But rather than appropriating Oswald's sound works, Fowler remixes Oswald's 1985 essay "Plunderphonics, or Audio Piracy as a Compositional Prerogative," in which Oswald first introduces the now widely accepted term "plunderphonics" to describe his practice. Fowler plunders the plunderer, creating three versions of the text: one

28. Ibid.

in which he removes all the letters of the word "rhythm," leaving only characters not included in the word; one in which he removes all letters *except* the letters of the word "rhythm"; and one in which he removes all letters, leaving only numbers and punctuation, so "you get this little bit of percussion that's left over":[29]

"_____r_h____, _r ____ __r_y _ _ _m___t____
_r_r__t__"

- _ _r___t_ _y _h_ _____ t_ th_ _r_ ____ty ___tr_-
____t_ ____r___ _ _ T_r_t__ 1985.

M_____ __tr_m_t_ _r____ _____. _m___r_ _r____
m___. M_____ __tr_m_t_r_r____m___. T__r__r_r_,
r____, ___ __y_r_, _t_., r__r____ ____. _ _____ __h __
_ ____-__ m___ __ _r____ ____ __ r_r_____ m___. _
_h___r_h _ th_h____ _ _ _h_ h_/_r_t_h _rt_t _h_ ___y_
_ r__r_ ___ __ ___tr____ __h__r_ __th _ _h___r_h__
_____ __ _ ___tr_m, _r____ _____ _h_h _r_ _____
__ __t r__r_____ - th_ r___r_ ___y_r ____m__ _ m_____
__tr_m_t. _ _m___r, __ _____ _ r___r___, tr____rm___
__tr_m_t, __ _m__t____y _ __m_t__ ____ ___ _
_r_t__ _____, __ ____t r_____ _ _ ___t__t_ m____t_
_y ___yr_ht.
_r__ __m____
Th___ ___-_____, m__h-t____-__t ___t__ ____
__m_____ _____, _r_, _ _r_ t__, m___ m_m__ __r
_____, ___ t_r___r th_ _h___ r_h_tr__ _____y, ___
__ th_t _r_t_, _r _____. Th_ ___ "_m__" __, __ __r
__m_____ __t_r_, _t_ _r_-_____ _y th_ ____t__ _r__,
___ __ __ _ t_ _____r _r____t_ th__ _____t, _rh___

29. Ibid.

Jarrod Fowler, *Depredation as Rhythm, Text 2* (2007), www.jarrodfowler.com/OswaldToFowler2.htm (accessed November 3, 2008;), excerpt.

This raises the question of how and why such a work qualifies as sonic practice and not as conceptual poetics or even a form of visual word art. I am not overly interested in saying what does or does not qualify under a particular banner of practice. Rather than seek a determinant judgment that proceeds from a general principle in order to identify particular instances of it, I find it more fruitful to pursue the type of reflective judgment designated as "aesthetic" by Kant in the third *Critique*: to extrapolate out from particulars to general concerns. In Fowler's work there are a number of aspects that justify locating the sonic as the umbrella issue of his practice. *Depredation as Rhythm*, despite its operation *on* and *as* text, is a precise intervention into a sonic circuit. It engages one of the most important and influential

bodies of work dealing explicitly with the extramusical aspects of music: Oswald's plunderphonics. It isolates a single musical phenomenon (rhythm) in the text. Metaphorically it organizes the text rhythmically. But it also creates a rhythmic-semiotic code, creating a pattern of periodicity according to the rests of the underscores—representing absent letters—and the beats of the present letters. It is possible to read the texts of *Depredation as Rhythm* as a percussion score in three movements.

Additionally, Fowler's plunder acts upon the text in ways that are specifically associated with musical or sonic intervention. His text is a *remix* of the original, a cover version of sorts. It is edited in much the same manner that Pierre Schaeffer or Luc Ferrari edited audio, cutting and splicing individual lines of horizontal text like strands of reel-to-reel tape. There is even more to this simile: Oswald's text is treated as concrete material, its specific semantic content ignored in favor of its blunt materiality. Fowler, however, is no *akousmatikoi*. Although he works with the concrete neutrality of material, he always chooses this material and his mode of intervention in a most un-Schaefferian way, according to the potential interaction of the expanded situation of the content and his practice. Fowler's choice of material and mode of manipulation takes into account its semantic, cultural, political, and philosophical implications. Fowler's work is *about* sound, not sound-in-itself.

In his early CD work *70'00"/17* (2003), one can already identify Fowler's interest in the expanded situation of sound. The CD comes in a slipcase, blank except for the title and Fowler's Web address. Inside, in a wax-paper envelope, is a short note describing the work as "a methodical exploration of an island."[30] "An island is defined as an area established by a border. This border can be geographical (e.g.: a body of water), man-made (e.g.: a partition), or imaginary (e.g.: a municipality)." The notes then present a numerical grid, starting with

30. Jarrod Fowler, Notes for *70'00"/17*, JMF002, 2003.

the number 1 at the center and radiating clockwise outward in a concentric pattern, ending in the upper left corner with the number 17:

17		10		11
	9	2	3	
16	8	1	4	12
	7	6	5	
15		14		13

The notes refer to "the participant," who is instructed to designate an island and then to navigate from each numbered grid coordinate to the next. Each segment of movement takes four minutes, as measured by the enclosed CD, consisting of seventeen four-minute tracks of silence. "I like the idea of the CD being a timer; of being a blank CD, but not being blank as far as time is concerned."[31]

The enclosed notes also allow that the participant may not want to designate an island and follow the prescribed movements. In that case, "the CD assumes its role as a timer."[32] Fowler imagines that the CD can be used to accompany other quotidian activities:

This CD could also be used to frame a seventy-minute chunk of time. You do your dishes, you start your laundry, you make some breakfast, you read the paper, you clean yourself: that aspect of ambient music. It's ambient but there's no music.[33]

31. Fowler, conversation with the author.
32. Fowler, Notes for *70'00"/17*.
33. Fowler, conversation with the author.

Again, Fowler explicitly tests the tolerance of a category of practice, challenging the checklist of parameters that must be engaged in order for something to be called music. The provocation of *70'00"/17*, and much of Fowler's work is that it unproblematically accepts itself as music, while turning a faux-naive, deaf ear to the objections others might raise.

> It had a rhythmic structure and there was a percussive aspect to it, . . . the rhythmic aspect of moving around to different spaces, the rhythmic aspect of moving from track to track, the rhythmic aspect of the fact that a CD is in your hand and the percussive act of putting it into a player, the rhythm and percussion of focusing on knowing that there's an abstract musical context happening and of positioning oneself relative to that awareness, the basic fact that it's on a CD that you place in your stereo. That's enough for me. It has that very simple music-context value.[34]

So *70'00"/17* creates an empty space where the work ought to be, recalling Fowler's audio translation of Kosuth's *Text/Context*: "What you expect to hear has been removed, to be replaced by a kind of absence, which attempts to make audible what is unheard." The work constitutes itself purely from its *parerga*, its supplements. The enclosed notes, laser-printed on simple paper, provide the instructions and schematic through which the participant may animate the work. The CD player, normally nothing more than a vehicle in which the content of the work is transported, becomes central to the work. Usually the timer function of the CD player (or MP3 player, for that matter) is purely peripheral. It fulfills no central, functional role in the production or reception of the works of art and entertainment the player facilitates. The timer is a feature, an accessory, an add-on. A

34. Ibid.

CD player without a timer function would not cease to be a CD player. The experience of listening to music on a timerless CD player would not cease to be an experience of music. Clearly the timer and the information it provides are secondary to the experience of the content that the player makes available. But in *70'00"/17*, there is no work at the center of the work. The *parerga* must constitute the *ergon*. The frame creates the picture. "To me, that's how it's music: you put it into your CD player."[35]

Like Cage's *4' 33"*, Fowler's *70'00"/17* depends upon certain markers, certain framing devices, to designate itself as music. The picture is indicated by its frame. Derrida argues that beauty depends on the *parerga* to frame the form of the *ergon*. Without the frame, the work leaks out indiscernibly into the world. Without the frame, the picture's form is undetectable. If one cannot say where the work begins or ends, how can one define—not to mention *judge*—its form? The beautiful requires the frame to distinguish (in both senses of the word) itself. This, according to Derrida, points to a central deficiency in the body of the beautiful object:

> The beautiful, . . . in the finitude of its formal contours, requires the parergonal edging all the more because its limitation is not only external: the *parergon*, you will remember, is called in by the hollowing of a certain lacunary quality within the work.[36]

The beautiful lacks the components required to define itself purely from within itself. If it could speak its identity completely, then its contours would be established by what it simply is. But as we have seen, *it* is never simply it. *It* is always a product of differance, of the trace of the other in every instance of apparent self-sameness. Does this not, then, suggest that all aesthetics is actually an aesthetics of the

35. Ibid.
36. Jacques Derrida, "Parergon," in *The Truth in Painting*, trans. Geoff Bennington and Ian McLeod (Chicago: University of Chicago Press, 1987), 128.

sublime? At the center of any beautiful object is a lack, an abyss, an empty space. Emptiness, by definition, is not finite but amorphous (formless). By the same token, the process of differance is a process without identifiable beginning or end; it is infinite. Any judgment of beauty has necessary recourse to formlessness and infinitude and must therefore be based on an experience of the sublime. Even sound-in-itself abandons itself to its lacunae and to the constitutive interplay of the other.

Jarrod Fowler, performing *Drumming, Beating, Striking (Transportation As Rhythm)* at Axiom Gallery, Boston, MA, November 2008. Photo: Susanna Bolle. Courtesy Jarrod Fowler.

"Conceptualism . . . is the shifting terra infirma on which nearly all contemporary art is built."[37] Yet the conceptual turn may have been fundamentally, if subtly, misunderstood. It is often considered synonymous with—or at least parallel to—the "dematerialization of the art

37. Roberta Smith, "Conceptual Art: Over, and Yet Everywhere," *New York Times*, April 25, 1999, http://query.nytimes.com/gst/fullpage.html?res=9402EE DB173AF936A15757C0A96F958260&sec=&spon=&&scp=5&sq=roberta%20 smith%20april%2025%201999&st=cse (accessed February 2, 2009); Smith's declaration is also quoted by Jon Bird and Michael Newman in their introduction to *Rewriting Conceptual Art* (London: Reaktion Books, 1999), 3.

object," a transformation that, according to Lucy Lippard's epony-
mous book, took place between 1966 and 1972.[38] The conceptual
turn has also been understood as attempts to "demolish the distinc-
tions between art practice, theory and criticism," and to transform art
and art history, "through its rigorous self-reflexivity, its engagement
with the issue of how language frames practice, and, in particular, the
influence of feminist approaches to questions of history, gender, and
the body."[39]

As noted previously, Peter Osborne defines conceptual art as "art
about the cultural act of definition—paradigmatically, but by no means
exclusively, the definition of 'art.' "[40] Surely none of this is wrong. But
each of these claims is more appropriately and more productively
accurate if seen as a symptom of an underlying condition. As this
book nears its end, I want to nominate the condition at the core of the
conceptual turn. Squaring Lyotard's discussion of the sublime with
Derrida's reassessment of the centrality of *parerga*, the conceptual
turn presents itself as a kind of exodus, from the central concerns of
the artwork as conventionally conceived, to its outskirts. Especially
if we allow ourselves to think conceptually not just about the visual
and plastic arts, but also about the immaterial practices of the sonic
arts—as well as dance, literature, even criticism and philosophy—
then the crucial movement cannot simply be a move away from mate-
rial. It is more specifically, and more incisively, a move away from
the elements that conventionally establish the *ergon* of the work—the
issues, questions, and considerations that had historically been taken
for granted as the heart of the artistic matter. The conceptual turn is
not just a reaction against Greenberg's focus on materiality as the
central issue of painting; it is a reaction against the very notion of a
central issue of painting.

38. Lucy Lippard, *Six Years: The Dematerialization of the Art Object* (Berkeley:
University of California Press, 1997).
39. Bird and Newman, "Introduction," *Rewriting Conceptual Art*, 3.
40. Osborne, *Conceptual Art*, 14.

Understood this way, each of the symptoms of the conceptual turn—dematerialization, the demolition of distinctions between fields of practice, self-reflexivity, focus on language and discourse, feminist challenges to traditional definitions—all can be seen as different modes of emigration from the center to the frame, from *ergon* to *parerga.* This is absolutely not to suggest that these *symptoms* are less important for being symptoms, nor for being on the outer edges of the artwork's territory. It is, rather, to suggest that conceptualism is a *coming to terms* with the dispersed, diasporic, disseminated character of any act of identification. This is the cascading, propagating, inexhaustible movement Lyotard calls to arms with the final sentence of *The Postmodern Condition*: "Let us wage a war on totality; let us be witnesses to the unpresentable; let us activate the differences and save the honor of the name."[41]

The name, no matter what is being named, is a product of activated differences. The named thing is not inviolate, not freestanding, not always already named. Any act of naming (defining, categorizing, distinguishing) is a movement to the periphery; to the terms that delineate what the name designates from what it does not. It is an exodus from inside to outside. But it is an exodus that can never reach its destination because once it arrives at any location, that location becomes pertinent and, therefore, part of the designated territory. This is the meaning of Derrida's dictum, "Il n'y a pas de hors-texte" (There is nothing outside the text). To make something with a name— art, for example—is immediately and irrevocably to summon *parerga,* to activate differance. The conceptual turn was a recognition of this implicit fact. The condition at conceptualism's core is the postmodern condition. This condition has no use for an aesthetics of the beautiful, nor even for an aesthetics of the Kantian-modern sublime, which locates something unpresentable at the center of the *it*. The aesthetic of this condition is the postmodern sublime, which "puts forward the unpresentable in presentation itself."[42]

41. Lyotard, "Answering the Question," 82.
42. Ibid., 81.

One nearly literal conceptual strategy navigated the movement from the center to the outskirts by expanding the spatial territory of the encounter with the work of art. Artists from Mel Bochner to Daniel Buren to Michael Asher diffused the artistic focal point from a singular object in a space to the space itself. Whether constituted physically or categorically, the gallery space, as activating, facilitating medium, was transformed from frame to work. Asher's late 1960s and early '70s reconfigurations of exhibition spaces suck the object out of the experience, leaving an experiential void. Unlike Yves Klein, who in 1958 simply emptied the gallery to reveal the "pictorial climate,"[43] Asher's interventions are architectural. His installation in the *Spaces* exhibition, which opened in late 1969 at the Museum of Modern Art, modified the size, shape, and materials of an existing gallery space to minimize acoustic reverberation. As Brandon LaBelle points out, Asher's practice of this period problematizes both the site of artistic encounter and its discursive framework:

> Questioning the operations of art production as predicated on the fabrication and presentation of objects, Asher attempted to navigate between the prevailing aesthetics of Minimalism and the then emerging field of Conceptual art.[44]

By creating "continuity with no single point of perceptual objectification," Asher aimed to present an alternative to "phenomenologically determined works that attempted to fabricate a highly controlled area of visual perception."[45] While such a work may not fully escape the phenomenological emphasis on perception, it does succeed in expanding the field of artistic encounter, dispersing the act of reception, and

43. Yves Klein, "Le Vide Performance (The Void)" (1958), in *Yves Klein, 1928–1962: A Retrospective* (Houston: Institute for the Arts, Rice University, 1982).

44. Brandon LaBelle, *Background Noise: Perspectives on Sound Art* (New York: Continuum, 2006), 89.

45. Michael Asher with Benjamin H. D. Buchloh, *Writings 1973–1983 on Works 1969–1979*, ed. Benjamin H. D. Buchloh (Halifax: Press of the Nova Scotia College of Art and Design, 1983), 30; as quoted in LaBelle, *Background Noise*, 88.

transporting the *ergon* away from a central focal point in the room to the decentralized parameters/perimeter of the room itself.

In the early 1990s Marina Rosenfeld enrolled in the MFA program at the California Institute of the Arts, where Michael Asher has taught since the 1970s. After a childhood of classical piano training and an undergraduate education in music composition, Rosenfeld has pursued a broadly conceived hybrid of music and gallery arts. Asher's poststudio course proved pivotal in the development of her practice. Her concerns can be seen as evolving from Asher's and his generation of conceptualists, who pushed out from the center to the outer edges of their disciplinary territories. In Rosenfeld's most influential work, *Sheer Frost Orchestra* (1994), the territory includes the conventions of orchestral music. "The orchestra is such an interesting set of prejudices and beliefs—it's completely ideological—so to play with the idea of the orchestra was a natural for me."[46]

Unlike Asher's *Spaces* installation, the expansion initiated by *Sheer Frost Orchestra* is not literal. Instead of focusing on the physical space of encounter, Rosenfeld interrogates the conditions of musical production and reception, of music's symbolic and social space. Since its original performance during Rosenfeld's final year at CalArts, the piece has gained a significant reputation and has been presented at galleries and museums in the United States and Europe, including the Whitney Museum of American Art in New York, the Tate Modern in London, and the Kunstraum in Innsbruck, Austria. In each instance, Rosenfeld gathers a group of seventeen female volunteers from the area where the performance is to take place. In keeping with what she describes as "a basic punk rock idea,"[47] there are no performer prerequisites. Some of the women have musical and performance experience; many do not. Rosenfeld then convenes rehearsals in which she introduces her performers to the work's score, which asks them to play

46. Marina Rosenfeld, conversation with the author, New York, November 1, 2008.
47. Ibid.

electric guitars, laid flat on the floor, with nail polish bottles ("Sheer Frost" refers to the naming conventions of nail polish shades).

Marina Rosenfeld, *Sheer Frost Orchestra*. July 9, 1997, Greene Naftali Gallery, New York. Photographer unknown. Courtesy Marina Rosenfeld.

Many stable points of reference within the traditional space and practice of music are called into question by *Sheer Frost Orchestra* and by related later Rosenfeld works, such as *Emotional Orchestra* (2003), *White Lines* (2005), and *Teenage Lontano* (2008). The primacy of performance over rehearsal is destabilized by the importance of the social aspects of the rehearsal sessions, while virtuosity is disarmed by the unconventional playing technique that privileges spontaneity and idiosyncrasy over practiced craft. The qualities that recommend any given member of a Sheer Frost Orchestra could have as much to do with social skills as music skills. In recuperating the history of a movement toward a non-cochlear sonic art, it becomes evident that the shift away from the traditional territory of music often begins with rethinking the role and usage of musical instruments: Cage's early prepared piano works, his debilitation of the piano in *4' 33"*, Muddy Waters's electrification of the Delta blues guitar, Nam June Paik's *One*

for Violin Solo (1962), in which the performer raises the violin slowly to a vertical position over his or her head and then smashes it on a tabletop. A rethinking of the ontology of music rises up from within the history and tradition of its most accessible and legible symbols: the musical instrument. *Sheer Frost Orchestra* undercuts the matrix of significations inscribed in the body of the electric guitar from Muddy Waters onward, in the same way that the treatment of the "piano situation" is disassembled in George Brecht's *Incidental Music.* About her choice of instrument, Rosenfeld says:

> I realized musical instruments are these very unique hybrid forms between sculpture and tools. I have thought about musical instruments that way ever since. The truth is the piano also has these properties, but it was invisible to me at that moment and more available for me to perceive with the electric guitar.[48]

The symbolic grid of the guitar is subverted by its mode of deployment — placed flat on the floor and struck with nail polish bottles. The literal grid of the fret board, a schematic of dots and lines for the location of pitches and the placement of fingers, is destabilized by the inexact nature of the nail polish bottle as a performance tool and by the openness of Rosenfeld's score. The guitar-as-phallus is emasculated, deconstructing "the overdetermined, almost comic masculinity of the guitar,"[49] and undermining its latent male-gendered virtuosity. In performance, the horizontal array of performers, stretching across the floor directly in front of the audience, create a confrontational performance environment, a line of entrenchment that seems to dare incursion: "The wall of women with electric guitars spoke to people in ways that I hadn't anticipated. It was a spectacle that was hard to argue with."[50]

48. Ibid.
49. Marina Rosenfeld, "Interview with Anne Hilde Neset," in *Her Noise* catalog (London: South London Gallery and Elektra, 2005), 27.
50. Rosenfeld, conversation with the author.

Sheer Frost Orchestra creates what Rosenfeld refers to as "the music-social space" of the rehearsal sessions. These rehearsals, normally *parerga* to the *ergon* of the performance, constitute the work as much—or possibly even more—than the performance itself. It is here in this setting, both workaday and exceptional, that Rosenfeld's practice distinguishes itself. Rosenfeld takes as much inspiration from Michael Asher's approach to teaching as she does from his art, citing what she describes as his "aspirational relationship to conversation, [his] belief in the power of conversation to create new spaces or new realities."[51] In rehearsal, the women of the orchestra not only learn to play the piece; they are also transformed into the Sheer Frost Orchestra, complete with social, musical, and emotional bonds. Rosenfeld encourages them to socialize, to get to know one another, and to "laugh their asses off":

> The process turns into an attempt to create a social space of self-conscious improvisation. I ask them to adopt my outlook, which is that they themselves are already fine: sensitive human beings aware of being in a room with other human beings. It's very process-oriented and not so much results-oriented. There is something party-like or festive about it.[52]

One of the shortcomings of Nicolas Bourriaud's contested category, "Relational Aesthetics," has been its strict application to only the group of artists discussed in his book, who have tended, since the mid-1990s, to show and socialize together, including Rirkrit Tiravanija, Christine Hill, Douglas Gordon, Pierre Huyghe, Vanessa Beecroft, Liam Gillick, Dominique Gonzalez-Foerster, Angela Bulloch, and Jens Haaning. The term relational aesthetics has unfortunately become the name of a clique, rather than what, by all rights, it should be: a useful description of tendencies in contemporary practice. Like

51. Ibid.
52. Ibid.

the relational artists, the most radical aspects of the work of artists such as Tino Sehgal, Dexter Sinister, and Christof Migone are those that take place in the figurative space between people, rather than in the literal space of the gallery. Rosenfeld's work is exemplary of not only the social aspects of contemporary work, which might be termed "relational," but also of the latent musical model for relational aesthetics. How should one define the social collective often gathered by this type of work if not with the term "ensemble"? What category of activity describes the loosely coordinated expression of subjectivity if not "improvisation"? Does it not seem appropriate to characterize the intersection of various forms of interaction as polyrhythmic and contrapuntal? As Bourriaud has pointed out, this type of work and its effects are not strictly formal. The composition of the work as both experience and environment requires a calculus involving time, subjectivity, and convention, cross-referencing an array of intermittent, ephemeral, interdependent, semiotic matrices:

> I want to insist on the instability and the diversity of the concept of "form." . . . Gordon Matta-Clark or Dan Graham's work can not be reduced to the "things" those two artists "produce"; it is not the simple secondary effects of a composition, as the formalistic aesthetic would like to advance, but the principle acting as a trajectory evolving through signs, objects, forms, gestures. . . . The contemporary artwork's form is spreading out from its material form: it is a linking element, a principle of dynamic agglutination. An artwork is a dot on a line. . . . In observing contemporary art practices, we ought to talk of "formations" rather than "forms." Unlike an object that is closed in on itself by the intervention of a style and a signature, present-day art shows that form only exists in the encounter and in the dynamic relationship enjoyed by an artistic proposition with other formations, artistic or otherwise.[53]

53. Nicolas Bourriaud, *Relational Aesthetics* (Dijon: Les presses du réel, 2002), 20–21.

Sheer Frost Orchestra is an example of a Bourriaudian forma-
tion: an encounter of dynamic relationships presented as an artistic
proposition. Rosenfeld recognizes the dynamism of her materials.
The electric guitar is more than a bluntly male-gendered device; it is
also a network of connotative significations that weave through the
history of rock and roll, starting with Muddy Waters. The electric guitar
embodies a semiotic of masculinized performance tropes: the low-
slung horizontality of the strapped-on instrument; the axe-wielding
violence running from Jimi Hendrix and Pete Townshend to Sonic
Youth and . . . And You Will Know Us by the Trail of Dead; the stylized
sexualized prosthetics of Prince. It also carries the implicit and pro-
hibitive content of technical machinery: its exploitation of electricity,
its industrial fabrication of metal and wood in an apparatus of pre-
cision-honed parts and purposeful design. The electric guitar rivals
the automobile in its masculine symbolism. Significantly, Rosenfeld's
orchestra starts by setting the guitar on its back. It is then played, not
with fingers, as usual, but with Western culture's most salient marker
of gender difference in fingers: nail polish.

In contravention of the proscriptions of orchestral tradition,
Rosenfeld's intervention explicitly summons the extramusical. As
palimpsest, *Sheer Frost Orchestra* bears the marks of multiple signi-
fying systems. In addition to all the extramusical connotations of its
musical materials, *Sheer Frost Orchestra* avails itself of a host of gal-
lery-arts associations: Asher's conceptual influence, the connection to
relational practices, the fact that her work is generally presented in art
venues. Its aspirational relationship to conversation allows it to speak
back to and against those systems. Its materials—the electric guitar
and the nail polish bottles—communicate in a Duchampian mode.
"They're both readymades with gendered connotations."[54] And in the
context of the museum or gallery, the work implicates the tools and
obsessions of the history of modern art. "There's this tiny brush in pig-
ment and the whole thing adds up to a conversation about painting or,

54. Rosenfeld, conversation with the author.

if not painting, a borrowing of the much more developed conversation about the performativity of painting."[55] In *Sheer Frost Orchestra* it is not the artist's hand that is stayed but the tools of the Greenbergian trade: brush and pigment. This is action painting sans painting, a neutered form of painting or—if we are prone to play by the Duchampian implications of this book's subtitle—a nontactile engagement with the materials and medium of painting: the brush and pigment stay inside the bottle, untouched but not unengaged.

Tapping into the value of her materials in their real-world, nonart, readymade existences, Rosenfeld raises questions about the performers themselves: "Wouldn't it be interesting if people acknowledged that musicians on stage were also objects or material? Their individuality is both suppressed and essential."[56] *Sheer Frost Orchestra* reveals that the implicit status of the musical performance, as a Bourriaudian formation, is always also a Freudian reaction formation, in which the artificiality of the performance is defensively portrayed as natural. Rosenfeld's performers are not absolute; the performance is not uncontestable. They are performers and performance only by dint of the *parergonal* structures that authorize them as such.

> One of the important ideas in the work is the temporariness of all of the transformations that take place. The ephemeral character of the music-social space is always acknowledged. And there's no argument that the transformations are permanent. You don't become a guitar player, you become a Sheer Frost guitar player.[57]

Sheer Frost Orchestra initiates a shift from the indisputability of the musical text to the contestation of the ordering of musical practice. The external is brought to the center, preparation becomes realization,

55. Ibid.
56. Ibid.
57. Ibid.

nonperformer-performers bare the device of performance. And if the rehearsals are, as I have suggested, more central to the work than the performance, one must ask: Who is the audience for this work? Is it the performers themselves, witnessing their own actions and transformations, as if in a mirror? Is it Rosenfeld, who becomes the observer to the process she has initiated? Is it those of us not present but introduced to the work through apocrypha, hearsay, and documentation? To answer "yes, yes, and yes" is to accept *Sheer Frost Orchestra*, and Rosenfeld's related works, as engaged in the conceptual effort of pushing music away from the "proper" territory of the ear and toward the "improper" nonterritory of the frame; the nether reaches of the expanded sonic situation; the peripheral edges of the text, beyond which there is no outside.

CONCLUSION

LEND AN EAR

Sound alone, signifies itself. This accepted, essentialist reading of the two great bestowals of Cage and Schaeffer—silence-as-sound and sound-in-itself—accepts sound as a kind of god, a unifying and unified sign. This amounts to the same unsustainable premise upon which the phenomenological construction is balanced. It maintains that self-presence takes place in the *Augenblick*, the blink of an eye. It happens so fast, it is so apparent, that it requires no signs, no representation. This is exactly the point at which Derrida inserts the shim and Husserl's listing phenomenological edifice collapses. Sound-in-itself is just as inconceivable as self-presence; the *Ohrenblick* is just as impossible as the *Augenblick*. Lyotard's reading realizes a Cage more radical than the myth:

> When Cage says: there is no silence, he says: no Other holds dominion over sound, there is no God, no Signifier as principle of unification or composition. . . . Neither is there a work anymore, no more limits . . . to determine musicality as a region.[1]

There is no work anymore, no *ergon*. The limits of musicality as a region recede infinitely, pushed outward by the expansion of the sonic situation. A non-cochlear sonic art moves beyond the territory of the ear, resisting sound-in-itself in much the same way that conceptualism in the visual arts resists Greenberg, opposing not the focus on materiality as the central issue but the very notion of a central issue.

1. Jean-François Lyotard, "Several Silences," in *Driftworks* (New York: Semiotext[e], 1984), 108.

A non-cochlear sonic art does not accept the resolution of sound-in-itself—not because it seeks another kind of resolution, but because it denies the possibility of resolution, ipso facto. Thinking through the epistemological implications of sonic practice since 1948, it is apparent that resolution is not forthcoming. Consider the works we have subjected to a (re)hearing: from John Cage's silent works, Pierre Schaeffer's *concrète études*, and Muddy Waters's proto–rock and roll, to Janet Cardiff's sound walks, Jarrod Fowler's percussive dialectics, and Marina Rosenfeld's relational sonics. These works both constitute, and are constituted by, a vast canvas upon which any number of pictures (histories, narratives, meanings) may be projected. But that canvas is also composed of a surfeit of individual threads, each woven from finer fibers. The meaning of the phrase "whole cloth" (something entirely fabricated, with no previous history or associations) gives the lie to the notion of completion. What appears to be of a piece is always just pieces. As easily as it can be assembled, it can be disassembled and reassembled: a patchwork of semblance and resemblance.

In a 1998 interview, Luc Ferrari recalled the Darmstadt International Summer Courses for New Music in the 1950s: "You had to choose between serialism and girls. I chose girls."[2] Schaeffer, Cage, and Waters each represent a different alternative to serialism, or, more generally, to the systemization and quantification of the values of music. Schaeffer sought a sonic northwest passage that would circumnavigate both traditional Western tonality and Darmstadt atonality by focusing on the *objet sonore*, a discrete unit of recorded sound. Cage, similarly, bypassed the compositional systems of his day, returning to a sonic state preceding systemization in which sound is valued for itself. Waters represents the expansion of a music not fixated on form, acting as a kind of cultural flypaper, trapping the concerns of its time

2. Luc Ferrari, as quoted in Dan Warburton, "Interview with Luc Ferrari," *ParisTransatlantic Magazine,* July 22, 1998, www.paristransatlantic.com/magazine/interviews/ferrari.html (accessed February 2, 2009).

and place in the deceptive simplicity of its repetitive formal simplicity. The choice is actually two choices in one. First, one must choose to accept or reject a formal system as the activating mode of engagement with a given material. At a general level, music is one such system for engaging with sound. More specifically, serialism codifies the methods of music, refining the rules of engagement.

This book takes for granted the rejection of existing systems and focuses its attention on the second choice: if one chooses to reject a given formal system, or formalism in general, one must invent or discover another mode or method for engaging the practice in question. One can choose to move inward, toward the center, toward the essential, fundamental concerns of the field. Or one can choose to move outward, away from the center, toward that which lies beyond the traditional borders of the field. Ferrari chose to move outward to girls, from music to the world. In the gallery arts, the movement has been decisively outward, away from the center. In the sonic arts, however, the movement has tended to be inward, a conservative retrenchment focused on materials and concerns considered essential to music and/or sound. What I have argued for here is a rehearing and a rethinking of the recent history of the sonic arts, in which certain episodes, certain works, certain ideas, might be reconsidered as evidence of movement outward rather than inward. Such an argument rejects essentialism. Value is not inherent, but rather a process that overflows the boundaries of the thing-itself. Meaning is always contingent and temporary, dependent on the constantly shifting overlap of symbolic grids. *It* is never simply it.

This is an argument that has been made before, in many ways and by many people. Charles Sanders Peirce believed that *it* is always a matter of relations, of thirdness. Maurice Merleau-Ponty enlarged Edmund Husserl's phenomenology beyond the thing-itself, or even the thing-as-it-appears-in-perception, to include issues of language, knowledge, and society. Rosalind Krauss seized upon Merleau-Ponty's expansion, identifying the art-historical turn away from an emphasis

on material and perception to a concern with the discursive frameworks that authorize, motivate, and define a field of practice. What Krauss identifies as the transition to postmodernism, Peter Osborne sees as the conceptual turn to an art that questions its own ontological and epistemological conditions. Such reconceptions of art's status appeal to the innovations of poststructuralist thought, notably that of Jacques Derrida and the revolutionary reformulation of meaning as the product of the trace of alterity in the apparent self-sameness of the thing-itself. Derrida diagnoses the uncontainable differential processes at work in the constitution of the *it* and thus establishes the absence at the heart of what appears to be presence. The thing-in-question cannot be satisfactorily pinpointed or contained. It cascades outward formlessly and infinitely, necessitating an aesthetics of the sublime rather than of beauty. According to Jean-François Lyotard, such an aesthetic is characteristic of the postmodern condition.

After 2009 will come 2010, and so on. Paul Valéry recognized the incompletable nature of things, declaring that a poem is never finished, only abandoned. Accordingly, this book is abandoned in 2009, with these final thoughts: Whatever *it* is—book, year, thought, work of art—it won't sit still. It is always running away from itself. Rather than despair or contest the inevitable, the movement toward a non-cochlear sonic art takes account of this inexorable dispersal and makes itself accountable to the expanded situation of sound-as-text. As an adjective, "sound" means solid, durable, stable. Perhaps this is what leads practitioners and theorists alike to think that sound knows what it is: sound is sound. But what Gertrude Stein said of Oakland is equally true of everywhere and everything, including sound: "There is no there there." In order to hear everything sound has to offer, we'll have to adjust the volume of the ear, listening not *at* or *out* the window, but *about* the window. After all, about the window is the world.

Index

References to images appear in italics.

Minimalism, in visual art, xv, xviii,
xix, 37–39, 42, 43, 48n29, 56,
63, 67, 67n10, 76–78, 76n19,
82–86, 85n37, 92, 166, 167, 223,
231, 247
Minimalism, in music, 134, 213, 231
Morris, Robert, 35, 36, 42–52,
42n14, 44n19, 45, 46nn24,26,
47n27, 51n32, 55, 57–60, 58n47,
63, 64n1, 65–76, 66n9, 67n10,
72n13, 73n14, 78, 82–86, 134,
167, 188, 223
Motte-Haber, Helga de la, 116,
116n44
Musique Concrète, xvi, xix, 9–13,
40, 144, 159, 177, 180, 214, 260
Muzak, 3, 17, 19–22, 20n36, 21n39,
22n41

Nancy, Jean-Luc, 182, 182n11, 184,
206, 207n30
Nattiez, Jean-Jacques, 15, 15n28,
174, 174n29
Nauman, Bruce, 36, 213, 214
Neuhaus, Max, 108, 108n33
New School, The (John Cage's
Composition Class), 55, 56, 133,
169, 214
Newport Folk Festival, The (1965),
206
Nietzsche, Frederich, xviii, 205,
205n29, 206
Non-Cochlear Sonic Art, xx, xxi, xxii,
xxiii, 128, 135–138, 155–160,
167, 168, 209, 217, 249, 259,
260
Non-Retinal Visual Art, xxi, 36, 166
Nugent, Ted, 22

Obama, Barack, xxiv
Objet Sonore (see Sonic Object),
xvi, 8n16, 9, 10n18, 12, 13nn22–
23, 14, 14n26, 126n11, 144, 177,
218, 223, 260
Ohrenblick, xx, 128, 194, 259
Oliveros, Pauline, 168, 168n23
Ono, Yoko, 56, 57
Osborne, Peter, xxiii n8, 52n34, 54,
54n41, 84, 85, 85n36, 112, 158,
158n10, 170, 245, 245n40, 262

Oswald, John, 230, 237, 239, 240
Owens, Craig, 208, 208n32, 209n35

Paik, Nam June, 56, 134, 169, 214,
249
Parergon (parerga), 229, 242, 243,
243n36, 245, 246, 251, 254
Pater, Walter, 41, 41n12, 157, 157n9
Pavement (Band), 103, 198
Peirce, Charles Sanders, 63–68,
64nn2–3, 65n4, 66n7, 72, 74–77,
74n16, 88, 112, 145, 167, 182,
227, 261
Penman, Ian, 26, 26n44
Phenomenology, x, xviii, xxii n7,
8–10, 13, 14, 42, 49, 60, 63, 64,
67, 68, 71–73, 73n15, 75–79,
77n22, 82, 83, 87, 127, 140, 178,
179n4, 261
Phillips, Sam, 29, 142, 143,
143nn32–33, 145, 146
Pollock, Jackson, 7, 58
Postmodernism, xvii, xviii, 33, 82,
85–87, 151, 208n32, 218–222,
220n11, 232, 246, 262
Presley, Elvis, 29, 142, 143nn32–33
Pythagoras, 9

Rauschenberg, Robert, 35, 161–166,
164, 165n19, 213
Reich, Steve, 114, 114nn41–42,
134, 135, 189, 213, 230
Retrospective Composition, 49, 55,
188
Riley, Terry, 134, 135
Rilke, Rainer Maria, 97–101,
97nn16–17, 98 nn18,20, 109,
109n35, 110, 117
Rosenfeld, Marina, xi, 248–255,
248n46, 249, 250nn49–50,
253n54, 260
Russolo, Luigi, 3, 3n2, 4, 91, 96, 108
Ruttmann, Walter, 10, 91, 178

Satie, Erik, 19, 20, 108, 161n11
Schaeffer, Pierre, xvi, xix, xx, 8,
8n16, 9–13, 9n17, 10n18,
11nn19–20, 13nn22,24, 14–18,
29, 40, 64, 72, 91, 94, 96, 123,
126, 133, 138, 144, 145, 156,